Deeper Than Gold

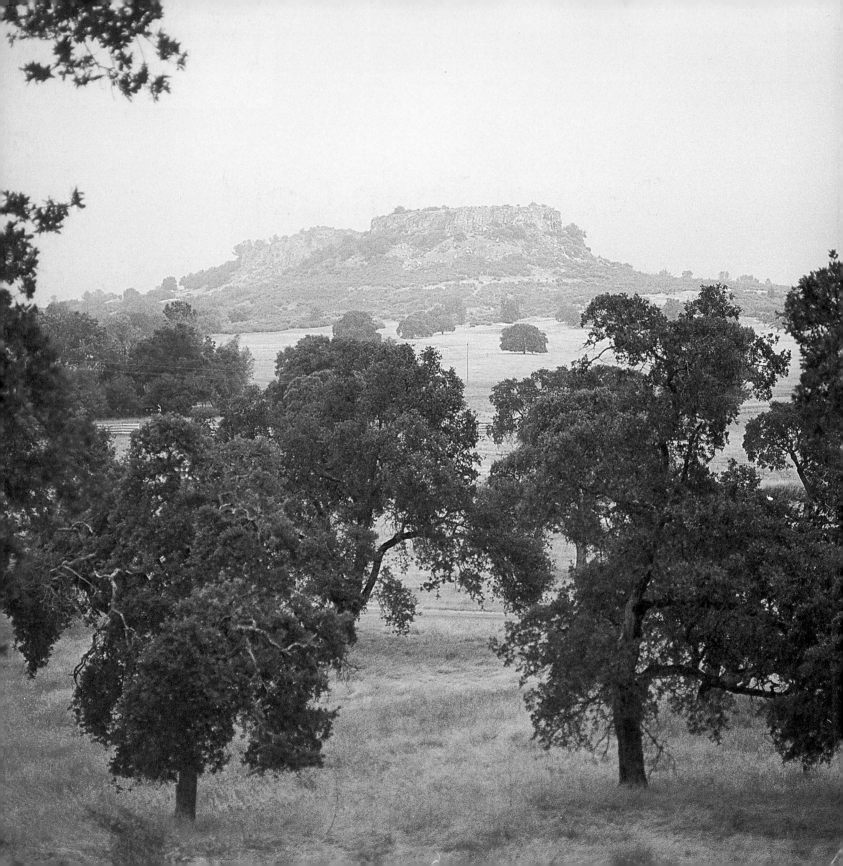

Deeper Than Gold

Indian Life in the Sierra Foothills

Brian Bibby

Photography by Dugan Aguilar

HEYDAY BOOKS *Berkeley, California*

Library of Congress Cataloging-in-Publication Data
Bibby, Brian.
Deeper than gold : a guide to Indian life in the Sierra foothills /
Brian Bibby ; photographs by Dugan Aguilar.
p. cm.
ISBN 0-930588-96-7 (pbk. : alk. paper)
1. Indians of North America — California — History. 2. Indians of North America — Sierra
Nevada (Calif. and Nev.) — Portraits. 3. Indians of North America — Sierra Nevada (Calif.
and Nev.) — Pictorial works. 4. Sierra Nevada (Calif. and Nev.) — Description and travel —
Pictorial works. I. Aguilar, Dugan. II. Title.
E78.C15.B475 2004
979.4'400497 — dc22 2004002705

Cover design: Rebecca LeGates
Interior design: David Bullen Design
On the front cover: Mimi Mullen (Maidu), grand marshal of the 1997 Greenville Gold Diggers
Day parade. Photograph by Dugan Aguilar
On the back cover: Frances McCabe Gann with a portrait of her great-grandmother, Mary Ann
Lewis Johnson, Mariposa County. Photograph by Dugan Aguilar, 1997

Orders, inquiries, and correspondence
should be addressed to:
Heyday Books
P.O. Box 9145, Berkeley, CA 94709
(510) 549-3564, fax (510) 549-1889
www. heydaybooks.com

Printing and binding: Malloy Incorporated, Ann Arbor, MI

10 9 8 7 6 5 4 3 2 1

Contents

Acknowledgments

Deeper Than Gold is dedicated to the memory of:

 Manuel Jeff

 Mary Wagner Jones

 Mimi Mullen

 Theda Martin Steele

 Bernice Burris Villa

Deeper Than Gold has been a collaborative effort requiring the knowledge and expertise of many people. We wish to express our appreciation to Craig D. Bates, Dal Castro, Shelly Davis-King, Randall Milliken, Bill Shipley, Ray Taylor, Glenn Villa Jr., and Suzanne Wash for their assistance and sharing. A special dept of gratitude goes to Richard Simpson and Bob Rathbun for their invaluable recording of native oral histories during the 1960s and 70s. Their work included a strong sense of local cultural landscape, and through them we are introduced to Lizzie Enos, Bryan Beavers, and Tom Epperson — remarkable individuals whose knowledge and experiences continue to inform us in a warm and personable manner.

Research for this book was conducted with the generous assistance of the

Fund for Folk Culture and the National Endowment for the Arts, through their contributions to Local Cultures/Musical Traditions, Inc. Funding from the California Arts Council contributed to the production of the book, and the LEF Foundation supported photography by Dugan Aguilar.

Brian Bibby

I would like to thank the LEF Foundation for the grant that allowed me to feel like a professional photographer. I would also like to thank Brian Bibby for allowing me to travel Highway 49 with him to meet the people who gave me their beautiful images; Malcolm Margolin and Jeannine Gendar for weaving the images together; and my wife, Elizabeth, for her support over the years. I would like to dedicate my part of this book to her.

Dugan Aguilar

List of Illustrations

I realize my humanity in proportion as I receive my reflection in the landscape that enfolds me. It has always been so. It is the cornerstone of religion; it is the great metaphor of belief, of wonder and holy regard, of profound reverence and deepest delight.

N. Scott Momaday

Introduction

In 1981, just after moving into an apartment complex in Sacramento near Watt Avenue and close to the American River, I was having a telephone conversation with Nisenan elder Betty Castro. When I told her where I was, she said, "Oh, you're down to Kadema." She was referring to the village of Kadema — the site only blocks from my new residence where her mother had visited relatives near the turn of the twentieth century. Later I came to understand that Betty knew the locations and names of several former villages now overrun by urban Sacramento and Folsom, and she still viewed the landscape in terms of those reference points; her sense of geography predated the formation of contemporary cities and towns.

Betty ushered me into that world. She had managed to screen out the new impositions on the native landscape and had preserved a Nisenan view of the region. She saw the land through a different lens: one informed by ancient myth, language, culture, and genealogy. It reached far beyond the prevailing sense of history most Californians embrace, of gold seekers and the era of pioneer settlement that took place roughly one hundred and fifty years ago. Eventually I would understand this to be the "cultural landscape." I came to see that the legacy of native people and culture in this region contrasts sharply with

American settlement and today's burgeoning international growth. It is the difference between eternal and transient, home and commodity, local and global.

The native landscape is relatively invisible to the general public. All along Highway 49, the main thoroughfare of the Sierra Nevada foothills—the Mother Lode—the tourist can easily see nineteenth-century buildings and imagine an earlier lifestyle, that of their pioneer forebears. And all of this is well preserved, honored, and promoted. But native cultural history is less obvious, less intrusive. Former villages have decomposed back into the earth, leaving little more evidence than a grouping of shallow depressions on the ground. Many of the subtle signs that might have remained of the region's indigenous past have been inundated, blasted out of the way of new roads, paved over, built upon, moved by bulldozers, hauled off by dump trucks, and otherwise rendered unrecognizable. As development increases in the foothills, this kind of destruction is on the rise.

The romance of the gold rush fades when tempered with knowledge of the environmental devastation that resulted from mining. A visit to Malakoff Diggins provides ample evidence of the earth-altering hydraulic mining ventures practiced in the Sierra Nevada. As the land gradually attempts to reclaim itself, other legacies of the gold rush continue to haunt us in very serious ways.

An estimated twenty million pounds of mercury (imported from mines in the Coast Range) were lost during gold mining activities in the Sierra Nevada. Used for the processing of gold ore, much of the mercury was ultimately released into foothill and mountain streams. Once in an aquatic environment, some of the mercury was converted to the toxic methyl form that affects the food web. (Recent research has found that this is not a natural phenomenon associated with the fractional amounts of mercury that occur naturally within the Sierra, but rather a direct result of historic mining.) Certain streams and reservoirs in the Sierra still hold dramatically greater amounts of mercury (and mercury bioaccumulation) than do unmined waters. This is also true for the greater Sacramento–San Joaquin Delta. As methylmercury moves up through the food web, the concentrations become greater and potentially more deadly. Herons, otters, mink, and other creatures (including humans) that feed off of

smaller organisms may be receiving doses elevated enough to warrant concern about developmental and neurological damage.[1] The toxic legacy from one hundred and fifty years ago lingers with us still. And while native communities continue the effort to right themselves from the impact of the gold rush, many of the creatures who were partners in their survival struggle amidst the poison.

Having grown up in Sacramento, I was frequently in the foothills as a boy, passing through the old towns (a lot more rustic and a little less dolled-up back then) with my father on our way to some fishing or camping spot. At age sixteen, with driver's licenses in hand, a few close friends and I often ventured into the foothills to camp and explore. Each town drew upon its romantic gold rush history in about every way possible: the 49er Motel, Nugget Motors, Gold Country Inn, Black Bart Motel, Pioneer Market—and it's still that way.

At some point it struck me that the identity of the region was being expressed via a brief and rather limited historical sequence. The places Betty Castro spoke of were already old when the first gold seekers arrived on the scene—and the myths went back to the beginning. It all made the gold rush history and identity seem fairly superficial in comparison—a thin layer of glitter spread over a deep foundation of human experience.

Deeper Than Gold is about the native people—Maidu, Konkow, Nisenan, Miwuk, and Chukchansi—of what is known as the gold country, and their relationship with the landscape, episodes in their history, and their continuing legacy in the region. The impetus for this project was the California Gold Discovery Sesquicentennial of 1999: in essence, this was a response to the celebration and commemoration of the California gold rush. We—David Roche, photographer Dugan Aguilar, and I, with contributions from many others— wanted to show that the region once was, and still is, a native place. Despite all the physical transformations that have altered and ravaged the landscape, some of the landmarks remain.

While it is true that the native population has experienced great loss and trauma, through susceptibility to European diseases, vigilante violence, removal from their homes, and indenture,[2] it is also true that they survived this

cataclysmic period and adapted to the changes that confronted them. The results of their labor and their participation in the evolving economics, culture, and environment of post–gold rush California are also very much a part of the contemporary landscape.

Native Californians were very much involved in the gold rush, and there are ample written records of this; history reveals the irony of a people thrown into circumstances beyond their control and working—often unknowingly—to their own detriment.[3] Once they had learned the process, native people began mining on their own, often using traditional winnowing baskets to "pan" for the ore.

William Joseph (Nisenan) stated that Indians and white men mined for gold at Bucks Bar, near Mt. Aukum, in El Dorado County. He also related a story of a Nisenan boy who discovered gold in a creek near the spot where he had killed a deer:

> When he brought [it] into camp he told his relatives, "There is a lot of this gold, let us go tomorrow!" he said. That morning at dawn they went, only the men, they left the women. They all brought a lot of gold. They took [it] to town to exchange, five or six times to that town, the same fellows.[4]

Soon a group of white miners tracked the Indians and discovered the spot. When the Indians returned to the location, they saw that the white men had taken it over. They did not contest the trespass, as it was the same group of men who had just weeks earlier hung an Indian boy for stealing gold from their cabin. The place became known as Indian Diggins.[5] In Sonora, native people were driven from their claim by a group of men from Los Angeles who later extracted fifty-two pounds of gold from the site.

Through the first quarter of the twentieth century, some native families continued to pan for gold as a source of income. Stories of elderly ladies supplementing their income with gold when times were hard are not surprising when one stops to consider that many descendants of the original people have remained on or returned to the land their ancestors knew so well—often, remarkably, within a few miles of ancestral villages.

The legacy of those ancestors is revealed in ancient myths. It is reflected in the living environment of the Sierra by birds and other animals, by stones and trees, hills and rivers. It is contained in native languages, historical memoirs, and personal remembrances. *Deeper Than Gold*, a collection of myths, photographs —contemporary and historic—bits of native languages, historic vignettes, personal stories, and commentary, is an attempt to reveal this legacy and to give readers an alternative view of the gold country.

Each culture is rooted in its mythology; tribal myths encompass nearly every aspect of the human experience. Myths recount the creative acts that gave the land its form—the oddly shaped hill, the deep cut of a canyon, the location of a lake. They also allow for informed interaction with the environment and all its creatures, instilling character and personality into the nonhuman portion of the world: the little white-footed mouse who steals fire for his people; fearsome, flesh-eating giants; gods reclining on a hillside; the oak woodlands that grew from the acorn caches of Blue Jay.

Often passed off as cute "legends" possessing little intellectual impact, native myths are not intended to be factual explanations of how the earth was created. They might best be appreciated as oral literature, or as Kiowa writer N. Scott Momaday characterized it, "the record of living experience." They reveal a spiritual mystery and wonder that were a part of life in a world—long ago—that was not well known. Ironically, for all our knowledge, the world and the way of life that they reflect are now nearly unknown. Because of this, we are usually unaware of the metaphors embedded in the myths and therefore often miss their deeper, less obvious meanings.

Yet Blue Jay still plants his acorns. In many ways the myths remain true and relevant. The stone figures, swirling pools, flat-topped mesas, sun, moon, and stars all remain in their places. We are looking upon the same scenes viewed by past generations.

Scattered throughout the countryside are landmarks with connections to the old myths. Many are not well known, while others are familiar geological features, everyday sights. The work of photographer Dugan Aguilar (Paiute/Maidu/Pit River) enriches *Deeper Than Gold* immeasurably, documenting this landscape as well as its native people. The landmarks have little or nothing to

do with man's hand: there are no Mount Rushmores here, and nothing resembling the Washington Monument. These are works of the creator, and a pantheon of characters who gave the world its form. They have been sanctified by time. This represents a fundamental shift in thinking—from an environment which man has a large role in transforming to one in which natural forms embody the creative history of life in this world.

The character of these places—as articulated in myth—includes a sense of life most people today would have difficulty understanding. Many places were viewed as living entities that appeared to reveal a sense of self with which people engaged in an ongoing conversation. Contact with such landmarks brought the individual within the realm of eternity. Nomlaki elder Joe Freeman was once describing a rock formation linked to an early episode in Nomlaki history. His interviewer remarked how distant the event was. Freeman responded, "Yeah, that was a long time ago, but that rock is there right now."

Language too is a window into the old world. Within the roughly three hundred miles from the mountain meadows of Plumas County to the roundhouse at Wassama, at the southern end of Yosemite National Park, the native people spoke seven different languages, and each language had several local dialects. These languages articulate a way of life, revealing interrelationships between people and their environment. In some instances, implied meanings are hidden within the words, drawn from a world of acute observation and experience, as exemplified in Miwuk personal names [see Chapter 5]. The sound of the language, the method and form of ritual oratory, the names of plants and animals, hills and valleys—all are part of the original soundscape of the Sierra Nevada.

The other window to the region is through human history and personal stories. Changes to the lifeways of the Sierra's native people have occurred with startling swiftness in the past hundred and fifty years. Whole languages have disappeared. Societal structures, value systems, religious traditions, and areas of knowledge we don't have any idea about have—in many cases—been damaged beyond recognition. Particularly painful has been the loss of things familiar: an ancestral home; the sound of acorns pounded in a stone mortar; the smell of

bay thrown on a ceremonial fire; the taste of toasted seeds from a plant no longer found. Collectively, this was the stuff of people's lives. I have often thought of how heartbreaking and depressing this must have been for the first generations who endured the non-Indian invasion that followed the discovery of gold. Generations were left in a sociocultural limbo, resulting in a messy trail of self-destruction, chronic alcoholism, and a variety of other social ills; there wasn't much to fill the void left by cultural disintegration. Wracked with poverty and, until fairly recently, lacking the economic foundation to press for their rights, the native people of the gold country have lived on the perimeter of the dominant society throughout much of the past century and a half. Their personal and cultural experiences are unique but not well known.

There appears to be a new image of native people emerging among non-Indians today, a picture of privileged people with gaming rights who get rich without working. This image does not match the experience of the individuals whose lives are touched upon in this book. Now, as another wave of startling changes moves in, it may be more important than ever to see the reality of their experience.

Many of the elderly native people I have known in this region were (and are) remarkably resilient individuals. Most of them worked hard, often relegated to physically demanding employment; though their presence is not always obvious, their labor — mining and logging, ranch and domestic work being the most obvious examples — has been essential to the development of the region. (Today their descendants are engaged at nearly every level of the workforce, holding important positions with the state of California, in health care, social work, the arts, and the administration of tribal government.) Many — men and women — were veterans of the armed services. Some were highly decorated. Their toughness revealed itself in a variety of ways, sometimes in their refusal to lose their native language despite social disapproval, or perhaps in their steadfast use of traditional foods. For many, the myths, language, art, and values of their people were a refuge from mainstream America — a sanctuary of the mind. Thus, to a large extent, the old world and old culture have survived as a product of memory. And regardless of their social or economic situation, these people have had a sense of home and belonging that extends beyond the

experience of most other Californians. Despite environmental degradation, damage to native cultural systems, and the massive influx of non-native populations, it's still Indian country.

Notes

1. D. G. Slotton, S. M. Ayers, J. E. Reuter, and C. R. Goldman, "Gold Mining Impacts on Food Chain Mercury in Northwestern Sierra Nevada Streams," in "Technical Completion Report for the University of California Water Resources Center, Project W-816"

2. Some native communities in Butte County were removed to Nome Lackee Reservation in Tehama County, beginning in September 1854. The reservation was abandoned in 1862. In 1863, Nome Cult Farm (i.e. Round Valley Reservation) was established by the federal government in Mendocino County. A major effort was made to remove most of the native people from Butte, Yuba, Sutter, Nevada, and Placer Counties to that reservation.

 An Act for the Government and Protection of Indians, Chapter 133 of the Statutes of California, enacted into law April 22, 1850, authorized the indenture or apprenticeship of Indians of all ages to any white citizen. It was repealed in 1863.

3. In June of 1848, less than six months after Marshall's discovery, Governor Mason estimated that of the four thousand men mining in the Sierra, two thousand were Indians. A neighbor of Sutter's brought fifty Indians to Coloma in April of 1848; seven men from Monterey brought some fifty Indians to mine on the Feather River; and another report stated that two men mining on the North Fork of the American River had employed two white men and one hundred Indians.

4. Hans Jorgen Uldall and William Shipley, *Nisenan Texts and Dictionary*, University of California Publications in Linguistics, vol. 46 (Berkeley: University of California Press, 1966)

5. Ibid.

Deeper Than Gold

Indian Life in the Sierra Foothills

One
Northern Sierra Mountain Meadows

JUST SOUTH of Mount Lassen, the last link in the Cascade Range, are the northernmost reaches of the Sierra Nevada. Here, the volcanic terrain of the Cascades gives way to the beautiful mountain meadows and valleys of Plumas County. In winter and early spring, snow often blankets the valleys, which are at 3,400 to 4,500 feet in elevation. When the weather warms up, abundant life—squirrels and deer, jays and finches, glorious maples, black oaks, and innumerable other animals and plants—makes it clear why these valleys have been the preferred residence of the Maidu people for untold generations.

Among the extensive meadows here are American Valley, in which the county seat, Quincy, is now located; Indian Valley, the site of Greenville and Taylorsville; and Big Meadows, now largely inundated by Lake Almanor. These and several smaller meadows, such as the Genesee, Butt, Sierra, and Mohawk Valleys, were the sites of Maidu villages, although some, like Mountain Meadows, were only occupied in the summer, when temporary camps with brush enclosures were set up.

The Maidu built their villages at the edges of the forests that bordered the meadows, which were lush and open but usually too damp and spongy to build a home on. Most of the older Anglo-American homesites are also found where

forest and meadow meet. A Maidu village might be home to a few families living in houses, often made of cedar bark layered and arranged into a conical shape, that could keep a family dry and comfortable throughout the winter. In a larger village, which might house a hundred people or more, you would find a roundhouse as well, the ceremonial center for the village and others in the area.

This chapter includes a look at how this world was created and an introduction to its flora and fauna; a look at basketry, an essential and beautiful element

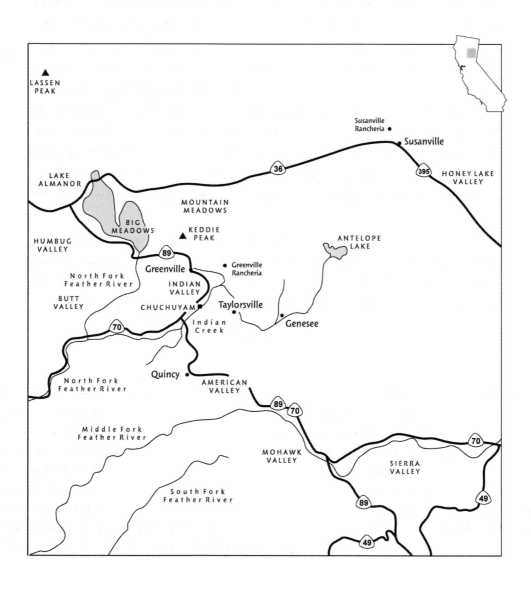

of California's native cultures; and a look at the trickster Coyote, whose opinionated and contrary ways led to many of humanity's ills, and whose influence continues to be felt.

Chuchuyam

The following story is just one episode in the rich body of Maidu creation stories. This version was told by Tom Epperson. Born late in the 1800s, he became an experienced singer and ceremonialist, a fixture at traditional bear dances in Indian Valley and at Jaynesville until his death in 1974.[1] His knowledge of Maidu oral literature was extensive, and he was a fluent speaker of the Maidu language. The details of his stories — a blow fly at the beginning of the world who sounded like a steam engine, for instance — span centuries of Maidu life. In the early 1960s, he shared this story and several others with Robert Rathbun (Coyote Man), who published them in *Sun, Moon, and Stars* (Berkeley: Brother William Press, 1973). The story of Chuchuyam is a link to the beginning of time: you can still see parts of the trail where Worldmaker walked in Big River Canyon.

The Worldmaker, the man who made this world, passed out and got a crazy dream. When he woke up, he told the Animal people about his dream: "I had a dream about grizzly bears. On this kind of a day water, water, water comes." He talked about water flooding the world. And then he began to sing his song:

hainu . . . hainu . . . hainu . . . hainu

American Valley	*silong kojo*	**Honey Lake Valley**	*hanylekem kojo* (from *hanylek*, "to hurry along, carrying something on one's back, and *kojo*, "valley or meadow." The present name for this area, Honey Lake Valley, is apparently derived from the original Maidu term, which sounds similar to "Honey Lake.")
Indian Valley	*tasim kojo* (from *tas*, "over there" or "on the other side," and *kojo*, "valley" or "meadow": *tasim kojo*, "the valley over there")		
Genesee Valley	*jetammetom*		
Big Meadows	*nakang kojo*		
Mountain Meadows	*hopnom kojo*	**Humbug Valley**	*tasma* ("Where the other side is")

Orthographic note: "j" is pronounced like "y," as in "yard," and "y" is pronounced like ə, i.e. like the "e" in "places."

When he finished, the water started coming. It flooded the country.

Worldmaker put up a big pole (the same as the roof-support pole in the roundhouse). That pole stretched from the ground to the blue sky above — no telling how far that is. All the animals who lived in that world were drowning. But the Worldmaker climbed the big pole and Sunflower Girl followed right behind him — she was a woman in those times. The water came up. The Worldmaker crawled up. The water came up higher. The Worldmaker crawled up again. Sunflower Girl followed him. The water came up. He moved up. And she moved up. He moved. And she moved. Sunflower Girl looked about — could not see anything but water: no mountains. Water covered everything. She sang about the water, singing that the water would drop and they could get back onto land.

> *I'm Sunflower I'm Sunflower I'm Sunflower Girl*
> *Looking down on something light and bright.*
> *There's water, too much water.*
> *Water covers the mountains, I cannot see the mountains.*
> *Maybe someday the water might go back down*
> *and we can get back to earth.*

But the water kept coming up. So she had to move on up the pole.

Finally, the water did stop, stopped rising. Worldmaker hung on the pole, away up there. The country was nothing but water then. At last he got tired and started singing, singing for Big Deer to shove his hind leg through the hole in the sky. Now, Big Deer lives in another country, the land above the sky. No telling how long that deer's leg was, but he stuck it down to Worldmaker. That big man drew the cord from Big Deer's ankle. He turned Big Deer loose. He split the cord, split it again and again. Then he sang for different birds. Pretty soon different birds fluttered around the pole: Mudhen; that black bird with the yellow chest; different birds. Worldmaker tied the strips of cords to the pole. Blackbird Woman flew away with the ends. She tied one end to a big pile of rocks to the north. At two or three places toward the east and south, she fastened them to the rock mountains sticking out of the water. Over to the west the cord was a little bit short: she could not get it clear across the water. She said,

"Well, I'll fasten it onto something." And she tied it to a rock over there. Then Mudhen Woman dove for mud. Blackbird brought a few weeds—whatever floated on the water. They brought little sticks, one thing and another, and piled them around the pole.

Worldmaker sang again, calling Robin Woman. Robin Woman came, bringing mud from the world above. (Now robins build their nests with mud.) She built her nest around where the Worldmaker fastened the cord. Pretty soon she had a good pile of muck built up. The Worldmaker watched them all the time, singing away. He put his right foot down in this mud nest and began shaking his foot, kept shaking it: that muck pile got bigger and bigger. Then he put his left foot down and kept shaking, kept shaking. No telling where he got all the mud and dirt but . . . all at once it went all over this world. Then there was land over the water. That way the Worldmaker made a new land when water covered his world. Over to the west, where the cord was short, there is water still.

The Worldmaker slid off of the pole and looked around. Sunflower Girl, she still held on up there, singing away. She came down and started to grow on the earth. Sunflower Girl still grows here in this land, hanging on top of a little pole, singing away.

Then the Worldmaker went on an inspection tour. He walked from the lower end of the world to the upper end. Mankillers lived all over the country then. If a person got past one place, something would get him at another place. So the Worldmaker walked along a trail and got rid of all those things. He came up from the lower end of the world and got to Chuchuyam. (Parts of the old trail still cling to the north side of Big River Canyon.) The Chuchuyam women were the bad bunch there: they pissed on everyone coming up the trail, like a fire hose—washed them into Sandy Creek and drowned them. This Worldmaker knew enemies lived there. When he came to that place, he stretched his walking stick and shoved it down into the creek bottom, maybe two or three hundred feet below. He held onto that stick and made it across the washout. He walked away, paying no attention to those women. The Chuchuyam women could not wash him into the creek.

Two boys, Mink and Fisher, who were fixing this world up then, lived at the next point up Sandy Creek. They were still working, going here and there,

naming the country, running all over, making these ravines, canyons, and springs. The Worldmaker came to their place. He laid down his packsack—he carried everything he needed in there, even his woman. He pulled a basket out of his packsack, and acorns. He told his woman, "Make acorn soup for these boys, so when they come they can have it."

His woman crawled out of the packsack and made acorn soup, enough to fill a big basket. He stuffed his woman back into the packsack and lay there until the two boys came home.

After they came they said, "Acorn soup? Is that pack big enough to carry all that acorn soup?" They ate. Afterwards the boys told the Worldmaker about a big snake: "At night this big snake crawls out of his hole, up the creek there, and comes down here." (Flies crawling around the mouth of a cave in the rimrock above Sandy Creek mark where that snake lived. The snake's wiggling motion leveled hills into sandbars and formed the meanders in Sandy Creek.) "In the morning he crawls back up into his hole. He keeps squirming back and forth. We set a trap. But we can't catch him—he broke all of our traps. Do you mind setting a trap and catching that thing?"

"Ya. I'll do it."

Some people say that blue sky is nothing but a long ways. But the next day the big man set a couple of good sticks way up in a hole in the blue sky. He fastened a string up there, some kind of string big enough to catch the snake. Whenever that snake got caught, the trap would pull it on into the other country up above, and there would be no big snake down here—at least not that big one.

That night, when those two boys came home, the big man told them, "When you fellows trap this animal, cut off a bit of the tail. Take that tail fat down the creek to the Chuchuyam women's roundhouse. They almost killed me, those women. I don't want them around. Kill them. Get rid of them. At night, when they dance, just throw the fat through the smoke hole and into the fire—then sit on the smoke hole. That snake smell will kill those women. Let them die and mash the whole roundhouse down." And the Worldmaker moved on.

So these two boys hired a big blow fly. They said, "When we catch that big snake in the trap, you holler. We'll hear you and run back down here." They set him to watching.

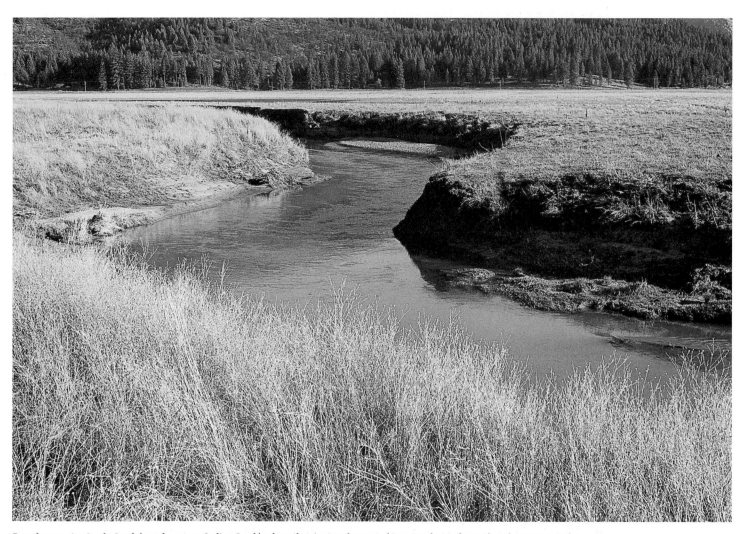

Bymykym sewim, Sandy Creek (now known as Indian Creek), where the giant snake created its meandering form. *Photo by Dugan Aguilar*

Then the boys started out, singing about running:

Henni en pumpumto . . . henni en pumpumto.

They must have been long-winded. Those boys ran all over this country, making these deep canyons and these rock mountains around this country—making everything. The big man gave them a basket, packsack-like, that never emptied. They carried rock. If they wanted a big rock mountain, all they had to do was reach back in their pack for a little chunk of rock and toss it to where they wanted a big rock mountain. They ran all over this world, throwing those rocks down. And they made these ravines: they'd get their feet down, making the holes and mountains all over. And they cast the seeds of the foods humans eat, and the grass, and brush, and trees of different kinds. They worked around This Place Meadow while the Worldmaker worked on making humans.

"Huwhssss!" This old blow fly hollered just like a steam engine. "Let's go!" they said. And they ran straight back through This Place Meadow. They just made it to the trap. The snake had just risen off the ground, going toward that hole in the sky. Fisher jumped, got a hold of the tip of the tail, and whacked off a bit with his big knife. He got a little piece of fat off of the big snake's tail. Some white stuff started leaking out of the tail. Old Skunk was in that camp, and Skunk ran under the snake tail to lick the greasy white snake oil. It hit Skunk on the forehead and, streaming to each side, it ran down his back. (Skunk got his white stripes then, and Fisher got his white belly.)

"Well," one of the boys said, "you know what that big man told us. We have to do it." That night they took a chunk of snake fat down to Chuchuyam. The boys sneaked around, sneaked around, and finally sneaked onto the roundhouse roof. Two or three women down there danced around the fire, having a fine time. The boys threw that piece of snake fat into the fire and sat on the smoke hole. No smoke came out. That snake smoke settled in the roundhouse and killed those women. The boys listened . . . all quiet. Those women died down there. The boys tramped down the roundhouse, made it cave in.

Worldmaker directed the creation of the Maidu homeland, but Coyote was there at every turn, playing his own indispensable role. Tales of this notorious

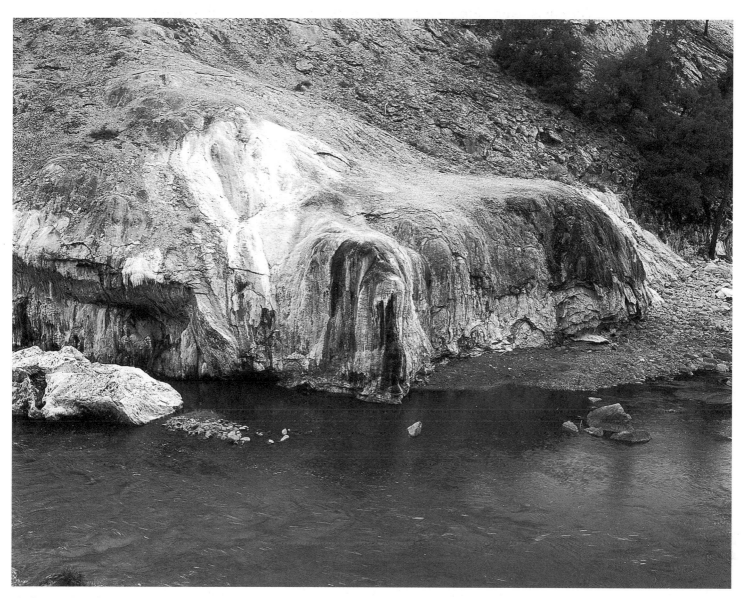

Chuchuyam, where the Chuchuya women lived and died. *Photo by Dugan Aguilar*

trickster are a window to an ancient and acute perception of the difficulties of human nature and life in general.

Coyote had made the three Chuchuya women. He took one, and Kingfisher another. It was the third woman, Whippoorwill, who spread her legs and leaned over backwards, trying to wash Worldmaker into the creek with her urine. This is what created the travertine terrace at Chuchuya. A big sinkhole above the terrace is the Chuchuya women's old roundhouse pit. The women became red-eyed birds.

The Chuchuya story may seem confusing, even surrealistic, but as you learn more about the landscape and Maidu technology, it is easier to follow. Consider the part where Worldmaker takes a cord from Big Deer's ankle. Sinew (tendon) from the forelegs of deer makes a strong, light material for fletching arrows and securing stone points to foreshafts. The packsacks in the story were probably net bags made of a strong and durable string obtained by cleaning and twisting the inner bark fibers of native hemp (dogbane, *Apocynum cannabinum*). Bags such as these were often carried by men while out hunting. Women used pack baskets, *wolom* (sometimes called burden baskets) woven of willow shoots,

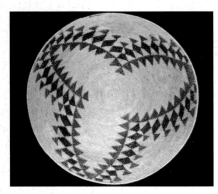

Winnowing basket by Lucy Baker (1859-1920), 16½" diameter, made from split shoots of big-leaf maple, redbud, and bracken fern on a three-rod foundation of willow. Collected in 1907. *Photo courtesy of Department of Anthropology, Smithsonian Institution, no. 313252*

California Indian baskets are collected and coveted by connoisseurs throughout the world for the skill and artistry that go into them. Before the arrival of Europeans, baskets were used to carry, store, and process all kinds of food and supplies. Maidu baskets are made in the two prevalent California techniques, twining and coiling, with sticks, roots, and other materials that have been painstakingly chosen, cleaned, split, and sized.

Bracken fern and big-leaf maple are two of the materials traditionally used in Maidu baskets. *Sulella*, or bracken fern *(Pteridium aquilinum)* roots are gathered and split open to expose a tough, dark brown filament that is then dyed jet black in a cold bath of water with either black walnut shells, acorns, or rusty nails added.

Dahpimcha, or big-leaf maple *(Acer macrophyllum)* branchlets are often pruned from recently cut stumps, then baked to make the bark easier to remove. The shoots are then split lengthwise and sized to be used as the white sewing strands that constitute the background in most coiled baskets.

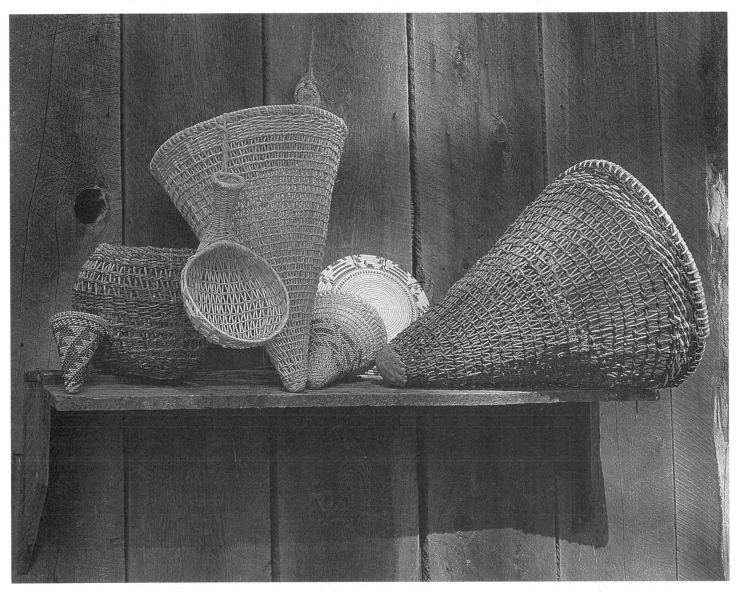

Baskets by Maidu weaver Ennis Peck. *Photograph by Dugan Aguilar*

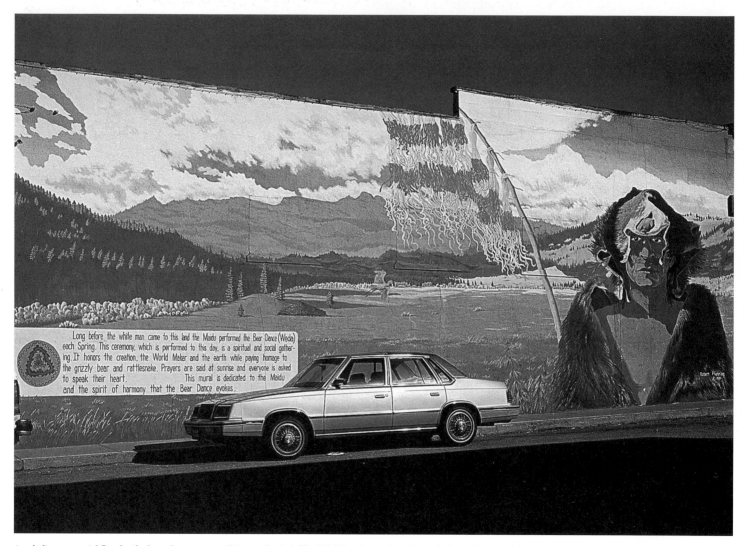

A *yokoli*, ceremonial flag for the bear dance, graces this mural painted by Bob Pfenning in downtown Quincy. *Photograph by Dugan Aguilar*

conifer roots, and beargrass, to carry large amounts of acorns, seeds, and other foods.

Maidu people, like indigenous people everywhere, often found more than one use for a specific plant, shrub, or tree. A single plant might provide food and medicine and be used for everything from day-to-day needs to ceremonies. The inner bark of maple, for example, can be shredded, pounded into flexibility, and used to make skirts and aprons. Maidu children once played with dolls that wore miniature maple bark skirts. Mature maple leaves were once used to line earth ovens for baking acorn bread and possibly other foods. A container made by weaving strips of maple bark around a wooden hoop was lined with maple leaves and used to carry acorn dough to neighboring villages. Bundled tassels of maple fiber are used to make a ceremonial flag, *yokoli*, used in the important spring ceremony known as *weyda boyem*, which includes the relatively well-known bear dance. The maple tassels are usually dyed with a series of horizontal bands, using a reddish orange dye made from the bark of alder trees.

Lilly Baker

Lilly Baker is the resident dean of Maidu basketry today. She is an esteemed elder whose knowledge, charm, humor, and gentleness are valued by virtually everyone who has had the good fortune to meet her. Born in Plumas County in 1911, Lilly has spent her entire life in the mountain valleys of her ancestors.

Basket weavers are abundant in Lilly Baker's family tree, reaching back in time beyond even Lilly's memory. Her mother, Daisy Baker, her maternal grandmother, Jenny Meadows, and her paternal grandmother, Lucy Baker, were also weavers of distinction, and their works are found within America's major museum collections. Lilly recently recalled her childhood experiences as a beginning weaver:

> I started weaving when I was about eight years old. I started a basket, and I worked on it, and it looked terrible! So I threw it away. But my dad came along, and he found it and scolded me. He took it and he pounded it all around and shaped it in a nice little basket, and he says, "You finish it." So I finished it and I kept it for a long time. It was coiled. It wasn't bad. I thought it was terrible looking, but it wasn't bad.[2]

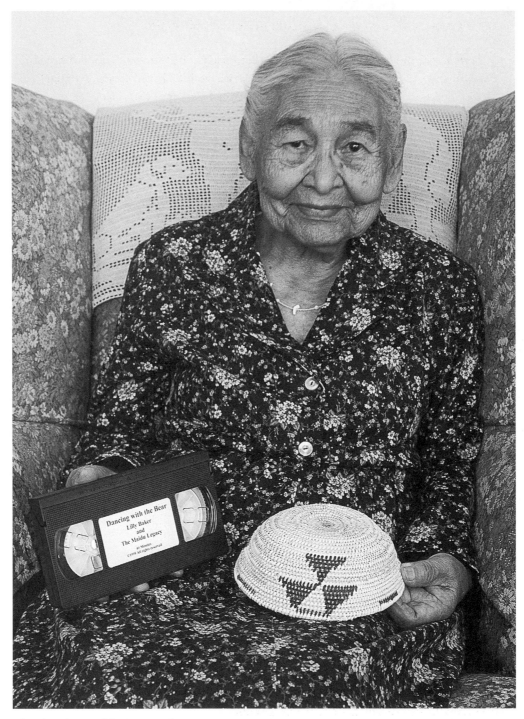

Lilly Baker. *Photograph by Dugan Aguilar*

Lilly has continued to weave throughout most of her life.

I do twining and coiling, both kinds. I like variety. I like to do the cone shape, round ones, big ones, and small ones. I love to weave, but I haven't been [weaving] that much lately. You just have too much work to do around the house.

Finding and gathering materials can be a challenge for today's weavers. Getting to the right spot for the right material when it is in optimum condition is difficult enough. Getting permission from private landowners or public officials adds to the difficulty. The quality and health of materials is also an issue. In the past, weavers could tend the plants—burning, pruning, and digging as needed to produce abundant, straight, supple shoots, leaves, and roots—but this is nearly impossible with limited access to the land on which the plants grow. Herbicides are yet another problem.

I try to go every year and gather and then that will keep me going for one year. And then the next year I go again. That's how I do it. I take a cutter and cut all my redbuds and my maple. I use maple for the tight weaving. I used to use bracken fern, but it's hard to get, and then I have to go through a lot of red tape to get it.

Lilly's fluency in the Maidu language is among her most precious gifts. In demand as a speaker and authority on Maidu culture, she has been an important resource for area schools as well as historical and cultural institutions for many years. More recently, her knowledge and skill have helped a new generation of Maidu weavers learn the art of traditional Maidu basketry, assuring its life span into the twenty-first century.

Coyote Loses His Son

Despite the disruptions of contemporary American life, a few traditionalists have, like Lilly Baker, done their best to keep the old arts alive. Others have preserved songs, dances, beliefs, and customs by continuing to share them. Among these was Tom Young, a gifted storyteller. There are still people alive who remember being brought into the roundhouse as children to hear his masterful renditions of old-time stories like this.

In the early days of this world, there was no death. When someone was killed or died, it was always possible to bring them back to life. It was Worldmaker who had said:

> When people die, after they are dead,
> they will be laid over into the river, and,
> when they have lain there,
> they will come to life again.

However, Coyote disagreed:

> When people die, they shall be dead,
> and they will be buried under the earth.
> Indeed, the dead will not be going here
> and there in the morning.
> When they are dead, they will be dead.

After that, Worldmaker did not speak. Instead, he gathered his things together and left. He soon came upon a small creek, whereupon he set two horsetail rushes on either side of the meandering little waterway.

Soon afterward Coyote asked his son, who he loved dearly, to fetch some water. When he reached the edge of the creek, the two horsetail rushes had turned into rattlesnakes, and they bit him. Then it was that Coyote's son died. It was then that Coyote pleaded to reverse the outcome of death he had argued for. But it was to no avail; it could not be undone. He chased after Worldmaker, pleading for his son to be brought back to life. Worldmaker ignored him, continuing to travel about the country. And so it is today: when people die, they stay dead. The horsetail rush continues to live by the stream, and sometimes they do indeed turn themselves back into rattlesnakes, there, by the water's edge.[3]

The willfulness of Coyote changed forever the shape and character of life in this world. It would not be the perfect world Worldmaker had intended, free from hunger, sickness, death, and sorrow.

Cloaked in irony and peripheral explanative motifs (horsetail rush turns into rattlesnake), this story, like most others, serves a pedagogical purpose; the

story of the first death presented the listener with a sobering view of life in an unpredictable world of great difficulty. With remarkable power, Maidu myths convey a worldview that reveals to individuals their place in the cosmos, and how they might best survive; the myths are blueprints for living. The prominent mention of local geographic features further grounded one to a landscape and to a homeland.

The Greenville Indian Mission School

All that went wrong for Coyote that day and all that he unleashed upon the world must have reverberated many times over in the minds of Maidu people as, in the mid-nineteenth century, Europeans entered the lovely mountain valleys of the Sierra Nevada. A way of life was suddenly in great distress. The disruption reached into every aspect of native life, even including government intervention in the rearing of Maidu children.

Established in 1891, the Greenville Indian Mission School was part of the federal government's boarding school system for American Indians. The school's objective was to teach young Indian children trades that would help them prepare for future occupations. English language instruction was another major focus. English-only policies were instituted and no one acknowledged the possibility that the children could function bilingually. Children were frequently disciplined with corporal punishment for speaking their native languages. We can now look back upon this policy of little more than one hundred years ago and see its impact on the decline of California's indigenous languages.

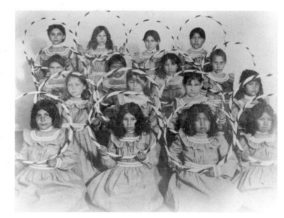

Greenville Indian School, ca. 1905. *Photo courtesy of Burt Trubody Collection, Plumas County Museum, no. 14-NP-24B*

At Greenville, children as young as five years old were separated from their families, sometimes by hundreds of miles — in addition to the local Maidu, children from tribal communities as far south as Mariposa County were transported there. The distance precluded contact with parents for many children throughout the entire school year, sometimes longer.

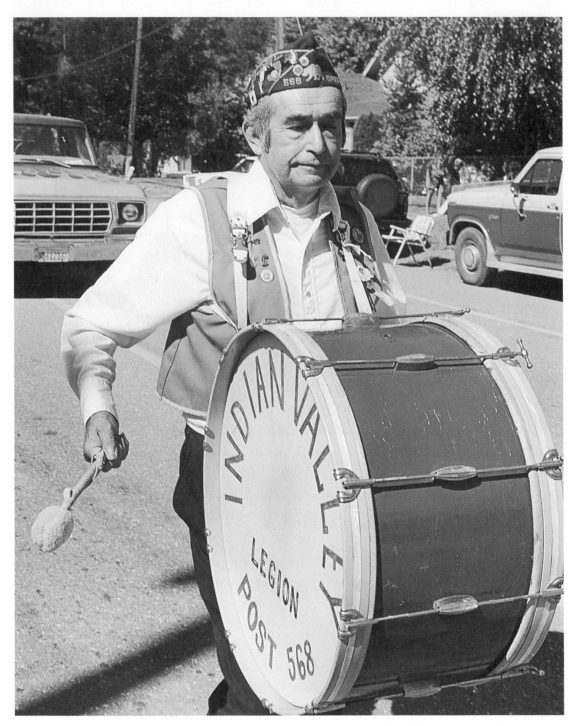

Tommy Merino represents the Indian Valley Veterans of Foreign Wars in the 1997 Greenville Gold Diggers Day parade.
Photograph by Dugan Aguilar

Thus, they were also separated from what remained of traditional culture in their communities. As a result, most of these children were derailed from pursuits such as basketry and other traditional arts, nor would they learn the traditional literature, songs, or ceremonial procedures that were the soul of their people. The traditional value system was being systematically replaced in the boarding schools with Euro-American values and a heavy dose of Christianity. Colonel Richard Pratt, founder of the Indian boarding school system, articulated the institutions' mission as it applied to the child: "Kill the Indian in him and save the man."

The Greenville Indian School burned to the ground in 1921 and was never rebuilt. After that, many children were sent out of state to federal Indian boarding schools in Nevada and Oregon.

The Maidu people have survived to see better days, and descendants of the area's original inhabitants have a strong presence here. The Greenville Rancheria (18 acres) has 150 members, mainly of Maidu descent. Susanville Rancheria (1,180 acres) has 413 members of Maidu, Paiute, Pit River, and Washoe descent.[4] In addition to those living on trust land, there are many other families who trace their ancestry to the mountain meadows at the northern end of the Sierra Nevada.

Notes

1. Traditionally, this spring ceremony was an opportunity for people to get on good terms with bears and rattlesnakes during the coming year. It was also an expression of good will among all the people there, and still is.

2. Lilly Baker's comments (here and below) are from an interview by Linda Yamane, California Indian Basketweavers Association, Newsletter #19, June 1997.

3. Adapted from William Shipley's translation of the story as told by Tom Young (Hanc'ibyjim), which appears in *The Maidu Indian Myths of Hanc'ibyjim* (Berkeley: Heyday Books, 1991)

4. 2004 *Field Directory of the California Indian Community*, Department of Housing and Community Development, State of California, and personal communication

Two
Feather River Country

THE THREE MAIN branches of the Feather River — the north, middle, and south forks — traverse Butte County in a meandering, southwesterly direction before making an abrupt turn southward on the valley floor and eventually converging with the Sacramento River at Verona. Forged well into the bedrock, forming deep canyons, the Feather River drainage flows through the heart of the Konkow homeland. Following the river from its source high in the Sierra Nevada, an invisible shift in the ancient landscape occurred — the language changed. Within an hour's walk, a native traveler would need to know another language, or at least the differences in a neighboring, related dialect. *Bululi* (black bear) of the mountain valleys is now *mɔɔde; mankobam* (raccoon) is now *ukah;* and *banɔɔmsah,* the ponderosa pine, is now *eneencham.*

The term "Konkow" apparently derives from a mispronunciation of the native term *koyongkawi* (the meadow, or open country). It was once associated with one native group in the region but is now more generally applied. The Konkow language is closely related to Maidu and Nisenan. There are approximately seven Konkow dialects and at least as many terms of self-identification, some lost or obscured over time. Many people from the Berry Creek–Bald Rock–Brush Creek area refer to themselves as *Tye* (pronounced tie-ee, meaning west), or *Tyme Maidu* (west people).

Present-day Konkow communities include the Berry Creek Rancheria (65 acres, 376 members), Chico Rancheria (50 acres, 413 members), Enterprise Rancheria (40 acres, 420 members), and Mooretown Rancheria (233 acres, 1,204 members).[1]

In this chapter, the cultural landscape is revealed by the eternal presence of petrified deities slumbering near a country road; by one of the great genres of Native oral literature, the trickster tale; by a fine portrait that connects us to a long-abandoned village, of which only the name remains; by the sacredness of humor and parody as articulated in a ritual exchange; and in a shrub—redbud—that serves as a link to family and culture.

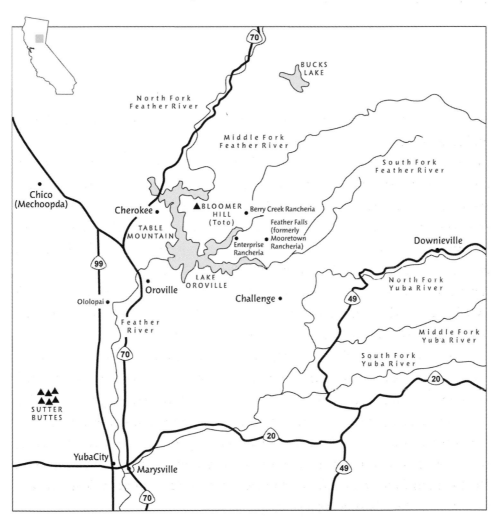

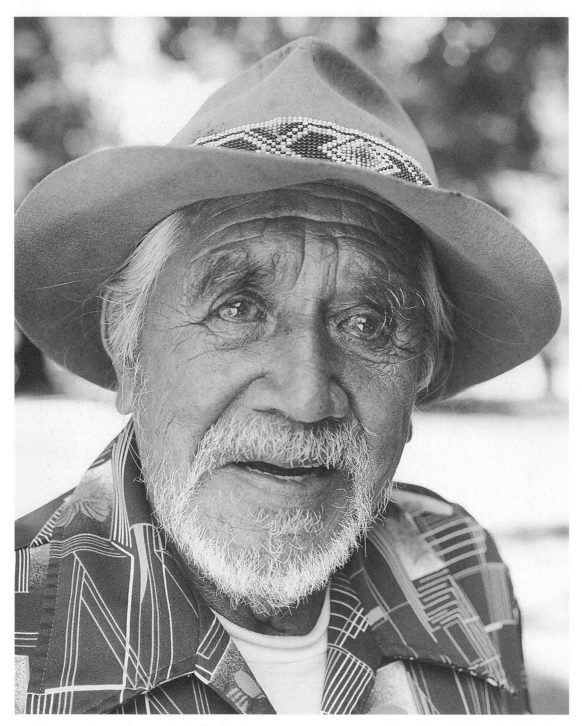

Franklin Martin. *Photograph by Dugan Aguilar*

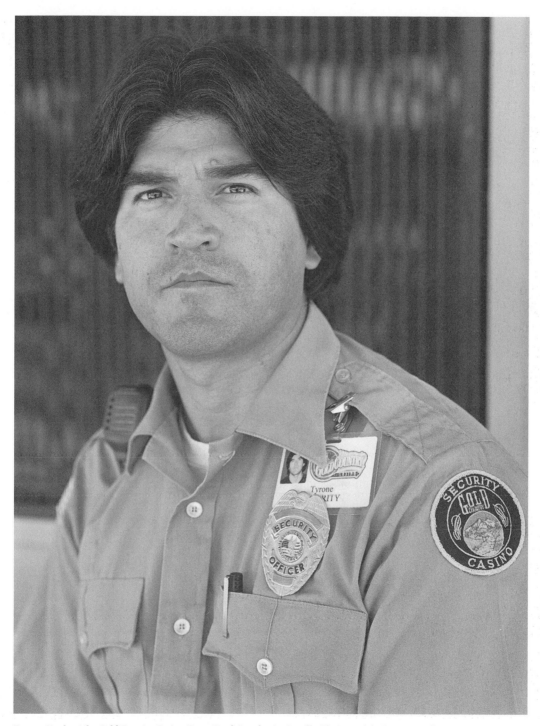

Tyrone Steele at the Gold Country Casino, Berry Creek Rancheria, Oroville. *Photograph by Dugan Aguilar*

Rella Allan

Rella Allan, Tyme Maidu, was born in 1921, near Brush Creek. Her mother, Lena Martin, was a basket maker, as were her aunts. The technological and artistic excellence of their work was standard for Konkow weavers. Today Rella is one of the few remaining weavers from her area. She is also one of the few remaining speakers of her language.

Although she was helping her mother weave baskets by the age of ten, Rella Allan left the art behind as she grew into adulthood. It wasn't until 1984 that she began to weave again. She uses redbud, *ləli (Cercus occidentalis)*, for most of her weaving material. In the late fall and early winter, when the nighttime temperatures approach freezing and the outer bark of the redbud begins to turn a dark reddish brown, she prunes the shoots. Annual pruning and copicing is essential for the growth of straight shoots and desirable weaving material. This was once a widespread environmental maintenance routine, carried out by the Konkow and other native weavers for generations, but here too, the barriers imposed by private and government ownership of property have presented obstacles to native basketry traditions.

Rella splits the redbud shoots lengthwise and then splits them a second time, discarding the heartwood and saving the strands of bark that adhere to the thin underlayer of wood. These will be the sewing strands for her basket, forming the design or pattern; the red-brown pattern is set against a light background. This light material is also made of split redbud shoots, but these were gathered in the spring, when it was easy to slide the bark off, revealing the shiny white surface of the wood underneath. The redbud strands are woven over a coiled foundation of willow shoots.

Soyba

Hiking through the dense vegetation of the Feather River canyons, you will find *soyba*, bay trees (*Umbellularia californica*, also called laurel or pepperwood). They often grow on the south sides of the canyons, where they have a northern

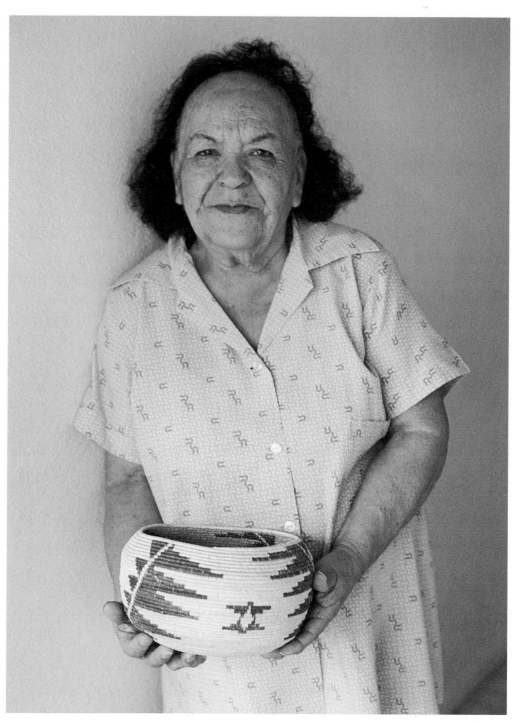

Rella Allan and her work. *Photograph by Dugan Aguilar*

exposure; a small grove beneath the perpetual shade of an imposing cliff face is a frequent sight. As you walk over spent bay leaves, crushing them underfoot, the air fills quickly with their pungent essence. Aroma is part of the indigenous landscape, a link to Konkow thought and values. The smell of *soyba* may evoke recognition or memories of purification as traditionally practiced in the ceremonial roundhouse.

In former times, leading members of the ceremonial dance society held branches of *soyba* over the fire briefly, until the leaves began to emit their characteristic aroma, and then proceeded to brush the floor of the sacred building and slap the interior poles with them. This cleansing ceremony was performed at the opening of the dance house and at the closing of certain ceremonies. It might also be performed within a dwelling when a threat of poisoning existed.[2] Poisoning involved the use of supernatural powers to send sickness to someone. Unless counteracted, this sickness could result in death. *Soyba* might also be burned in an effort to thwart a storm.[3] Not unlike the Buddhist or Catholic practice of burning incense, the use of *soyba* would signal an ability to cleanse, to purify, to pacify.

The small round nuts of the bay tree were a source of food. Gathered in the fall, they were usually roasted in an earth oven and then hulled. The meat was pounded into a pasty dough that was oily enough to be rolled into little balls. Ashes from roasted *soyba* nuts were also part of the ritual of mourning: a widow would crop her hair very short and daub a mixture of *soyba* ashes and pine pitch on her head and face, leaving it there for several months, until it came off on its own, which signaled that an appropriate period of mourning had been completed.[4]

Billy Preacher

Billy Preacher was a member of the sacred ceremonial dance society at Mechoopda (now Chico) known as the *Kumeh* (literally "of the dance house"). In fact, he was the head instructor, or *kuksuyu*, of the boys who were chosen for initiation into the society. He held at one time the highly regarded position of

Peheipe, ritual clown, and it was also Billy Preacher who addressed the village and delivered prayers from the roof of the roundhouse in a loud, clear, oratorical style.

Born about 1840, Billy Preacher was raised at the village of Ololopai, on the Feather River a couple of miles south of present-day Oroville. (The area has since been completely destroyed by dredging activities.)

Becoming a member of the *Kumeh* was a serious undertaking that required adherence to a strict set of rules and a responsibility to the society as well as the rest of the village. Membership in the *Kumeh* was also a source of status, and most young men were eventually initiated.

New initiates, called *yombasi*, were actually captured in a mock sort of way, perhaps while they strolled about the village grounds looking for firewood or on their way to perform some other chore. Hustled into the roundhouse, they would be kept there for several weeks, during which they underwent prolonged periods of detailed instruction regarding the *Kumeh's* origin myth and song texts, as well as training for specific dances. At Mechoopda, there existed a wealth of ceremonial dances performed within a cycle that began in the early fall, continued through the winter and spring, and terminated with the arrival of summer.[5] Lower-level dances were taught first, and gradually, over the ensuing years, the young initiate would have opportunities to ascend to more significant roles and performances. When a *yombasi* had demonstrated his knowledge of the society and the leading members of the *Kumeh* were in agreement as to his progress, the young man became a fully initiated member, thereafter known as *yeponi*.

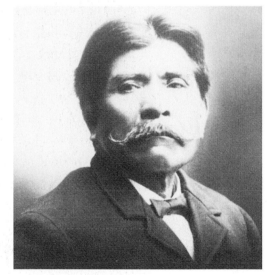

Billy Preacher, c.1890. *Courtesy of private collection*

The late Henry Azbill, who was raised at Mechoopda, recalled Billy Preacher as a man of firm religious conviction. "When he said to do something, he meant business."[6] Billy Preacher's exacting and meticulous nature is evident in the regalia he made. Although it is presently in poor condition due to insect

damage, his dance cape, *siikli*, collected at Chico in 1908 and now housed at New York's Brooklyn Museum illustrates a careful and even arrangement of feathers, each quill bent over the cape's netting and neatly wrapped with string. Wing and tail feathers of the great blue heron (*woksə*) are arranged as they were on the bird: the right side of the cape holds feathers from the right side of the bird, the left side of the cape holds feathers from the left side. Tail feathers are arranged left, center, and right, along the bottom of the cape.

Born eight years before the beginning of the California gold rush, Billy Preacher may have been seven or eight years old before he first saw a white person. Accommodating to change, as a young man he went to work on John Bidwell's Rancho de Arroyo Chico (located squarely within the bounds of present-day Chico), eventually becoming stablemaster, taking care of the barn and personally attending to Mrs. Bidwell's carriage. Annie Bidwell recalled that when she first met Billy Preacher in 1868, her husband said, "I want to introduce you to an Indian boy who has never done anything wrong."[7] Bidwell's rancho provided a safe haven and labor opportunities for individuals and families who had been disinherited from their former homes by the influx of miners and settlers to the region.

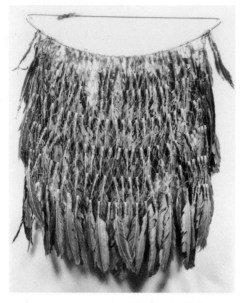

Dance cape, *siikli*, made by Billy Preacher. Collected by Stewart Culin at Chico, 1908. *Courtesy of Brooklyn Museum, catalog no. 08.491.8692*

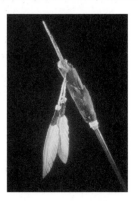

The *ononkoli* hair pin was an emblem of the *Kumeh*. An example collected from *Kumeh* member George Barber at Chico in 1908 contains sixteen bright red scalps of pileated woodpeckers. These are lashed onto a double-pointed rod made from the heartwood of manzanita. Swan feathers were employed in making the two suspensions that dangle from the pin. White glass trade beads also adorn the piece. The *ononkoli* was thrust through a woven hairnet at the back of the head at a horizontal angle.

Dance society hair pin, *ononkoli*, collected by Stewart Culin from George Barber at Chico, 1908. *Courtesy of Brooklyn Museum, catalog no. 08.491.8812*

Eventually Billy Preacher came to accept Christianity, attending church regularly. His impeccable appearance in a portrait from this time almost obscures the fact that he was born in an earth-covered dwelling. Yet beneath the finely trimmed handlebar mustache and fashionable frock coat were the mind and heart of a man who was completely Indian. Billy Preacher died in Chico on December 2, 1920.

As a child, Billy Preacher lived in a traditional semi-subterranean earth house about twenty feet in diameter. Four main posts supported several large crossbeams, which in turn supported successive layers of smaller branches and bundles of brush, topped with sod. In 1850 Adam Johnston, federal Indian sub-agent for the region, commented, "When once inside, these lodges are not uncomfortable. The thickness of the earth over them prevents the sun from penetrating them in the hot season, while in the cooler seasons they protect them from the winds." (Adam Johnston, September 16, 1850. Senate Executive Documents, U.S. Congress, 33rd Congress, special session, Doc. 4. Johnston estimated the population of Ololopai in 1850 at about 150 individuals.)

The smoke hole was located at the roof's center and doubled as the main entry in and out of the house. A notched log leaning against one side of the smoke hole served as a ladder. A smaller hole at ground level on one side of the house helped draft smoke out of the building's interior. This hole was generally just large enough to also serve as a crawl space in and out of the house for children.

H. B. Brown, in the company of an expedition traveling up the Sacramento Valley in the early 1850s, produced a series of drawings that document native life in the region. One of Brown's drawings of Cheno, a native village a short distance across the river from Chico, provides perhaps the earliest and most accurate image of the architecture and ambiance of the region. Billy Preacher's home at Ololopai may have looked very much like this.

The cylindrical structures that appear in the back of Brown's drawing are granaries. Acorns, grass seeds, dried salmon, dried greens, and any number of other preservable foods were stored, often in distinct levels, within these tall, basketlike structures. They were built up and around existing tree stumps or boulders, so that air would circulate through the bottom layers, thus preventing the accumulation of moisture and the onset of mold or mildew. Granaries were common features of most permanent villages.

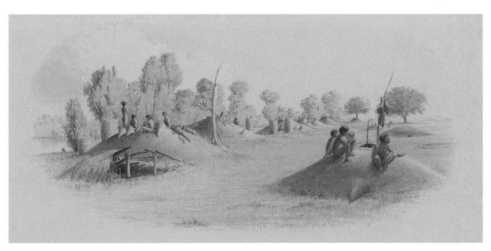

Cheno *(ts'eno)* village, near Monroeville, California.
Drawing by H.B. Brown, ca. 1852. Courtesy of the John Carter Brown Library at Brown University. Bartlett Drawing 127

Peheipe

The ceremonial clown, Peheipe, plays an important role in Konkow ceremonies, starting when the ceremonial leader asks him to take part in the ritual of calling forth the community and announcing the beginning of an event.

One of the clown's traits, fully understood by the community, is his gluttonous appetite for food (not unlike the mythic Coyote). He always seems to be eating, and when called upon to assist in beginning the ceremonial gathering, he usually makes his appearance munching a huge piece of acorn bread. An essential part of Peheipe's outfit is a necklace strung with deformed acorns, those that bend to one side.

The dialogue with the ceremonial leader is intended to cause a good deal of hilarity among the assembled crowd. In this excerpt from Roland Dixon's *The Northern Maidu*, the leader is identified as "Shaman" and Peheipe as "Clown."[8]

Shaman: Where have you been, clown?

Clown: I've been lying down. I'm ill and have pains in my stomach. I found some medicine that never fails, if there be only enough of it. (He takes a bite of the bread and sits down by the fire.)

Shaman: Why don't you put away that bread, and wait till the dance is over before eating?

Clown: Then I can't get any!

Shaman: Who is going to steal your bread?

Clown: I don't know. Perhaps you might.

Shaman: Where did you get your bread?

Clown: I brought it with me. Didn't you see me coming in with a big loaf?

Shaman: I saw you come in with nothing but your cane.

Clown: No, no! I had the bread under my arm. On the other hand, I would not lie about a loaf of bread.

Shaman: Put away that bread, and go out on top of the dance house. I'm going to talk to our people, and you must help me.

Clown: No, it's dark and I'm afraid!

Shaman: What are you afraid of? Are you a woman?

Clown: Yes, I am a woman. Would you like to marry me?

Shaman: Stop your joking and go out at once! I will take care of your bread until you have finished.

Here Peheipe breaks off a piece of the bread and, putting it under his arm, gives the rest to the leader. He then goes out and climbs onto the roof of the dance house.

Shaman: Are you there, Peheipe?

Clown: Yes, I'm here. Don't eat my bread! Oh! The ants up here are eating me up!

At this point, the ceremonial leader begins his speech to the people.

Shaman: Don't fail to hear me! Don't fail to hear me! We are going to have a dance in which both men and women must take part.

Clown: Don't fail to hear *me!* Don't fail to hear *me!* You are going to have a dance in which you all must take part.

Shaman: We come here not for trouble.

Clown: I came here not for trouble.

Shaman: But we came to dance and feast.

Clown: But you came to dance. I came to eat and gamble!

Shaman: Bring on the soup.

Clown: Bring on the soup! Bring on the bread! Bring on the fish! Bring on the meat! Ha, ha, haaa! Don't fail to hear me! Don't fail to hear me!

Shaman: Bring on some wood. How can we gamble without wood?

Clown: Bring on wood, all of you! How can I gamble or keep warm?

Shaman: Bring on the soup! Bring on the bread! Bring on the fish! Bring on the meat! We are all hungry!

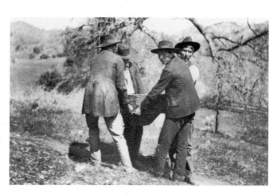

Four men carrying a basket full of acorn soup. *Photograph by John W. Hudson, March 21 or 22, 1903. This photograph was taken at the Foreman Ranch, located near Bidwell Bar (now inundated by Lake Oroville). Courtesy of the Field Museum, no. CSA9513*

Clown: Haa-a-a-a-a-a! I am going down! (Off the dance house roof) Bring on the soup! Bring on the bread! Bring on the fish! Don't fail to hear me! Haa-a-a-a-a! Come on, come on! Fill up my old woman's burden basket! Haa-a-a-a-a!

As clever and truly funny as Peheipe may be, his role and behavior reach beyond mere clowning. Some Konkow myths place this figure at the side of Kodo-yampeh (Worldmaker, also called Wonomi) as an assistant when the earth and all its life forms were created. And while his gluttonous behavior appears absurd and rude to everyone, he does indeed foretell an abundance of things.

Ceremonial clowning was known throughout the Sierra region and much of California, as well as the rest of North America. One of its primary functions was, on a deep psychological level, to introduce the threat of chaos by trespassing upon society's rules of conduct and behavior. By doing so through entertaining and ingenious performances, clowns actually reinforced the very social constraints they so humorously mocked. Thus, they helped define the society's sense of order. Among the Konkow, the role of Peheipe was a highly esteemed ceremonial position, and the performance a sacred one.

Wonomi and Coyote

Within Konkow mythology, creation of the world and all its living entities — plants, animals, and later, people — is truly an epic drama that consists of many, perhaps even an endless number of events and episodes. The creator figure, Wonomi (the Immortal One, literally "doesn't die"), and his ever present companion and antagonist, Coyote, are generally responsible for the shape and character of the Konkow world. What follows is a very small glimpse, an almost anecdotal portion of a much larger series of stories that at one time constituted the body of Konkow oral literature. One of the greatest casualties resulting from the invasion of California and the serious changes wrought upon traditional Konkow culture was the decline of oral tradition. Very little of this knowledge was ever written or recorded, and while we can enjoy the stories and the sense of place they give us, we will likely never understand the overall context or deeper connections to the traditional Konkow worldview.

While in the process of creating the world, Wonomi and Coyote came upon a place near the back side of Table Mountain. There Wonomi continued to work on the creation. He began to carve a squirrel out of a piece of wood, but Coyote grabbed it before he could finish and threw it in the river. Only the head and feet had been formed on this incomplete carving. It became a turtle.

Wonomi then began to create an unusual fruit. He explained to Coyote that this fruit would be a particular treat for old people, a fruit without seeds to get stuck between their teeth. Coyote laughed heartily and chided Wonomi. "All fruits have seeds," he scolded. Ignoring him, Wonomi continued to create his newest fruit. However, just as the fruit was completed, Coyote reached into a bag he carried and quickly tossed a handful of tiny seeds on Wonomi's small, red fruit. That is why strawberries have their seeds on the outside.

Eventually Wonomi decided to lie down and sleep for a while. He found a comfortable spot and stretched out on his back. Also weary was Coyote, who snuggled up next to the creator. And there they slept. And there they remain today, two stone figures, sleeping endlessly through time. If one drives up the old Cherokee Road only a short distance from Oroville, Wonomi and Coyote can be plainly seen from the roadside.[9]

The story of Wonomi and Coyote yields yet another opportunity to reflect on the very beginnings of life and culture and human history. Standing there on that lonely little road in relative quiet, only feet away from the two petrified figures, gazing at their forms, remembering episodes of a creation story, I cannot help but be transported to another time. I like to think of what it was like. How did it go? How many generations of a family passed by this spot, retelling stories of Wonomi and Coyote? It's as if all of time, from the very beginning to right now, is there, lying beneath the crust of their metamorphic coats.

Among the Konkow, as among other indigenous cultures around the world, history was told rather than written. Konkow literature was oral literature, transmitted in an immediate and personal manner from speaker to listener. The entire record of a community's experience depended upon the memories of its members, and upon the faithful, accurate, creative transfer of knowledge from one person to another, one generation to another. Children heard stories

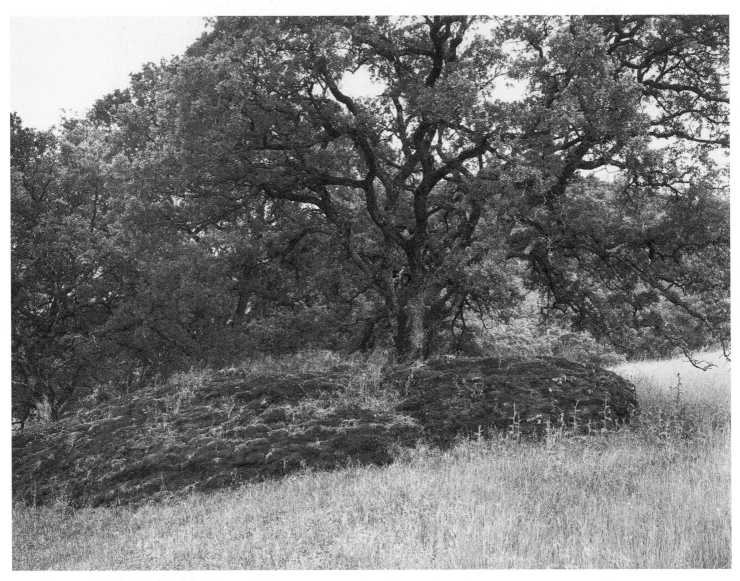

Wonomi, lying on his back, asleep. *Photograph by Dugan Aguilar*

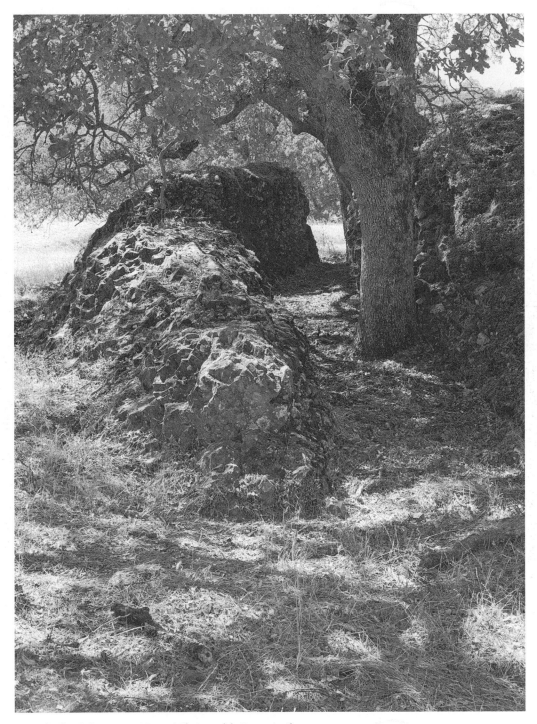

Coyote (left) curled up next to Wonomi. *Photograph by Dugan Aguilar*

time and time again and were expected to listen until they knew them well. Any adult might tell a story, but certain individuals were known as gifted story-tellers with great repertoires. They could be very expressive and animated in their characterizations, using mannerisms, gestures, and comic voices. They were noted for their use of fine language and their deep knowledge of the tribal oral literature.

Maidu elder Herb Young recalled that his grandfather, Tom Young, told sto-ries while lying on his back. It appears to have been a formality among Maiduan people (and perhaps others) that the storyteller recline while relating a myth.[10] Most storytelling was restricted to the winter months. There are various expla-nations for this. Some have said that stories are told in the winter because that is when the snakes are in their dens. If you tell a story at another time of year, when snakes are above ground, they will steal your story and take it into their holes, and you'll forget it. On a practical note, winter weather often forces people into their homes, and the nights are very long. It's a good time for stories. Today, with television, recorded music, books, and a multitude of other options, it's hard to realize the importance of storytelling, or the amount of entertainment and practical information that stories brought into the home on those long winter nights.

Native myths are more like poetry than prose; they are not obvious recollec-tions of historical events, or intellectual attempts to explain the nature of things, but rather metaphors for another truth. As the late Joseph Campbell noted, stories are poetic because they present "a vocabulary in the form not of words, but of acts and adventures which connote something transcendent of the action."[11] In a culture in which myths play a large role, the individual might view life as a poem and see himself or herself participating in the poem. There is a feeling of personal accord with the world. Unfortunately, the term "myth" is often understood to imply a falsehood or a lie. However, as Campbell points out, "every myth is true, as metaphorical, of the human and cosmic mystery." Konkow myths certainly fit into that paradigm. They provide us with a sense of wonder and open the world to imaginative mystery.

More about Coyote

Estom yamani henom luiweto luiweto
Coyote, to the middle mountains (Sutter Buttes)
Coyote Dance song from the village of Mechoopda

The view of the Sutter Buttes, just west of Marysville about fifteen miles away, is a spectacular feature of this area. The six peaks rise abruptly from the uninterrupted flatlands of the Sacramento Valley, which is about sixty feet above sea level, to heights ranging from 1,670 to 2,132 feet.

Within the Sutter Buttes lay Coyote's dance house. In sharp contrast to Euro-American attitudes toward the coyote, Konkow tradition places Coyote in the role of a co-creator, or as the gifted Konkow storyteller Bryan Beavers once remarked, "God's brother-in-law." Coyote's creative acts shape the world in ways that are contrary to what Wonomi envisions. In other words, it is Coyote who gives us the real world, a world of contradictions, difficulty, and death. Within Konkow tradition, these aspects of life, however undesirable, were accepted, and it was not considered a good idea to kill a coyote. Coyotes were not eaten. To intentionally poison or otherwise kill a coyote because of its natural function as a predator would not only be considered somewhat sacrilegious by a traditional Konkow, but resolutely dangerous. Konkow ceremonial life, with its seasonal cycle of dances and commemorations, provided a place for Coyote.

The last of the old-time coyote dancers in Konkow country was Mike Jefferson (1856–1935), from the village of Mechoopda at Chico. Being the coyote dancer was his position, his role. The late Wallace Burrows (Nomlaki) remembered Jefferson's performances of the 1920s and 1930s at Grindstone Rancheria, in Glenn County. He used to say that only a single man should take on that role, because Coyote's lascivious character and spirit would eventually take over. And so it was with Mike Jefferson. When dancing the coyote spirit, as with any other, the dancer becomes that which he dances.

"Becoming" what one dances during a performance is fundamental in

Estom yamani, "the middle mountains," or Sutter Buttes. *Photograph by Dugan Aguilar*

Konkow dance, as it is with most native ceremonial dances that are considered sacred. It is one facet of a multi-layered relationship between humans and animals, rooted in the sacred myths and realized from intimate associations with, and observations of, the land.

Coyote's absurd nature, his entirely inappropriate behavior, his many disasters and remarkable resurrections are a rich source of humor. Bryan Beavers told the following story, which involves two prominent features in the landscape of northern California: the Sutter (or Marysville) Buttes and Table Mountain, a sprawling mesa with abrupt sheer cliffs that look down over Oroville. Bryan Beavers referred to Coyote as "the devil."

They said one time when the valley filled up with fog all the time in bad weather, in the wintertime — up here in these ridges it's all clear, but the valley, it's just plum full of fog clean across — one day the devil come down, coming down one of those ridges, and he looked across towards the coast range, and the Marysville Buttes was stickin' out of the fog like this. And he thought that was water. He seen a rabbit over there and he hollered across, he said, "Hey cousin, how'd you get over there?"

"Oh," the rabbit said, "I swam across. I swam right across."

"Well," he said, "I'd like to come over there. I might come over there."

Rabbit said, "Just jump right in and swim, you'll make it easy. That's the way I got across here."

The devil said, "Well, I might try it," he said. "I might come over."

"Sure," Rabbit said, "come on, it's good over here."

The devil always walk with a nice walkin' stick, pretty one. So he said, "I'm going to throw my walkin' stick across first."

And the rabbit said, "All right, you throw it."

And so the devil was on Table Mountain down here, and it was three or four hundred feet straight down the cliff under him, and fog right up to his feet almost. He said, "Well, here it comes." He threw his walkin' stick hard as he could throw it, and it went out there, and it disappeared in the fog and fell way down in the rocks down there. Rattled around.

Table Mountain. *Photograph by Dugan Aguilar*

And when he done that the rabbit jumped to one side over there, and Rabbit said, "You be careful! You pretty near hit me with that stick!"

"Well," he said, "all right, I'm coming. I've got to make a run," he said. "Yeah," he said, "make a good run, good jump to start with."

The devil, he backed back and he made a big run and he bluffed out. He stopped before he got to the edge. Rabbit told him, "Oh, don't be afraid. You can make it. Just dive right in."

The devil, he backed way back. "Well, I'm comin'," he said. And he just run out there to the edge and just dove right out and started to swim . . . and it was all fog. He went down four or five hundred feet into this rock pile. Broke all to pieces. Died."[12]

Toto

One of the oldest and certainly largest live oak trees in the state is found just east of Table Mountain, across Lake Oroville at Bloomer Hill, within the now-abandoned Konkow settlement known as Toto. A roundhouse used to stand here. People played here, especially handgame. A guessing game, this is usually played with two pieces of deer-leg bone about four inches long, one marked and one unmarked. While players on one team shuffle the bones behind their backs or under a handkerchief, their teammates sing gambling songs. Opponents try to guess which hands hold the marked (or sometimes unmarked) bones. The score is kept by passing counters—peeled sticks, sometimes decorated—back and forth. This apparently simple game, requiring only the most elemental equipment, can be the setting for astounding feats of intuition.

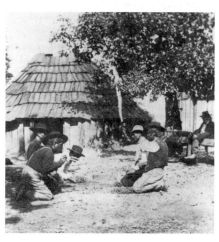

Konkow men playing handgame in front of Billy Day's roundhouse, ca. 1907. Billy Day is front left. Others include, left to right: Lewis Parker, Hood Smith, John Johnson, and Peter Cruz. Bill Foreman is seated at right. *Photographer unknown. Courtesy of Herb and Peggy Puffer*

For generations, Konkow families have interred their loved ones and sent them on their journey to *hipining kodo*, the above land, *yongkodo*, the flower land, from beneath the massive limbs of this great tree.

In the 1850s something dug up several of the native burials here, leaving them scattered about on the ground. Some thought it might have been grizzly

Theda Steele (left) and Tonja Armus playing handgame. *Photograph by Dugan Aguilar*

Steele family handgame players (left to right): Francis Steele Jr., Jason Steele, Francis Steele Sr. *Photograph by Dugan Aguilar*

bears, but others placed the blame on miners who were perhaps looking to rob graves of their valuables, including the gold coins which were sometimes buried with the deceased. Exactly who was responsible is still unclear. Several Konkow men gathered up the disinterred remains of their family members and tied them up in bundles in the limbs of the great live oak until they could be reburied.[13]

Today the tree's limbs reach outward and upward as if it were some huge bird protecting its young from the elements. On a visit to the site, Mary Jones recalled camping out under the great tree for a funeral that was to commence the following day. The canopy of the tree nearly obscured the night sky. Only the suggestion of moonlight could be sensed, trying to filter through the great leafy ceiling. Mary Jones's mother and father are buried here.

Mary (Wagner) Jones, ca.1922. *Courtesy of private collection*

Mary (Wagner) Jones grew up in a household that spoke Koyongkawi (Konkow Maidu) exclusively. Her mother, Maggie Wagner, was one of more than four hundred Konkow who were collected by the U.S. Army in 1863 to be removed from the Butte County region and relocated to Round Valley Reservation in Mendocino County. Maggie Wagner was a very small child at the time. Several people died on the march. Many escaped. Others stayed, and many of their descendants continue to live in Round Valley.

"I was born [in 1918] and raised in Challenge," Mary Jones says. "My family's name is Wagner. They came from around Bucks Lake area. My brothers and sisters were born there. My mother said she was born in the Cherokee [Butte County] area. She was driven to Round Valley [Reservation] when the Indians were taken over the mountains. But somehow or another my mother ran away and got back to Cherokee.

"My mother didn't speak English, just a few words that she heard us speak, and she'd repeat 'em. When I first went to school they tried to keep me from talking Maidu. They'd ask me a question and I'd answer them in Maidu, which didn't go over very good. So they kept getting after me, and finally I did, I guess, talk English enough so they could hear it. So, it took me a long time to get out of school on account of that.

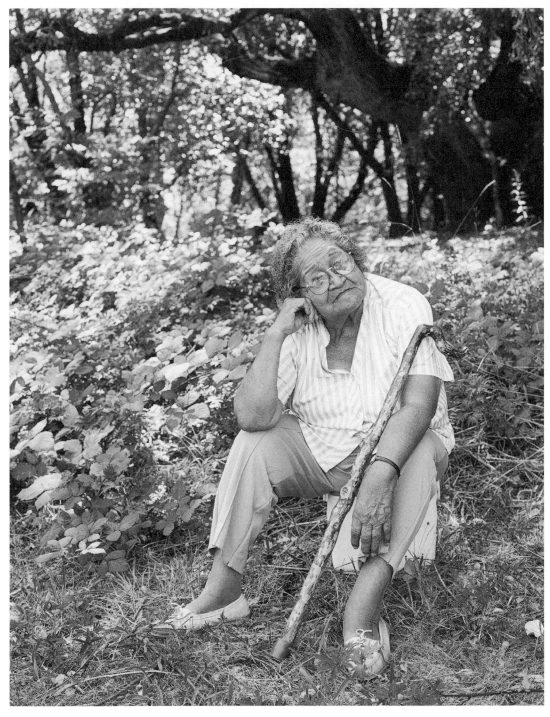

Mary Jones and the giant oak at Bloomer Hill. *Photograph by Dugan Aguilar*

"In them days, my mother was taught not to speak to her in-laws. So she'd wear a handkerchief over her head and then pull it down to hide her face when my husband came into the room."

These three statements encapsulate the experiences of many native families of the region: having been uprooted through removal policies and the systematic attempt to replace native languages with English, several people nonetheless managed to adhere to native values and tradition. Despite, and perhaps in defiance of, the swift and radical changes going on all around, the Konkow world remained intact the moment Maggie Wagner pulled that cotton print handkerchief over her face. That's how she maintained order amid the chaos, meaning within the meaningless. A seemingly small gesture, but invested in a value system that was already ages old before the first handkerchief found its way to California.

Notes

1. *2004 Field Directory of the California Indian Community,* Department of Housing and Community Development, State of California, and personal communication, Mechoopda tribe

2. Roland B. Dixon, *The Northern Maidu* (New York: Bulletin of the American Museum of Natural History, Vol. 17, No. 3, 1905)

3. Ibid.

4. Ibid.

5. The Konkow cycle of dances begins in the early fall with the *Hesi* and continues through winter and into late spring, where it ends, with the Hesi again. The dances in the cycle are *Hesi, Luyi, Loli, Salalungkasi, Waimangkasi* (Goose), *Hatmangkasi* (Duck), *Panongkasi* (Bear), *Olelemkasi* (Coyote), *Chamyempingkasi* (Creeper), *Anosmankasi* (Turtle), *Kenu, Toto, Moloko* (Condor), *Sumingkasi* (Deer), *Enimkasi* (Grasshopper), *Aki* (Acorn), and *Hesi.* The Coyote Dance, although often performed in the winter, may also be performed at other times of the year.

6. Craig Bates, personal communication

7. Annie E. K. Bidwell, *Rancho Chico Indians* (Dorothy J. Hill, ed., Annie Bidwell Papers, California State Library)

8. Dixon, *The Northern Maidu*

9. Story adapted from a version originally published by Donald P. Jewell in *Indians of the Feather River: Tales and Legends of the Concow Maidu of California,* based on stories told by Konkow elders Leland Scott and Bryan Beavers (Menlo Park, Calif.: Ballena Press, 1987)

10. Herb Young, interview by Robert Rathbun, c. 1968 (Dorothy J. Hill Collection, Meriam Library, California State University, Chico)

11. *Joseph Campbell and the Power of Myth with Bill Moyers* (New York, Mystic Fire Video, 1988; originally a public television broadcast)

12. From the film "Bryan Beavers: A Moving Portrait" by Richard Simpson, 1969

13. Jewell, *Indians of the Feather River.* The Konkow artist Frank Day painted a striking depiction of this event, *Burial Tree.*

Three
Sierra City to Plymouth

Here in the Yuba River watershed, Highway 49 becomes the thoroughfare for a journey through Indian country. Snaking its way west from Sierra City, the road parallels the twists and turns of the Yuba River's north fork. It crosses the middle fork a few miles past Camptonville, and the south fork about eight miles before reaching Nevada City. This Yuba River drainage marked a change in native language as well: *sumi*, the black-tailed deer, became *dəəpe*; *susu* (valley quail) became *hanpie*; and *pamenim* (gooseberry) became *yuhem*.

Three major watersheds—the Yuba, the Bear, and the American Rivers—and their tributaries nourish this region. Sugar pine, ponderosa pine, cedar, and black oak forest the upper elevations. Big-leaf maple, dogwood, live oak, yew, and madrone are found in the canyons. Bull pine, blue oak, manzanita, buckbrush, deer brush, and chamise cover much of the lower foothill belt. Moving through this chapter and along these watersheds on Highway 49, readers will get a long look at the gold rush, an introduction to tribal leaders of that era and their living descendants, and a sense of villages that thrived where suburbs now sprawl.

A naturalist might illustrate the uniqueness of a particular region by pointing

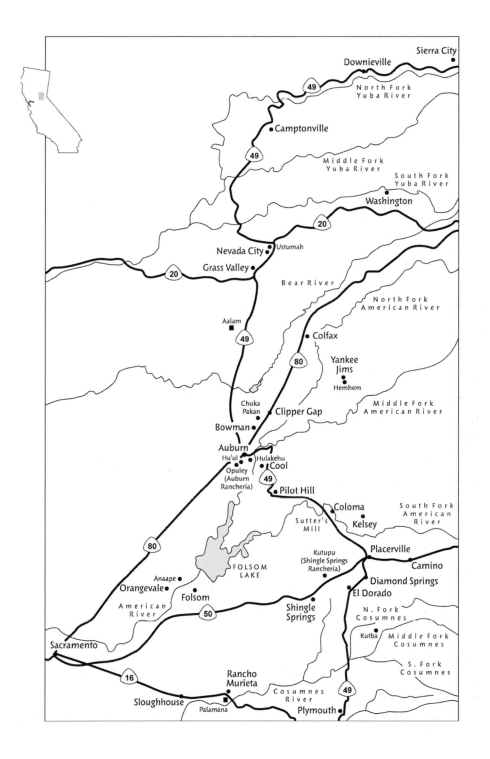

Sierra City

Downieville

49

North Fork
Yuba River

Camptonville

49

Middle Fork
Yuba River

South Fork
Yuba River

Washington

20

Nevada City • • Ustumah
Grass Valley •

Bear River

North Fork
American River

Aalam ■
49

Colfax •

80

Yankee
Jims

• Hemhem

Middle Fork
American River

Chuka
Pakan • Clipper Gap

Bowman •

Auburn •
Hu'ul • • Hulakehu
Opuley • ♦ Cool
(Auburn
Rancheria)
49

Pilot Hill

Coloma •
Kelsey •

South Fork
American
River

Sutter's
Mill

80

Kutupu
(Shingle Springs
Rancheria)

Placerville •

Camino •

Diamond Springs •

Anaape •
Orangevale •

FOLSOM
LAKE

El Dorado •

Folsom •

American
River

50

Shingle
Springs

N. Fork
Cosumnes

Kutba ■ Middle Fork
Cosumnes

Sacramento •

S. Fork
Cosumnes

16

Rancho
Murieta

49

Sloughhouse •
Palamana ■

Cosumnes
River

Plymouth •

out its plant and animal life or its geological constitution, but the indigenous cultural milieu and the languages associated with specific portions of the landscape we all now traverse are equally important indicators of the startling diversity that is (or was) California. Linguists and anthropologists identify the people of this region and their language as Nisenan (pronounced "nish-ee-non"), which translates to "from among us," or "of our side."[1] Speakers of Nisenan occupied much of the country now encompassed by Yuba, Nevada, Placer, Sutter, El Dorado, and Sacramento Counties. It has been estimated that seven different dialects of Nisenan were spoken within this area: as one traveled from the Sierra foothills onto the Sacramento Valley floor, the dialect changed; if one ventured south from the Yuba River drainage to the Bear River area, the dialect changed again; and so on.

Native communities were organized much the same throughout the Sierra region. A hereditary headman, *huk* in Nisenan, owned the ceremonial roundhouse, was largely responsible for village welfare, and held influence over several smaller villages within a definable geographic region. The role of native headmen was not so much to rule as to lead; their obligation to look after their constituents is poignantly illustrated in Edwin Bryant's description of meeting a small group of Nisenan about an hour and a half (by horseback) east of Johnson's Crossing, near Camp Far West, in August 1846. Upon being introduced,

Villages near Auburn

Bakacha, at Rocklin

Kaubusma, at Colfax

Chuyumom (slim willow water), near Colfax

Koyo, three miles south of Colfax

Sumyan, east of Colfax

Hemhembe, one mile west of Colfax

A'ilpakan (sand spring), near Weimar

Kauyama, near Colfax

Manaiyi, near railroad bridge north of Colfax

Soloklok, on a flat just north of Colfax

Chistok'umpu, large village south of Colfax

Manim Pakan (cedar spring), west of Colfax

Chuka Pakan (Indian potato spring), near Clipper Gap

Penui, large village near Clipper Gap

Suminim yaman (sugar pine hill), near Clipper Gap

Weemah, at Weimar, named after headman

Hawnos, on South Fork Dry Creek

Yolos yaman (redberry hill), near Tunnel Hill

Didit, a mile southeast of Clipper Gap

Popokemul (deep water where tule grows), just northeast of Clipper Gap

Hakaka, at Ragsdell's Place

the headman requested a gift of tobacco. "I had a small quantity of tobacco," writes Bryant, "about half of which I gave to the chief, and distributed the residue among the party as far as it would go. I saw, however, that the chief divided his portion among those who received none." [2]

While the names and locations of many Nisenan villages are lost to history, some settlements occupied during the gold rush or established afterwards remain in tribal memory. Indeed, several major American towns are presently situated atop former Nisenan villages.

Surviving the Gold Rush

Among the gold-country tribes, perhaps the Nisenan suffered the earliest and most severe consequences of the gold rush: it was at Sutter's Mill, literally within a stone's throw of the old village of Kulloma, that James Marshall found gold. Changes to the landscape and to the lifeways of the Nisenan came with startling swiftness. The native people eventually found ways to cope with the gold rush—even to participate in it—but the confusion, anxiety, and depression associated with the immigrant invasion and the subsequent loss of power over their own destiny can only be imagined, never fully understood.

An early witness to the chaos was a Swiss pioneer, Heinrich Lienhard. Working in various capacities for John Sutter, Lienhard found himself on the American River in 1849 with a Nisenan crew, working the gravels for gold ore. His account of events in the region sheds light on the lawlessness and intimidation local native people were subjected to.

> Some travelers who had come in on the *California*, the first steamer on the New York–San Francisco run, arrived, and several of these ex-passengers, now en route to the mines, stopped at our camp. They were heavily armed and had all the earmarks of being the scum of large cities in the East. Glancing at the Indians loitering nearby, they said they would like to try their guns on them.
>
> I pointed out to the newcomers, who would like to shoot them, the fact that no matter how our natives looked, they were a placid, good-natured race, and that we would not allow them to be harmed. Finally they departed. [3]

Within two days, the headman of a village near Lienhard's camp had been murdered, along with another Nisenan man, by a group of five men on horseback, some of whom were Oregon Indians. A young Nisenan, Konnock, who worked for Sutter and accompanied Lienhard to the Coloma area, explained to Lienhard the details of his uncle's murder. Lienhard wrote:

> The Indian ran four or five miles at top speed, then found a member of his tribe, whom he warned to run for his life. Together they continued along the bank of the river until they reached a small village that stood on the right bank of the stream directly across from the camp of the German miners.
>
> Closely followed by their tormentors, the poor Indians hoped that their lives would be spared; but they were mistaken. Suddenly the chief jumped into the river, as if he intended going to the mines, and while Indians are good swimmers, he was too exhausted to remain under water. As he rose to the surface, he was shot through the head by the murderers, and killed.
>
> When he was dead, the cold-blooded scoundrels got off their horses and, as the lifeless body was washed ashore, scalped and hung the head near the bridge, as a token of victory; that of the other Indian was also suspended above the bridge. The ceremony over, the murderers, posing as heroes, went on to Coloma.[4]

The near extinction of Nisenan people and their culture is a part of the legacy of the gold rush, but it is equally important to concentrate on their survival. And that has been no small achievement.

Betsy, an elderly Nisenan woman who had lived at the village of Ustumah, which was located where Cottage and North Main Streets intersect in present-day Nevada City, recalled the days when Indian children were abducted for the brisk and often brutal slave trade that prospered in California during the 1850s

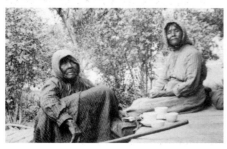

Betsy (left) and her friend Josie Cullie, near Nevada City, c. 1915. *Photo courtesy of Searls Historical Library, Nevada City*

and 1860s. Their parents found ways to protect them when a journey into town was necessary. "Indian children . . . when taken to town would blacken their faces with dirt so the newcomers would not steal them."[5]

In the photograph here, Betsy sits on the porch of a neighbor's house to enjoy some coffee or tea. She was known to most by her American name of Betsy; we don't know her

Acorn trees. *Photograph by Dugan Aguilar*

"First acorn that fall, those green ones, they call that New Acorn. Old-timers always have big doings for New Acorn. Every woman from every camp bring New Acorn, and menfolks kill lotta deers and rabbit.

"Womenfolks pound that acorn and they make New Acorn soup. That's the way they have big prayer. They don't say much, but they just talk a little bit and then you all go ahead and eat. Just same as white people.

"Old-timers used to do that, but late years we don't have that anymore—we don't have New Acorn prayer. That's why my mother used to say, "Acorns sometime no more because you don't pray for it."

Lizzie Enos, as quoted in *Ooti, A Maidu Legacy,* by Richard Simpson (Millbrae, Calif.: Celestial Arts, 1977)

Nisenan name—perhaps she had more than one name, maybe nicknames. When she was born (c.1818), James Monroe was the U.S. president and nearly two-thirds of the American population lived within a hundred miles of the Atlantic Ocean. James Marshall wouldn't find gold at Sutter's Mill for another thirty years. During her lifetime she witnessed the arrival of Euro-Americans in her country and the subsequent loss of her homeland. She experienced radical changes to her way of life and, like others, survived by adopting new strategies to cope. Her age at the time of her death in 1923 was estimated to be 105.

Rose Kelly Enos is a great-great-granddaughter of Betsy. The old woman died before Rose was born. Rose recalls being told only that Betsy was blind in her old age, and that she never developed a liking for shoes.

Rose Enos and her family continue to gather and process acorns for their own use, and for ceremonial occasions. Friends and relatives are invited to the Enos place—now an island of rural and cultural character amidst growing suburban expansion—every spring and fall for ceremonial gatherings that commemorate the gift of acorn. Their place, known as Chuka Pakan, or Indian-potato spring, is near the hamlet of Clipper Gap, a few miles northeast of Auburn.

I have heard of Lizzie Enos's warning about the threat of acorn's disappearance due to neglect repeated many times. The continuity I sense, with her words in my mind, while watching Rose crack acorns is truly impressive. Never mind that acorn is no longer a staple food in the modern economy—the feeling of obligation toward it remains strong, deeply embedded in personal and tribal memory. There is recognition that generations of ancestors survived because of the richness and abundance of this food. "It's what got us here," says a friend. So Rose's grandchildren grow up hearing the pop of black-oak acorns being split open by a hammerstone, and they will remember stepping on discarded shells with their bare feet as they ran around the yard.

Distinctive features of the landscape also provide a sense of continuity, particularly when one knows their ancient stories. The story of Aalam (the tall/long rock) is an example.

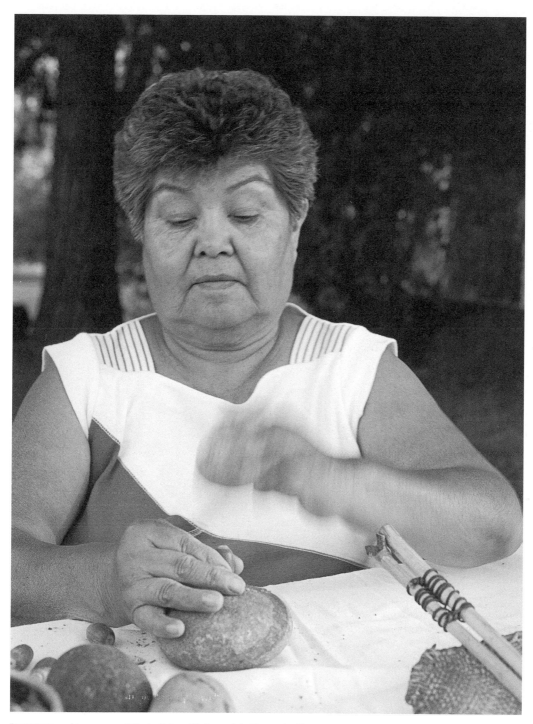

Rose Enos cracking acorns at Chuka Pakan. *Photograph by Dugan Aguilar*

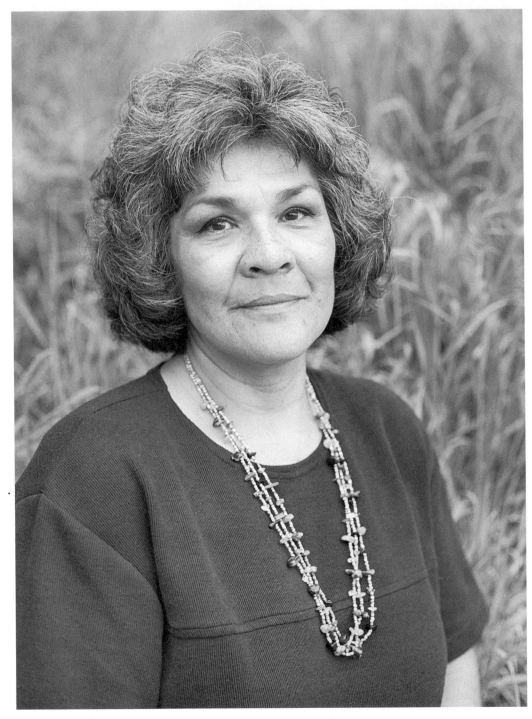

April Moore, great-granddaughter of Lizzie Enos. *Photograph by Dugan Aguilar*

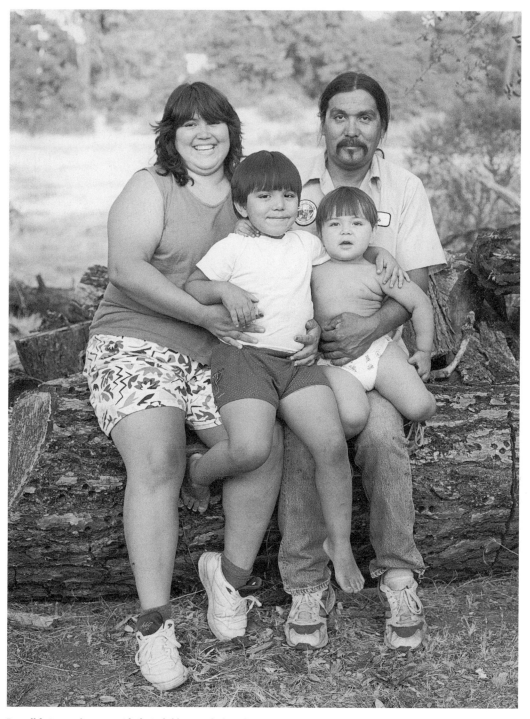

Russell & Samantha Enos with their children at Chuka Pakan. *Photograph by Dugan Aguilar*

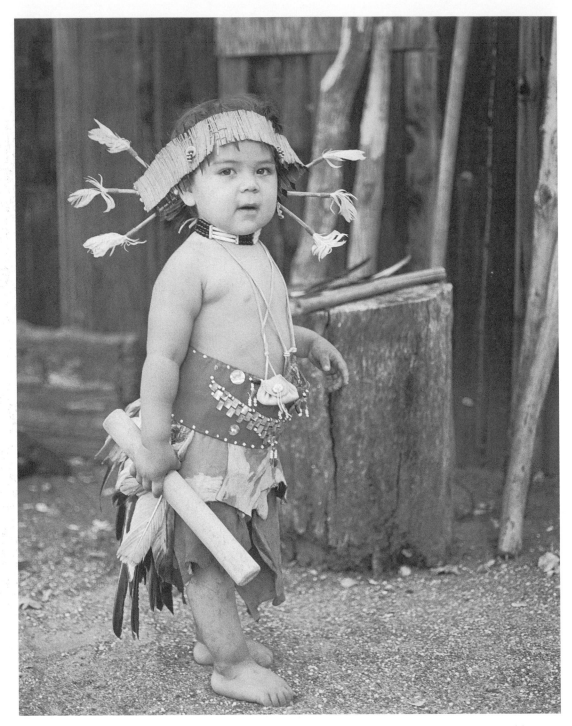

Adam Enos. *Photograph by Dugan Aguilar*

Bear and Deer were sisters-in-law. One day Deer said to Bear, "Let us go and pick clover." While they were there gathering clover, Deer said, "Something is biting me on the neck (like a flea or gnat). Bite me on my neck."

Bear replied, "I am afraid I might bite you in two."

"Don't be like that, go ahead and bite me," insisted Deer. Bear then bit her, and in doing so, bit the neck in two, killing Deer. Bear then ate the Deer. She put Deer's head in the bottom of the large burden basket they had brought with them. She covered Deer's head with clover and returned to her house with it.

Bear had a young cub, and Deer had two fawns. When Bear returned, the two fawns asked, "Where is our mother?"

Bear answered, "She has gone with some hunters." Then she said, "Go ahead and help yourselves to some clover, but don't dig down too deep!" However, one of the little fawns dug down deep and saw his mother's head. He told his elder brother, and he looked in the basket to see it.

At this time there was a campfire burning, and they both went to the smoke side of the fire to cry. They didn't want Bear to see them. Later, Bear said to the fawns, "Look after your cousin, I am going to pound acorns." The fawns looked after their cousin for a while, then decided they would play a game. One of the fawns said, "Let us play 'smoke the other out.'"

They proceeded to dig a hole in the side of a hill. They said to the young bear cub, "We'll go into the hole and you build a smoky fire, covering up the entrance. When it gets very smoky inside we'll say, 'Let us out,' and you remove the covering." The two fawns went in the hole and their cousin made the smoky fire. He covered the entrance, trapping the smoke inside. When it was very smoky inside the fawns said, "Let us out," and their cousin removed the covering. Then the elder fawn said, "Now it is your turn."

The bear cub entered the hole and the fawns tossed pine needles on the smoldering fire. They closed the entrance and began stacking wood against it. Soon it became very smoky inside and the young cub cried, "Let me out!" But the fawns did not let him out. Soon he was smoked to death. They took him out of the hole and brought him inside his mother's house. As they were planning to run away, the mother bear returned from pounding acorns and asked where her cub was. "He is tired from our playing and is sleeping now." They then said, "We are going to get wood."

As they ran away from the camp they spat on a stump and told it, "When she (Bear) says, 'Where are you?' you say, 'We are here.'" They did this all along as they went. When Bear discovered her cub was dead, she realized the two fawns had killed him and soon began to chase after them. As she called out, "Where are you?" a stump answered, "Here we are!" In this way it took her a long time to find them.

Soon, the mother bear was getting near the fleeing fawns. They came upon a boulder and jumped upon it, hoping they would be protected from Bear. Once on top they realized it was not high enough to keep the mother bear from reaching them. They called out, "Go up! Rise up!" and just as Bear was drawing near, the boulder began to rise upward, higher and higher. When the angry mother bear arrived at the base of the boulder, she stood up on her hind legs and stretched her paws as high as she could, reaching for the two fawns. But they were now far above her reach. All she could do was paw at the tall rock pillar, scratching it with her claws.

The younger fawn looked up in the sky and saw his uncle coming toward them. "Our uncle is coming," he said. But the older brother said, "You are crazy, we have no relatives anymore!" But the younger brother repeated, "Our uncle is coming." At that moment the older brother looked skyward and saw their uncle. He took the two fawns up into the sky. There they played with a ball made of elk skin, rolling it along, kicking it. They eventually rolled the ball in through the doorway of a roundhouse. The younger brother looked inside and saw his mother. He ran to tell his older brother.

"Our mama died long ago!" said the older brother. "I will go and get some milk," said the younger brother. He went and got a mouthful from his mother's side and brought it back to his older brother, spitting it into his hand. The older brother tasted it. "Yes, younger brother, this is our mother's milk!" he said. They both returned to the roundhouse and suckled from both sides of their mother.

At night, the little one cried for water and the mother went out to look for some. She fell into a hole and died there. The two little fawns remain in the sky, kicking their elk-skin ball around, making the thunder. Those two little ones are said to live up there, at the edge of the sky, making thunder.

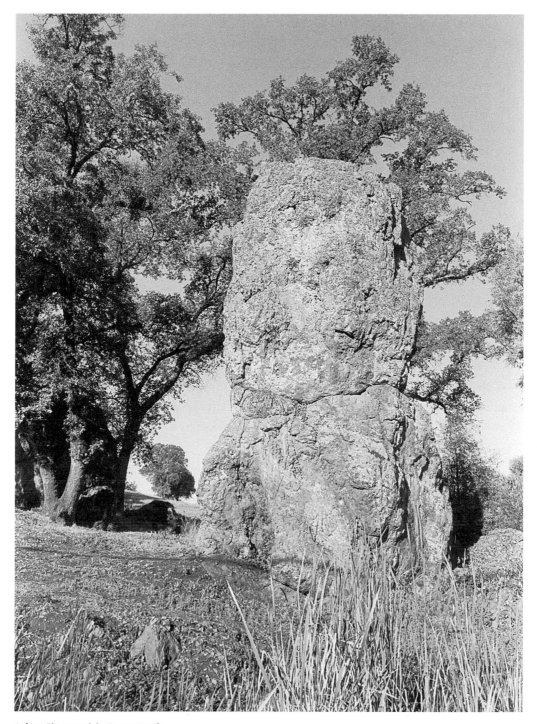

Aalam. *Photograph by Dugan Aguilar*

Stories defining the relationship between Deer and Bear were told in many parts of native California. This version is based on a recitation given by the venerable storyteller William Joseph, better known as Billy Joe. He told it to linguist Hans Jorgen Uldall in the Nisenan language sometime between 1930 and 1932. Uldall later transcribed the story into English.[6]

Billy Joe (c.1860–1934) was born into a village located near Forest Home, in Amador County. The village had long been abandoned by the time he told the story of Aalam to Uldall. Billy Joe's grandfather Holla was a signatory of the treaty made between the United States and the Wapumne Nisenan at Forks of the Cosumnes, September 18, 1851. This treaty would have, to some extent, compensated the Nisenan for land and resources taken by Americans. However, on July 8, 1852, the U.S. Senate refused to ratify this and the seventeen other treaties signed with tribes of California. In fact, the Senate ordered the treaties to be filed under an injunction of secrecy that was not removed until 1905.

About Billy Joe, Uldall later wrote that he was "not only completely familiar with his people's mythology, which in his childhood was an integral part of the education of boys, but he was also, in his way, a very gifted person, a brilliant storyteller, and a considerable polyglot (besides Maidu, i.e. Nisenan, he also spoke English, Spanish, and Miwuk)."[7]

Today Aalam remains in its mythic position, perhaps inching farther toward the heavens and the outstretched limbs of black oaks. It can be viewed from Lime Kiln Road, off of Highway 49 between Auburn and Grass Valley.

Auburn

The sign says "Skyridge," naming a street that runs gradually uphill through the heart of a subdivision just south of old-town Auburn. Less than a mile away, Herdal Drive opens up into another small cluster of recently built upscale homes. At neither location is there anything to suggest the relatively recent presence of a Nisenan village. Yet there remains an individual who is a living link to both villages.

Dal Castro, overlooking a recent development near the Auburn Rancheria. *Photograph by Dugan Aguilar*

From his bedroom window, looking north across a small canyon through a screen of bull pine and blue oak branches, Dal Castro can gaze upon the site of Hu'ul. Captain John, also known as Oitey, had a roundhouse there. He had moved his people, some one hundred to two hundred individuals, from the village of Wenne'a (near the railroad line south of Auburn) to Hu'ul, perhaps in the late 1850s. There he sponsored several ceremonial gatherings, or "big times."

Born about 1825, Oitey exercised considerable influence over the entire Auburn region. He had served in Sutter's army during Don Manuel Micheltorena's governorship of California from 1842 to 1845, and he had worked on Sutter's Hock Farm, near Yuba City. In 1851 he signed the Camp Union Treaty on behalf of the "Ya-ma-do" (perhaps the village of Yamankodo, on the lower American River, upstream of Watt Avenue).

Oitey owned a large rabbit net, and it was he who notified people of various local villages when a rabbit drive was to be held. After a large number of rabbits had been caught, people from Colfax, Clipper Gap, and Sugar Pine Hill gathered together at Hu'ul for a big time. Inside the roundhouse, or *kum*, Oitey would address the gathering in the formal manner expected of a captain. Seeds from wild grasses were tossed on the fire as an offering to the spiritual forces of

Captain John (Oitey) c.1864, holding what appears to be a musket, with at least one jack-rabbit and a gray squirrel attached to his belt. *Photograph by Thomas Houseworth & Co. courtesy of California Historical Society, no. SC8389*

The Nisenan used a net several hundred feet long and four to five feet high when hunting rabbits. A group of hunters, often including women and children, flushed the rabbits from the brush and grasslands and herded them toward the net, where they would become entangled in the mesh, which was made just large enough for the rabbit's head to fit through. Rabbit drives usually took place in the spring, when the ground was soft and the wooden stakes that held the net upright could be driven into the ground deeply and firmly. Rabbit skins were generally cut into a long spiral, forming a strip, and woven together to make blankets.

Long ago, before there were people, Coyote was walking about and saw a cottontail, a deer, and a jackrabbit, *boye*. He chased the cottontail, but it ran into a hole. Coyote then chased jackrabbit. Boye used to have antlers, and as he ran to escape Coyote, Boye kept banging his head against the brush. He was hampered by his antlers, and Coyote nearly caught him. Then Coyote and Deer fought. Later, Boye took his antlers off and said to Deer, "You put them on, brother." Deer put them on and has had them ever since.

the world as Oitey directed his words to the four cardinal directions, beginning in the north and finishing in the west, and then the ceremonial dances would begin.

Sometime in the 1860s, the people left Hu'ul. They may have abandoned the village because, with the construction of a "bloomer cut" completed in 1864, the railroad nearly passed right through it. A historical marker at the site com-

Jim Dick (right) and Ray Smith, c.1925. *Courtesy of Dal Castro*

memorates the cut as the "eighth wonder of the world" of its day and acknowledges the labor feats of Chinese workers. Curiously, the plaque gives no mention of the existence of Hu'ul.

Dal Castro's grandfather, Jim Dick, had lived at Hu'ul, and from there moved a little farther up the ridge to establish Hulakchu. In the roundhouse there, Jim Dick presided over a variety of social and ceremonial gatherings. In 1905 an outbreak of smallpox caused several fatalities, including the death of Dal's grandmother. In response to the epidemic and the death that it brought, Jim Dick destroyed his roundhouse with fire. He supervised the construction of a new roundhouse years later at Opuley (Auburn Reservation, 22 acres and 245 members in 2004).

Elder residents of the reservation still recall Jim Dick's booming voice as he addressed gatherings from atop a boulder, delivering his speeches with great oratorical style. At ceremonial dinners, *weda,* given during the spring, he would stand on top of the table when making his speech. One community member recalled how the power of Jim Dick's voice frightened him as a child. Jim Dick continued to live at Hulak-chu until his death in 1937. Dal is likely the last person to be born (1934) at Hulakchu.

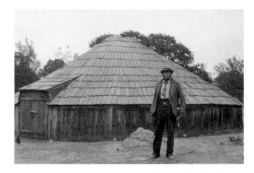

William Joseph (Billy Joe) at Auburn Reservation, c.1931. *Photograph by Hans Jorgen Uldall, courtesy of Elizabeth Uldall*

There were a number of other villages within the area encompassed by present-day Auburn or near it: Pihu, at Scotts Corner on the Folsom-Auburn Road, where Antone Wiley was the headman; K'otomyan (literally, manzanita hill) near the old railroad bridge, was the home of Captain Tom Lewis; and Bisiyan was located at the present site of Bowman.

Jane Lewis

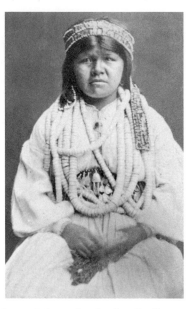

In 1945, an aged woman died on the Auburn Reservation. She had lived there for many years. Nearly everyone called her Koto Jane.[8] She was thought to be one hundred years old or more, but nobody knew for sure. Government documents reveal that her maiden name was Winn and identify her as the daughter of John Winn, also known as Captain John, or John Oitey, signer of the 1851 Camp Union Treaty.[9]

A photograph taken of a young woman in Auburn about 1873 during Stephen Powers' now historic ethnographic expedition to California is identified as "Captain Tom's wife." Elder residents of the reservation at Auburn recognized the woman as Jane Lewis, the wife of Captain Tom Lewis from the village of K'otomyan. She wears several strands of large, clamshell-disc beads, *howok*, and a belt ornamented with a hundred or more pendants of abalone. This type of belt, *pacha*, was originally covered with the scarlet scalps of the acorn woodpecker. Later, red wool was used to simulate the color of the scalps.

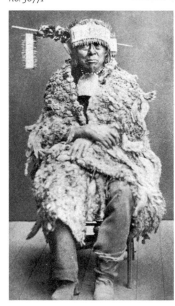

Jane Lewis may have been born at the Nisenan village of Anaape, located near what is now known as Stone Corral in Orangevale.[10] She recalled moving around to various locations during her youth. Perhaps her people were forced to abandon villages because of the influx of ever greater numbers of settlers, or they may have been searching for traditional foods which, with the ongoing arrival of Euro-Americans, had become more difficult to obtain. Her family may have moved frequently to find work on the ranches and farms that occupied more and more of the landscape.

During her lifetime, Jane Lewis saw great change and experienced numerous hardships. In the early 1860s, she hid from soldiers who made sweeps of the foothill area as they gathered Nisenan people for removal to the Nome Cult Reservation in Mendocino County. A Chinese settlement on the edge of Folsom became an opportune

refuge: she would dress and fix her hair in the Chinese style, and when soldiers came to locate Indians for removal, they overlooked Jane and several other Nisenan girls.[11]

Known as a fine basket maker, Jane Lewis showed expertise in several types of weaving. She made large, twined, conical burden baskets for carrying loads of acorn and gathering grass seeds. Sewing strands of split shoots from maple, redbud, or willow around a coiled foundation of three willow rods, she made cooking baskets for acorn soup, small storage bowls, and flat trays for sifting acorn flour.[12]

Jane Lewis became a respected doctor among her people. She knew where and when to gather certain roots and plants that were helpful in fighting coughs and fevers, and in her house numerous medicinal plants could be found hanging from the ceiling to dry.[13] She would hold wormwood in her hands and sing while doctoring. At times she went into the roundhouse alone, built a small fire, and tossed acorn flour upon it as she talked. Former patients recall that she sometimes entered a trance and would sing all night. One account relates how she doctored a man who suffered with fainting spells and bleeding from the mouth and nose, an ailment believed to have come from close contact with *kuksui*, a spirit figure. She sang for a long time, then threw something in the fire that smelled very bad. She would also press patients frequently with her hands on their bodies and heads.[14]

Koto Jane presided over the ceremony in which adolescent girls, on the occasion of their first menses, were blessed and doctored; in the roundhouse, she would sing, talk, and gently toss acorn flour on the young women to help them enter a new phase of life.[15] At this time she also gave them adult names. Several people from the Auburn Reservation who were born before 1945 received their names from Jane Lewis. "I don't have an Indian name, because Koto Jane died just before I was born," says one member of the community.[16] She was an important figure in other ceremonies as well. Elders have stated that she knew several songs and dances not seen or heard anymore. Auburn elder Dearstein Starkey recalled that Jane Lewis lived in an old-style conical wood-slab structure known as a *hubo* until a modest frame house was built for her sometime in the late 1920s.[17]

Living on the Auburn Reservation in her later years, Jane Lewis was called Koto Jane by nearly everyone, and as her family gradually died off, reservation residents, often children, would care for her. They carried her water, brought food and firewood, cooked, and washed her clothes. She became blind in her old age. For people who knew and respected her, Koto Jane was the embodiment of strength and knowledge, a keeper of tradition, and a link to a very distant past — to a different world.

A Revival at Pilot Hill

South of Auburn, Highway 49 passes the small town of Cool. Near here was the village of Okilkil, said to be the birthplace of Jim Dick. At Cool were the village of Siyakaiyan and an important salt spring. A large hill, possibly Pilot Hill, was apparently known as Yamani kaiyan.[18]

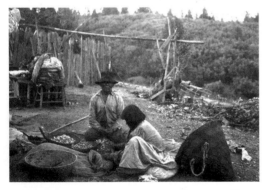

Old couple husking acorns, possibly at Hemhem, a village located where the settlement of Yankee Jim stands in Placer County, 1902. *Photograph by C. Hart Merriam courtesy of Bancroft Library, University of California, Berkeley, no. 1978.008 u/20m/P8 no. 1*

At or near the American settlement of Pilot Hill, a revival of ceremonial dance took place around 1890. Jim Dick's father, Inkoi,[19] and uncle, Captain Joe of Pilot Hill, supervised the construction of a new roundhouse there. The men cut timbers and built the structure while the women and children cut grass for the roof. The two captains, one inside and one outside, oversaw the construction. After the roundhouse was completed, a hunt for rabbits and deer was organized and large batches of acorn soup were prepared, and a big dinner was held. The first fire in the new roundhouse was built, and the food was cooked in its ashes. Everyone ate inside, and before the dances began the captain prayed.

Before departing, the visitors left one singer, one male and one female dancer, to serve as instructors at Pilot Hill until the next big time.[20] Inkoi invited the people to Auburn for a big time to be held in a month. There, the young Pilot Hill dancers would show how well they had learned. Those who had survived the gold rush now attempted to reconnect an important emotional and social link to their former ceremonial and communal life. For the young — those born into the fractured world of the post–gold rush period — the

ways of their parents and grandparents were unveiled before them in forms they had likely not seen before. The journal entry of anthropologist and naturalist C. Hart Merriam from a 1902 visit to Yankee Jim encapsulates the dynamics of maintaining traditional lifeways in the midst of ongoing change:

> I drove to a small country settlement known as Yankee Jim and turned west, and on a knoll a quarter of a mile away came to the camp of the two families of Ne-se-nun Indians living there. One family consists of a very old woman and her husband, nearly blind. They were shucking and splitting black oak acorns when I saw and photographed them. . . . The old woman was splitting the acorns open (the shells) by hammering them between stones, one resting on the ground, the other held in her right hand. [The man] split the green acorn meat or nut in two, lengthwise, with the fingers, and tossed the split halves into another *pah-ti* (work basket). They were now ready to be dried before pounding into meal. All of the acorns were green. They had several bushels just gathered.
>
> Close by the house a small, roughly oval place was fenced in, to keep out the stock. Inside the fence is a grape arbor, and under the arbor is the mortar for hammering acorns, hollowed out of a large rock. Beside it was a very old and large burden basket *(mal-la)* which I purchased. The man at the head of this camp told me his name is Hunter Bill. He and the others were very polite. The people here say all these Indians are good hard-working honest people, self-supporting and respectable.[21]

One of the historical ironies of the gold rush and its aftermath is native participation. Beginning with Marshall's discovery, native labor was an essential and noticeable part of the early gold extracting operations. More than fifty years later, native families throughout the Sierra Nevada supplemented their incomes by panning for gold. On his visit to Yankee Jim and Todd Valley, Merriam also noted, "At both places the Indians live in rough board houses built a long time ago. Besides these, at the Todd Valley camp there is a circular house for their ceremonials . . . The family living at the roundhouse were away—the men (father and son) cutting wood and the women washing gold on the North Fork American River."[22]

Coloma

My mother used to tell me about this Indian lady that had [a] gold cracking rock, big round one. She crack acorn with that for a long time I guess . . . until this white man hear about it. White man come there and give that old lady fifty cents for it and take it away. But she don't care. That old lady had lotta those regular cracking rocks and fifty cents besides. Old-time Indian never seem to care about gold like white people.

Lizzie Enos [23]

Leaving Pilot Hill and proceeding to the south fork of the American River at Sutter's Mill, you will come to the site of the Nisenan village of Kulloma. Recent archaeological excavations date human occupation in the Coloma vicinity from approximately 2,000 to 2,500 years ago, based on evidence of ancient (Martis Culture) artifacts.[24] In November 1846, a census of local native communities yielded a count of 485 Yalesumne (the local Nisenan-speaking group), 228 male and 257 female; this represented the largest population, by far, of the fifteen Nisenan communities/tribes visited by the census takers.[25]

It appears that the mining town of Coloma was built directly over much of the Kulloma village site; the area seems to have been occupied when Sutter attempted to lease the land to build a sawmill. In January of 1848, the "Sutter-Marshall Lease with the Yalesumney" attempted to procure:

the following described tract of land for the term of twenty years, beginning at the mouth of a small creek [that] empties into the south branch of the American Fork, a tributary of the Sacramento River thence one mile from said fork on the north side at the distance of one mile from said stream to a point three miles above a sawmill building by said Sutter and Marshall thence in the southeast direction until it strikes crossing the south branch the said Pumpumel Creek thence down the same to the point of beginning . . . [26]

Terms of the agreement obligated Sutter and Marshall to "erect one pair of mill stones and to grind the grain for said tribe taking one bushel in eight, and to pay on the first day of January each year one hundred and fifty dollars to Pulpuli, Gesu, Colule & Sole, their heirs."[27] In less than two years, the agreement

would become moot as Coloma was inundated with miners from all over the world. In addition, Governor Mason explained to Sutter later that the agreement would not have been valid, as "the federal government did not recognize the right of the tribes to sell or lease the lands on which they resided."[28]

A Conversation with Artist Harry Fonseca

In July 1997, nationally and internationally recognized artist Harry Fonseca (Nisenan, Hawaiian, Portuguese) discussed his new works on the discovery of gold in California and the impact of that discovery on his people. The interview took place on the Shingle Springs Rancheria in western El Dorado County. Harry spoke about his new works and what he felt were the long-term effects of the gold rush.

When I began the series, "The Discovery of Gold in California," my first concern was to make these paintings as beautiful as I possibly could. The series began outdoors, here on the Shingle Springs Rancheria, on the side of the hill looking out upon the beautiful foothills of the Sierra Nevada range. The energy of this land and knowledge of what took place here during the gold rush began to transform my style from representational to abstract. As the work progressed, I was inevitably drawn to Coloma to paint at the site where gold was discovered in the American River.

The gold rush was an explosion on all levels—beautiful stuff to work with. There were cultures coming together, conflicting; a profusion of greed, of loss; massive change; and I hope this overall drama is expressed by the passion in these pieces. As I painted, the brutality which took place during the gold rush began to surface in a thickening, a dripping, an actual eruption of gold paint in the work. The damage inflicted during that chaotic time was extensive. It injured the land and the living things that were there, Native Americans, and other peoples as well.

I feel that a societal upheaval of this magnitude must have caused some psychological and emotional crippling, which may have been passed from generation to generation. I think the people, naturally introspective and reticent, seem to have been driven deeper into themselves by the impact of the gold rush and the

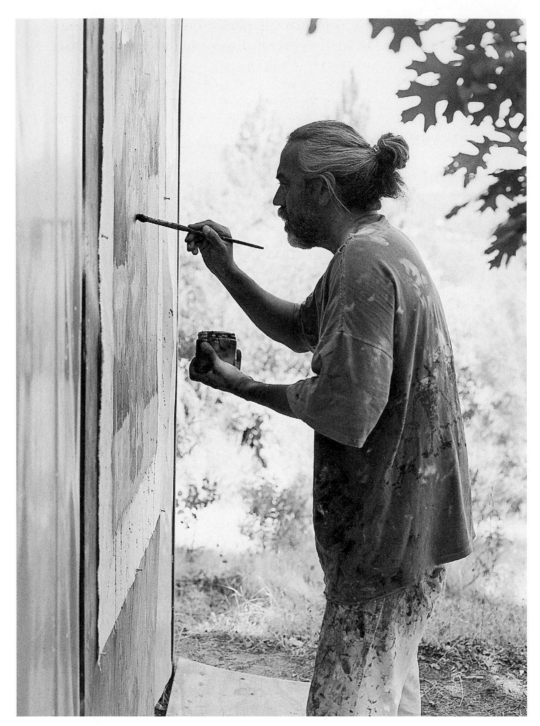

Harry Fonseca at work. *Photograph by Dugan Aguilar*

immense changes that followed. I know this quality of being. It is sort of like feeling less, feeling not full, not complete within yourself. I could fall into that in a heartbeat, but I just won't allow it to happen.

I think ramifications from the gold rush are still felt, not only by us, but by everyone. The people who live around here are still in an exploiting "rush," even though the focus has changed. A realtor's billboard near here advertises "The Greatest Earth on Show." We still have picks in our hands and don't even know it.

Harry Fonseca's Nisenan ancestors were residing at the village of Pusuni, on the north side of the American River near its confluence with the Sacramento, when John Sutter arrived in the region in 1839. Accompanying Sutter were several Hawaiians he had brought with him to California. Eventually, one of the Hawaiian men, Hukawilla, would marry a Nisenan woman known as Pamela, Harry's great-grandmother.

As the city of Sacramento grew, the people of Pusuni found themselves landless and lived wherever they could, individually, in and around Sacramento. Some descendants resided at the village of Kadema (Watt Avenue at the American River) until the early 1930s. The federal government purchased the 160-acre Shingle Springs Rancheria, west of Placerville, in 1916 to provide land for homeless Indians. Today there are 396 members. (It wasn't until the 1980s that the government followed through with its commitment to install a water system and roads.) The Shingle Springs Rancheria is sometimes called Kutupu, an older traditional name for a camp or village site once located there.

Kapa Hembo

Kapa Hembo was born in the early 1800s and lived most of his life in the area around Coloma. Owner of a stentorian voice, he was a headman with influence throughout an area encompassing Kelsey, Mosquito, and Irish Creek. He died in 1892 at Chicken Flat. Local oral histories claim that Kapa Hembo aided many of the early pioneers in the area, bringing them food and guiding them over trails.[29] His eyes were witness to some astounding sights—people and things he might never have imagined. It is also likely that he saw bloodshed and experienced aggression and episodes of violence directed at his people during the great rush of 1849 and the decades that followed.

Late in the nineteenth century, Kapa Hembo was a favorite of local children in the Chicken Flat area. He delighted them with traditional myths and stories of his childhood. One story concerned the origin of his name. It happened that three young men were walking a trail between Rock Creek and Mosquito Canyon. They were suddenly confronted by a grizzly bear. Two of the young men fled, but one stayed. Drawing his bow, he sent an arrow into the bear. The bear tore away at the arrow, growling loudly. The man quickly shot another arrow into the bear, whereupon the grizzly lashed out, striking the shooter across his forehead. The young man was able to send a third arrow into the bear, killing it. This episode apparently resulted in his being named Kapa Hembo, bear slayer.[30] Those who knew him in his later years recalled the scar on the old man's forehead. And like Jim Dick's namesake (condor), the creature for which Kapa Hembo was named became extinct in his homeland.

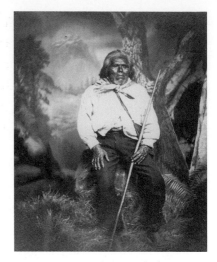

Kapa Hembo (Bear Slayer), c.1890. *Courtesy of the El Dorado County Historical Museum, no. 00601*

Placerville to the Cosumnes River

Proceeding south to Placerville and vicinity, the traveler passes numerous native village sites, some with names that survive in the historic record and others that are now nameless. The terms or names associated with native villages are often hard to translate. Some village names are clearly translatable and

In traditional times, bear hunting was carried out by three or four men together. Billy Joe related the procedure as follows: "The one who shot first owned the skin. They cut up the meat. Then they divided it. When they had done this they shouted four times before getting home. The people in the camp said, 'They must have killed a bear.' When they arrived, they told about it. They hung it (the skin) up in a tree. They left it there four nights. They took it down at a little celebration. They gave that bear skin to the chief of this camp. Another man tanned it. The chief paid him. He also paid

the one who gave the skin. Then the chief gave another big time (celebration)."

The arrows Kapa Hembo used to kill the grizzly bear were likely made from the shrub known commonly as mock orange *(Philadelphus lewisii)*. Its favorite habitat is the shady recesses of canyons. Most Nisenan arrows were two-piece: the main shaft and a short foreshaft of hardwood. The pithy core of the mock orange could be hollowed out for the fitting of a solid foreshaft. Shafts are ideally gathered in the fall or winter, after the leaves come off and the sap is down. They are bundled in groups to dry slowly and prevent warping.

refer to obvious local features, but it appears that some villages were known by more than one name, and names may have changed frequently. A settlement might be known by the name of its headman, and then the name could change when he died or was succeeded by another. Some settlements were temporary in nature, camps rather than permanent villages, and their names may not have been as permanent as those we assign to American or European towns seem to be—as a look at a world map from the early 1960s shows, it is not unusual for cities and even entire nations to change their names.

Besides Coloma, several other nineteenth-century American towns were built very near, or directly over, former Nisenan settlements. For example, the community of Camino appears to cover much of the former village of Saskiyan. There had been a large roundhouse there, and Captain Tom was said to have been its last headman. As late as 1928, the town of Camino was still called Saskiyan by Nisenan living in the vicinity.[31] West of Highway 49 and near Highway 50, the site of Bamom ("salt water") is now occupied by the town of Shingle Springs. It was said to have been a very large village with a big ceremonial roundhouse.

Heading south, Highway 49 winds its way to Diamond Springs. This area was known to the Nisenan as Moloko Pakan (condor spring). Near El Dorado, close to Slate Creek, was Onachoma (eat hair), and at Toll House was Chayit Pakan (blue jay spring).[32]

Villages near Placerville:

Poyope', near head of White Rock Canyon

Bubuhu, near Oak Grove on South Canyon Creek

Moluilui, south of Smith Flat near Webber Creek

Tu do te', near Moluilui. A man named Hudok owned the roundhouse here

Matin Pakan, "oak spring," near a white settlement also called Oak Springs

Angtaim'o, "elderberry rock", a small camp near Brewsterville

Hoitemmelop, settlement near Cedar Ravine

Oko Pakan, small camp across the south fork of American River

Koi'umol, northeast of Placerville

Tapashu, fifteen miles east of Placerville, across the south fork of the American River

Chehu'huhe, near Six Mile House

Koimo hi'em, "rattlesnake brush," a summer camp

Wuhuluk, at Texas Hill, north of Webber Creek

Yohimu, small village near Shingle Springs

Tulul, small village near Shingle Springs

Omlukai, large village above Squaw Hollow Creek

Kutumpa, on Slate Creek

Chitok Pakan, "poison oak spring," five miles south of Shingle Springs

Kutba

Just after turning its course almost directly south, running parallel to Highway 49, the north fork of the Cosumnes River reaches the old settlement of Nashville. About four miles east of Nashville, at a place along Big Canyon Creek known as Telegraph Flat, was the village of Miimenek. A man named Widuk was the headman there. He is said to have been on friendly terms with the Washoe people to the east and to have invited them to Miimenek for big times. As Billy Joe recalled:

> He ordered some young fellows to go and fetch the Washoes, so that they might come to the big time *(lumai)*. When the Washoes came they brought meat, which they came to exchange for acorns. When they went back, Indians from this country escorted them. That is the way Widuk treated the Washoe.[33]

After Widuk's death, his nephew, Hunchup, became the headman. He moved the village to another location, as the people were alarmed by the telegraph lines that now ran through their village, looming overhead.[34] This village, located between the middle and north forks of the Cosumnes River a short distance from Nashville, was known as Kutba (deer salt).

Hunchup (born about 1832) was known to be a poison doctor. Children were

It was Chayit (blue jay, also called western scrub jay, *Aphelocoma californica)* who first told the animal people about the existence of fire in the valley to the west. Mouse then traveled to that place and stole a small piece of fire, bringing it to the hill people. They built a large fire in the roundhouse and held a dance. Chayit was the foot drummer, and at one point kicked the wooden slab of the drum so hard that it broke. From the depths of the pit below the foot drum, acorns flew up into the air and out the smoke hole of the roundhouse. They went all over. In this way, oak trees began to grow all over the hill country. Even today one can watch Chayit taking an acorn and hiding it in the ground somewhere. Later he forgets where he put it, and an oak tree grows there.

admonished to stay clear of him for fear of becoming sick. People often knew when he was coming near, as they could smell his medicinal roots before he appeared. They say he killed half-white girls with poison air, and when Hunchup was himself killed, he became a coyote.[35]

The village of Kutba had a roundhouse which hosted ceremonial dances, feasts, and gambling games. It also served as Hunchup's residence. Another of his uncles, Wodop, traveled from village to village throughout the region as a carrier of news, *weda bone'pa*. The headman appointed a man to this position for his ability to speak, and for his powers of observation. Such a "reporter" often traveled at night. He was always welcome and rarely interfered with. Arriving in the morning, he would present himself at the house of the headman, who soon summoned the people to the roundhouse. No one interrupted him while he talked, and when he finished, everyone clapped and shouted. He related all the latest gossip: who had died, married, or been taken sick. He also reported where he had seen good crops of acorns, manzanita berries, or other foods.[36]

Looking at C. Hart Merriam's photograph of Hunchup and his family reminds me of their remarkable effort to bring what they could of village life

Woman harvesting seeds near Yankee Jim, 1902. Identified only as "Hunter Jim's daughter-in-law," this woman uses a seed beater to knock seeds loose from their stalks, sending them into the large, open mouth of a burden basket. *Photograph by John W. Hudson, courtesy of The Field Museum*

Winnowing tray collected at Kutba by A. M. Tozzer, 1901, made of split and peeled spring redbud shoots and split winter redbud shoots on a three-rod foundation of whole willow shoots. This type of basket was used to separate seeds from their husks by rubbing them in the basket, then tossing the seeds into the air, allowing the breeze to carry off the husks and leaving the heavier seeds to fall back into the deep tray. *Courtesy of Peabody Museum of Archaeology and Ethnology, Harvard University, no. 01-3:55981*

The tiny seeds of the clarkia plant *(Clarkia* spp.) were harvested by using a seed beater and burden basket. With the advent of agriculture and grazing, clarkia, like so many other native seed-bearing plants that native people used for food, quickly became scarce. Buttercup seeds, *t'apanim komi (Ranunculus* spp.), were another of the many varieties of seeds gathered. The tiny seeds are parched on a basketry tray with hot coals before being eaten.

into the twentieth century. They had no legal rights or title to the land on which Kutba was situated, yet there they were, a ragged little group of people — remnants. It's an image of freedom. Within a few years they would leave Kutba. Whether they were forced off the land or left voluntarily, I don't know. Billy Joe said:

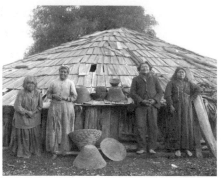

Hunchup with wife and relatives at Kutba, 1904. *Photograph by C. Hart Merriam, courtesy of Bancroft Library, University of Caliornia, Berkeley, no. 1978.008 u/20m/P1 no. 2*

> When his mother died, [Hunchup] came to Sloughhouse and left his roundhouse. He stayed with white people and Cherokees at Sheldon, and there he has died. His wife has died there too. Then nobody lived at Telegraph Flat [Kutba]. That roundhouse was burned when they all died. There are no Indians there now, at Telegraph Flat."[37]

Palamana

> On our way back, we passed the remains of Indian villages, long since abandoned . . . the inhabitants had long since passed away and there was none to tell their story. The wild beasts had disinterred the bodies of the dead and their bones were bleaching in the sun.
>
> *William Dane Phelps, August 1, 1841, on an outing some miles from Sutter's Fort*

An isolated mound of earth sits amid the rolling plains of eastern Sacramento County, clipped on one side by a busy highway, surrounded by cyclone fencing, its once round top leveled to accommodate a water tank and gazebo. Altered, crippled, yet enduring beneath the recent encumbrances, it can be seen as a symbol of native California's mythic heritage. It was in this area, along the Cosumnes River near the present community of Rancho Murieta, that a village

Mound created by *hiiki*, the giant snake, near Palamana. *Photograph by Brian bibby*

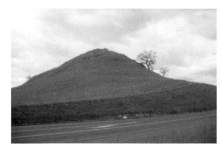

called Palamana once existed.[33] The late Nisenan elder Betty Castro often mentioned the place in connection with this hillock that rises suspiciously from its flat surroundings. The village name meant something like "fish with hands," but the hill was the focus of her story.

A giant snake, *hiiki*, once lived near the village of Palamana. It was an enormous creature fully capable of consuming a

human being. People were terrified of it. Then one day the great serpent went out onto the open plain a few hundred yards from the river and began to coil. Its coiling caused the earth to mound up, ever larger and higher. Sitting atop this mound, the giant snake spoke to the people. It said that it was going away and would never return, and it forecast great changes in the world to come. The snake said it had seen a vision of the future, with many people lying along the banks, up and down the river, dead. Soon afterward it left, and they never saw that snake again.

Today thousands of travelers pass this mound as they commute along Highway 16, unaware of its legacy. Betty Castro heard the story when she and her family stayed in the labor camp between the rural hamlets of Sloughhouse and Cosumnes, picking hops. She once related how, as a child, she hustled up the large round hill and challenged the great mythic beast: "Come on back, you big fat snake, I'm not afraid of you!"

Betty Murray Castro was a keen student of her people's mythology. Her uncle Henry Charleton, who had worked for John Sutter during the gold rush era, told her many such stories

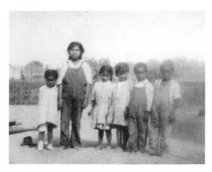

At the hop fields near Sloughhouse, c.1915. Left to right: Izzie, Elsie (Adams) Fonseca, Elizabeth (Murray) Castro, Nellie Adams, Harry Montero, Hicky Murray. *Courtesy of Harry Fonseca*

when she was a child. She also heard stories from Billy Joe after he moved to the Auburn Reservation, where her family lived. Betty possessed a deep knowledge of this oral literature and was herself, as the following story of Ollele indicates, a skilled and highly entertaining storyteller. This is the story as she told it in 1984, and as always when committing oral literature to the written page, I am acutely aware of what is missing — in this case, the light behind Betty's eyes, the expressive hand motions, and the animated intonations of her voice. She was wildly funny and delivered a story with complete command and believability.

The half-brother to this Ollele [bat] was Chamba, you know, gray squirrel. And this Ollele had two big fat women. Oooh, they was fat. And they was Indian, they was Maidu.[39] And one old lady told the other one, "This damn Ollele, all he want to do is go and cut his belly open and get his old fat" and rat-tat-tat on the rock, and make the fat, and take it home to them. So they eat out of his belly — because he had a big, big belly.

And so they would eat on that. And then of course they would steal things too. So they was making eyes at the half-brother, that squirrel. And he was up gettin' his *hope'*. That's the green pine nut. I guess he was talkin' about green pine nut, *hope'*. So he was rich, and oooh, he was a nice lookin' Maidu, because he was slick and clean, whereas that old bat was black and ugly.

But Ollele had these two women, and he was asleep. He slept in the middle of them, and when one would roll on him he'd say, "Get the hell off! You're too big and fat, and you're too hot! Get your goddamn *pok* out of my way!" And so they would crawl away. And they got sick and tired of that, so they went to visit the half-brother. And so I guess they went and they slept with the *chamba*, and he was giving them *hope'*, that there green pine nut. His hands were ooh, just *piyeto*, black with dirt. But he cleaned with this here wild tomato. I don't know if you've seen wild tomato? Take that off, all that pitch. And so they have that roasting, just a eatin'. That old Ollele come. "Ahah! You sons-a-bitches! You sons-a-bitches! I'm going to kill you!" See, he was pointing at his two old ladies, fat old ladies, and his half-brother. And the half-brother is just smart, clean looking. And he looks, "I want to kill you too!"

And so they kept talking to him. "You go back down the hill where you're supposed to be." Supposed to be down here at the American River. "Go back to

Ollele, the bat (*Myotis californicus,* one of many bats found in the Cosumnes River watershed)

Pitch, *petto,* was an important adhesive in setting arrow points into the foreshafts of arrows, and in plugging the ends of dance whistles. *Hope',* the immature or green pine cones from the bull pine *(Pinus sabiniana),* were roasted whole to help remove the sticky pitch, then split open to harvest the nuts. The nuts, their hard shells not yet developed, were eaten whole. *Tonima,* the same kind of needles that poked through the pitch-covered eyes of Ollele, enabling him to see, were sometimes bound into a bunch and used as a brush. Pine needles also served as bedding material and as a floor covering inside the old earthen-floor homes.

your old camp and stay there. We don't want to stay with you." And so he come back next day, and he's sittin' there. "You sons-a-bitches, I'll kill you tonight! I'll kill you!" And his half-brother got his hands just full of *petto*, you know, pitch.

And while the old bat was sittin' down . . . see, he was sittin' down like this, against a rock with his little leg crossed. And he's sittin' down like this, "I'll kill you . . . kill you!" And he was cussing. And his half-brother [Chamba] got up there and he put his hands across Ollele's eyes and plugged his eyes up with the *petto*, and he couldn't open his eyes. And oh, he was cussin', yellin' for those two injuns [wives] to help him. And they just laughed because he couldn't see. They know he was going to starve to death.

So they went on, supposed to be going way up north. And Ollele laid down there under a pine tree, and he was saying,

> *upi munu wonono wonono wonono,*
> *upi noton wono, upi upi*

He was saying, "Come north wind, come north wind." And this here *tonima*, the needle, the wind would blow it. And he would say,

> *kusa kusa munu munu,*
> *kusa munu munu munu*

And that north wind just blowed. Just blowing. And every time it blow, the needles poke in his eye, and that's how he got his little eye. That's how he got it. The pine needle did it.

Walking through the foothills in the heat of summer, I can smell the pitch in the bull pines. It's not detectable in other seasons. But in the heat, there is a scent that seems to come from them, slightly acrid, as if the pitch is being cooked. It's the same smell that comes from melting pitch to dab and plug the ends of dance whistles. As I pass a bull pine amid the toasted hillside grasses, the rising aroma conjures images of Ollele and Chamba. They are inseparable. Sometimes the wind will come up suddenly, sending a cluster of pine needles sailing downward. As I look up, cautiously, Betty's story races through my head.

Notes

1. Hans Jorgen Uldall and William Shipley, *Nisenan Texts and Dictionary*, University of California Publications in Linguistics, vol. 46 (Berkeley: University of California Press, 1966)

2. Edwin Bryant, *What I Saw in California* (Lincoln, Neb.: University of Nebraska Press, 1985)

3. Johann Heinrich Lienhard, *A Pioneer at Sutter's Fort 1846–1850, The Adventures of Heinrich Lienhard*, (Los Angeles: The Calafia Society, 1941), 182

4. Ibid., 189

5. Belle Douglass, "The Last of the Oustemahs" (Nevada City, Calif.: Nevada County Historical Society Bulletin, vol. 13, no. 4, March 1960)

6. Uldall and Shipley, *Nisenan Texts and Dictionary*

7. Ibid.

8. *Koto* is the Nisenan term for grandmother, and a term of respect that may be used toward any elderly woman, regardless of lineal descent.

9. Department of the Interior, Office of Indian Affairs, applications for enrollment, 1928

10. Betty Castro, personal communication, 1973–1988

11. Ibid.

12. Ibid.

13. Dearstein Starkey, personal communication, 1987–1997

14. Betty Castro, personal communication

15. Ibid.

16. Harold Starkey, personal communication, 1987

17. Dearstein Starkey, personal communication

18. Hugh W. Littlejohn, "Nisenan Geography," ms. Bancroft Library, University of California, Berkeley

19. Possibly Hincoy, signatory of the 1851 treaty on behalf of the Wopumne

20. Ralph L. Beals, *Ethnology of the Nisenan*, University of California Publications in American Archaeology and Ethnology 31(6) (Berkeley: University of California Press, 1933), 335–414

21. Robert F. Heizer, ed., *Ethnographic Notes on California Indian Tribes/C. Hart Merriam*, Reports of the University of California Archaeological Survey, no. 68 (Berkeley: University of California Archaeological Research Facility, Dept. of Anthropology, 1966–1967), 305–306

22. Ibid., 68

23. Richard Simpson, *Ooti, A Maidu Legacy* (Millbrae, Calif.: Celestial Arts, 1977)

24. Jerald J. Johnson, personal communication, 2000

25. McKinstry Documents, no. 4–5, ms., Bancroft Library, University of California, Berkeley, 9–10.

26. "The Sutter-Marshall Lease with the Yalesumney Indians, 1848," in Robert F. Heizer and Thomas Roy Hester, eds., *Contributions of the University of California Archaeological Research Facility*, No. 9, *Papers on California Ethnography* (Berkeley: University of California Archaeological Research Facility, Department of Anthropology, 1970), 109–110

27. Ibid.

28. Senate Executive Documents, United States Congress, 31st Congress, 1st session, Executive Document 18, 466

29. Phyllis L. Gernes, *Hidden in the Chaparral* (Garden Valley, Calif.: Gernes, 1979), 67–68

30. Ibid., 68

31. Littlejohn, "Nisenan Geography"

32. Ibid.

33. Uldall and Shipley, *Nisenan Texts and Dictionary*, 137

34. Littlejohn, "Nisenan Geography"

35. Simpson, *Ooti: A Maidu Legacy*

36. Beals, *Ethnology of the Nisenan*, 367–368

37. Ibid., 139

38. Also spelled "Pallaamul," based on Billy Joe's pronunciation. Located at Michigan Bar.

39. Tribal names for the Maiduan people—Konkow, Maidu, and Nisenan—are not strictly applied by Maiduan people themselves; "Maidu" is often used instead of "Konkow" or "Nisenan." In a region where a family or two might constitute a political unit, large tribes of the kind found in other parts of North America are more an intellectual construct than a concrete reality.

Four
Plymouth to Angels Camp

THE COSUMNES RIVER marked a major change in language and culture. Approaching Drytown and Amador City, today's traveler has left the home of the Maiduan languages behind and is now clearly within Miwuk-speaking country, where *Dǝǝpe* (black-tailed deer) became *ǝwǝǝya*, *hanpie* (valley quail) became *hekheke*, and *chakawi* (blue oak) became *molla*.

Within the Sierra Nevada chain, from Plymouth southward to Mariposa (a distance of about ninety miles), three Sierra Miwuk languages were spoken: Northern, Central, and Southern. Several local dialects of Northern Sierra Miwuk were spoken within the area covered in this chapter — most of Amador and Calaveras Counties. Major streams — the Mokelumne and the Calaveras — will intersect Highway 49 before the language changes again.

The Cosumnes and Mokelumne Rivers derive their names from Miwuk communities; the Miwuk village of Cosumne, abandoned before the gold rush, was located out on the valley floor, a few miles west of Galt; the village of Mokel, located near Lodi, was associated with the Mokelko (i.e. Mokelumne) tribe.[1]

There is an easy, gentle appearance to the country here. The firm structures and rounded crowns of blue oaks claim much of the landscape. They conjure images of blue jay, who is responsible for their abundance. Along the rivers, in

the shade of intimate little canyons, shrubs of mock orange are found — their straight, sturdy shoots perfect for arrows. Clothed in grass, the rolling, oak-studded hills present themselves perfectly, obeying the changing seasons and the cycles of weather: in January, looking like bolts of green velvet tailored perfectly to their contours; in April, splashed with the random shapes of bright yellow, white, pink, and purple wildflowers; in July, shimmering with an amber tone that reflects the heat and dryness of the season; and in October, hushed beneath the subdued hues of spent grass stalks.

Moving through the cultural landscape, the traveler passes a pair of rocky peaks that project abruptly above the horizontal plain. Their ancient legacy, which reaches far back into the mythic past when the world was still in the process of being formed, has been preserved by contemporary voices. The road leads past countless acres of brush, largely forgettable to travelers and residents

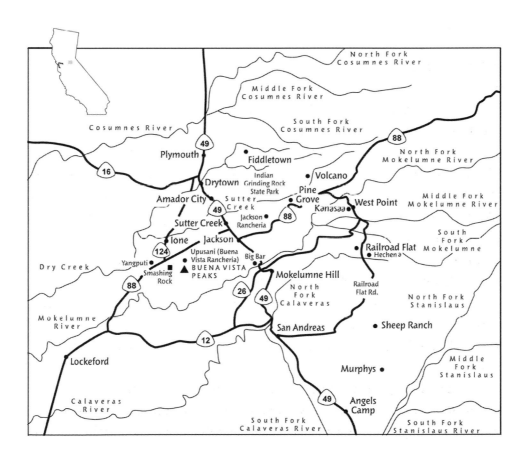

Buena Vista Peaks. *Photograph by Dugan Aguilar*

alike, yet once essential to native hunters. And an elder, the living link in a chain of interlocking conversations, delivers us to another place and time.

Today many descendants of the people who lived here before the arrival of Europeans remain here in small communities, including the 67-acre Buena Vista Rancheria; a 40 acre private parcel near Ione (the Ione band of Miwuk Indians includes about 540 members); Jackson Rancheria (331 acres, 27 members); and enclaves near West Point and Sheep Ranch.[2]

The Buena Vista Peaks

On the south side of the old village of Upusani ('əpəəsani, swimming place[3]), south of Highway 88 and west of Highway 49, two buttes rise out of the gentle landscape, quite literally casting a shadow on the village site. The Buena Vista Peaks, as they are known locally, figure prominently in Miwuk oral tradition. The flat-topped, mesa-shaped south butte was known as *hawwa*, pillow.[4] The name for the taller north butte has been recorded as *soo-so*[5] (perhaps *sussu* "yellow jacket" or *sussa* "frost" or *səssə* "firewood"). Some of the local Miwuk knew the buttes as *putchaka:* when passing by the buttes it was customary to stop, break off a piece of brush, and strike one's legs with it, or sit down and press the arms and legs with dust as a remedy for weariness.[6] The term *putchaka* appears to refer to this practice.

When Bernice (Burris) Villa was a little girl living in Jackson Valley, her uncle Joe Walloupe told of an event that occurred during mythic times, an episode that shaped the destiny of human beings. And it took place on those curious, rocky buttes that she saw resting so solidly on the horizon when she glanced eastward.

There was nothing but water between Buena Vista and Mount Diablo. In those days, there was nothing but animals here, no people. The Coyote and Lizard met up on Buena Vista Peak. They wanted to create man. So they began creating him, but they couldn't decide what kind of hands he should have. So they argued—for days and days. Finally, they decided to play handgame, and whoever won, well, that's the way we would be.

If Coyote won, we'd have paws. He argued that paws were better—you could dig up roots and wouldn't be hungry . . . you'd have all the roots and things to eat. But the Lizard said that people should have hands like him so that we can do things with our hands. You could do everything with hands: you could pull up roots with your hands, and pick acorns, or pick watercress. So they played handgame. They played for days, and finally old Lizard won. So that's why we have hands like him. The old *sakkeṭi* won.

Sometimes, maybe drying herself with a towel after washing a load of dishes, Bernice takes a quick look at her hands, and while contemplating the condition of her fingers or her worn, smooth palms, she has a fleeting thought of lizard. An unconscious shift of the eyes upward, out the kitchen window, and the rocky formation is there.

A Northern Sierra Miwuk myth recorded by anthropologist and naturalist C. Hart Merriam around the turn of the century recounts the early days of the world, and how things went at a place very much like the Buena Vista Peaks.

When water covered the world only the top of the highest mountain rose above it. The people had climbed up on this mountain, but could find no food and were starving. They wanted to go off and get something to eat. When the water went down all the ground was soft mud. After a while the people rolled rocks down to see if the mud was hard enough to hold them. When the rocks stayed on top, the people went down to search for food.

But the mud was not hard enough to hold them, and they sank out of sight, leaving deep holes where they had gone down. Then *kahkalu*, the ravens, came and stood at the holes, one at each hole where a man had gone down. After a while, when the ground hardened, the ravens turned into people.[7]

Passing by the buttes, one can see many of the large boulders that were pushed over the edge—those that did not sink completely. Miwuk elders tell of bird tracks evident on the stone surface of the south peak, made when the world was new and everything was still soft, even the stones.[8]

Another ancient story, the Northern Sierra Miwuk account of how people

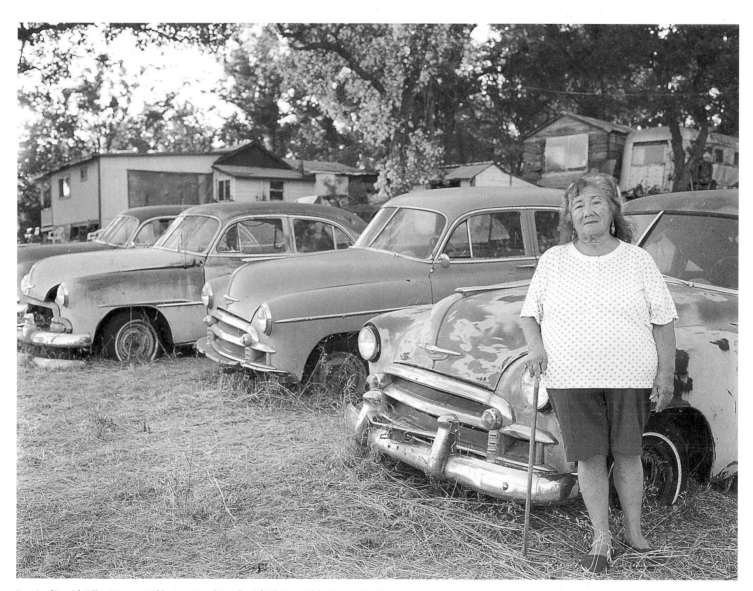

Bernice (Burris) Villa at Yangputi (the Ione Band Rancheria). *Photograph by Dugan Aguilar*

got fire, reflects the local features and inhabitants of the landscape faithfully.

How Tollelu Got Fire
for the Mountain People

Wekwek the falcon and Wipiaga the golden eagle were chiefs of the valley people. Among the members of their tribe were Molluk the condor, Hu'azu the buzzard, Huluuwi the dove, Wittabuh the robin, who was keeper of the fire, and Tiwaiyu the red-shafted flicker, who as anyone can see when looking at the bright red-orange under his wings and tail, must have been very close to the fire. There were also Hakiah the elk, Halluzu the antelope, Sakmumcha the cinnamon bear, and others.

The mountain people were in darkness and wanted fire but did not know where it was or how to get it. Ole'chu the coyote-man tried hard to find it but did not succeed. After a while Tollelu the white-footed mouse discovered the fire in the valley and the mountain people sent him to steal it.

Tollelu took his flute of elderberry wood and went down into the valley and found the big roundhouse of Wekwek and Wipiaga and began to play. The people liked the music and asked him to come inside. So he went in and played

Growing along the road that passes below the Buena Vista Peaks, one may find an abundance of *pasaali*, yerba santa *(Eriodictyon californicum)*. Its long, narrow, serrated leaves look as if they've been glazed on their upper surfaces. The resinous quality that creates this glaze contributes to the plant's medicinal value. Miwuk people gathered *pasaali* to be dried and later steeped as a tea for respiratory congestion, coughs, and colds. Indeed, some elders refer to it as "Indian cough syrup." Bernice Villa recalls being taught by her parents to pick the leaves and chew them, as a preventative measure, when she walked to school.

Chewing the fresh leaves causes a unique sensation. Folding a leaf several times, chewing it for a short while, and then leaving it to rest between cheek and gum, one notices increased salivation and, at first, a bitter taste. However, before long a sugar-sweet sensation brushes across the tongue. Elders have said this is an important quality of the plant and helps a person who is far from water keep the mouth moist and refreshed.[9] Indeed, *pasaali* is most commonly found in dry, rocky country. When one does come upon water, spitting out the remnants of the leaf and taking a drink, the water has a particularly sweet flavor, a treat enjoyed by generations of Miwuk people.

for them. Soon all the people felt sleepy. Wittabuh the robin was sure that Tollelu had come to steal the fire, so he spread himself over it and covered it all up in order to hide it, and it turned his breast red. But Tollelu kept on playing his flute, and in a little while all the people were sound asleep. Even Wittabuh could not keep awake.

Then Tollelu ran up to Wittabuh and cut a little hole in his wing and crawled through, stole the fire, and put it inside his flute. When he had done this he ran out with it and climbed up to the top of a high mountain called Uyumpelle [Mount Diablo] and made a great fire that lit up all the country till even the blue mountains far away in the east [Sierra Nevada] could be seen. Before this all the world was dark.

When Wekwek awoke he saw the fire on Uyumpelle and knew that Tollelu had stolen it. So he ran out and followed him, and after a while caught him. Tollelu said, "Look and see if I have the fire." Wekwek looked but could not find it, for it was inside the flute. Then Wekwek pitched Tollelu into the water and let him go.

Tollelu got out and went east into the mountains and carried the fire in his flute to the mountain people. Then he took it out of the flute and put it on the ground and covered it with leaves and pine needles and tied it up in a small bundle. Ole'chu the coyote smelled it and wanted to steal it. He came up and pushed it with his nose and was going to swallow it when it suddenly shot up into the sky and became the sun.

Ole'chu sent Liichichi the hummingbird, and another bird named Liichikutamah, who also had a long bill, after it. But they could not catch it and came back without it. The people took the fire that was left and put it into two trees, *uunu* the buckeye and *monoku* the incense cedar, where it still is and where it can be had by anyone who wants it.[10]

Fire in the mythic sense of this story is really not to be thought of as flaming fire, but rather the essence of the power of fire. Thus, Tollelu can carry it around in his flute and submerge it in water briefly without putting it out. Other local native myths of this genre use the sun to represent light and warmth. Merriam describes it in his introduction to *Dawn of the World:* ". . . a primordial heat and

light—giving substance indifferently called fire, sun, or morning—for in the early myths these were considered identical, or at least interconvertible."

Upusani and the Olivers

The Miwuk village of Upusani was located on the east end of Jackson Valley near the location of today's tiny settlement of Buena Vista, on the north side of the Buena Vista Peaks. There was a ceremonial roundhouse there of the old style: a large pit some forty feet in diameter excavated four feet below the surface of the ground, with an earth-covered roof.

A Miwuk woman named Susie Gainer who lived at the village of Upusani told a story, retold here by longtime local resident Pauline Ringer, about a rocky place that lies literally down the road from the little town of Buena Vista. Jackson Valley Road runs right through it.

> There was a tribe of Indians living on the Loughey ranch called the *see-tie-yah* tribe. Their roundhouse was in the Loughey field above the corner of Jackson Valley Road and Martin Lane. The queen of the *see-tie-yah* tribe was allowed to use the rocks while sunbathing and no one else came near during this time.
>
> There was a large sloping rock facing south. The road has been blasted through most of it, but some is still in place and is near Woolford Gate. This rock

Uunu, the buckeye *(Aesculus californica),* is common throughout the foothill region. Its branches are laden with fruit—globular balls, each encased in a pod—in the fall. The fruits were harvested by native people, leached, and boiled to make a porridge. The limbs of *monoku,* incense cedar *(Calocedrus decurrens),* were used for bows.
Angtayə, elderberry *(Sambucus californica),* was the source of flutes and clapperstick rattles.

Tiwwayə (or *Tiwaiyu*), the red shafted flicker *(Colaptes auratus):* The quills of this woodpecker were stripped of their feathering, except for the ends, and sewn together to make bands worn across the forehead as part of men's and women's dance regalia. The bright orange coloring of *tiwwayə's* quills was attributed to his standing too close to the fire when *Tollelu* came to steal fire.

Glenn Villa Sr. at *Natchatnə sowa,* the smashing rock, near Ione. *Photograph by Dugan Aguilar*

Patti Villa. *Photograph by Dugan Aguilar*

was called "sun bath rock" in the Indian language, but became known as *natcha-tu-yah [natchatnǝ sowa']*, meaning smashing rocks. This came about when soldiers came up from Mission San Jose and sorted out the healthy and vigorous Indians from the old and weak, and the babies.

The old were burned in the roundhouse. The babies were smashed on the large sloping rocks. One Indian lady, in fighting the soldiers over the babies, was killed and is buried on the hill above. The Indian wife of Governor Pico is said to be buried there.

The large standing rock is called *you-mu-mee*, or "windbreak." The knoll of rocks and the area above the road was called *weta-lee-hah*, or "resting place"; the Indians met and camped here in going through the valley to the rivers or mountains.[11]

Sometime before the turn of the century, Casus Oliver became the headman at Upusani. The story of Casus Oliver and his son Louie is a welcome reminder that the Spanish missions did not succeed in destroying native culture.

Casus was a refugee to the area. It appears that he was of Chilamne Yokuts heritage, from the lower Calaveras River, and his mother was among the hundreds of Yokuts and Miwuk people of the Sacramento and San Joaquin Valleys who were taken to Mission San Jose between 1811 and 1836. In 1903, C. Hart Merriam interviewed Casus Oliver at Upusani and noted:

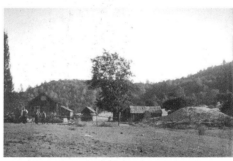

The village of Upusani, near Buena Vista, Amador County, September 1903. Casus Oliver is standing in front of the barn. *Courtesy of the Phoebe A. Hearst Museum of Anthropology and the Regents of the University of California — photographed by C. Hart Merriam, no. 1978.008 v/21l/P1 no. 4*

His mother was stolen by the Spaniards when young and taken to the mission at San Jose, where the old man [Casus Oliver] spent his early boyhood. His mother took him and escaped. She joined a village of Mokalunme [Mokelumne] Indians near where the town of Lockeford now stands, and there they lived many many years — by far the greater part of his life — until the white men took up all the land and the remaining Mokalumnes were driven away and scattered. Now the tribe is practically extinct. This happened about twenty years ago as near as the old man can remember. He then came up to Amador County and joined the Mu-wa (Miwuk) settlement of You-poo'-san-ne (Upusani), where he has since made his home."[12]

California's native population was reduced, according to some estimates, by as much as 90 percent in the first hundred years of contact with Europeans. Here, in addition to the calamity created by removal to the missions, the villages along the lower Mokelumne, Cosumnes, and Calaveras Rivers were devastated by an epidemic of an unknown variety in 1833. The largest number of baptisms of Miwuk from this area occurred in 1834, reflecting not a large birth rate, but the fact that many of the surviving Plains Miwuk and Chilamne Yokuts elected to stay at the mission and in the nearby Livermore Valley rather than return to their old country. It was in this area that Casus Oliver was likely born. His name was originally recorded as Jesús Alvarez. In later years it was anglicized to Casus Oliver.

Many of the residents of Upusani in Oliver's time were in fact immigrants from lowland villages, particularly the village of Lokolumne, located on Dry Creek downstream of Ione. Casus married Lizzie, a Lokolumne Miwuk, and later he married a Nisenan woman named Amanda, who lived near Gold Hill, in El Dorado County. Amanda was the sister of Jane Lewis and the daughter of Captain John Oitey [see Chapter 3].

During his visit to Upusani in 1903, Merriam encountered the generous hospitality that was characteristic of native leaders:

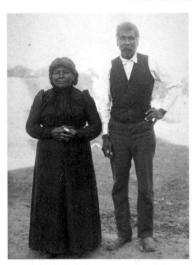

Casus Oliver and his wife, Amanda, at Upusani, September 1903. *Photo by C. Hart Merriam, courtesy of Bancroft Library, University of California, Berkeley, no. 1978.008 v/21l/P1 no. 6*

As I was here at noon they asked me and my driver to take dinner with them, which we did: hot, excellent biscuits, potatoes, eggs, pork, and tea, served on a table with clean white tablecloth and nice clean dishes, forks, and spoons."[13]

Sponsoring a "feed" was a traditional responsibility for a Miwuk captain, and one that Casus's son Louie maintained following his father's death in 1916. Several long tables were set out and groups of people would take turns eating. Elders remember Louie pacing back and forth behind the seated diners, repeatedly encouraging them to eat heartily by bellowing, *"ɘwwayʔpo! ʔwwayʔ po!"*[14]

These annual gatherings took place on Memorial Day and lasted into the late 1960s. Louie Oliver died in 1973. Today, though the roundhouse has long since collapsed and reverted to the earth, and the old hosts have passed on,

memories of sunny May afternoons, abundant servings of good food, and warm hospitality remain in the hearts and minds of many.

Rock Art

There are several pictograph (painted stone) and petroglyph (pecked stone) sites in the vicinity. While some petroglyphs might be found in the open, on the surface of a cliff wall or boulder, most "rock art" is located within rock shelters. The brick-red pigment used in pictographs is an iron oxide, readily found in this region in pebble form.

The original purpose and meaning of these pieces may be lost to time. Even their age is difficult to estimate. But perhaps more important than knowing their age or purpose is understanding that they represent an ancient presence; they are one of the few lasting "monuments" of the host civilization.

Standing within the shaded recesses of a cliff face in the cool, heavy air, one can only gaze at the painted patterns and wonder about a way of life, a way of seeing the world. What was it like to stand here a thousand years ago and look out, past the collage of buckeye and live oak branches, onto the countryside? What was the world like then? What did the people who made these paintings know about it? What is it that I don't know about it? At a place like this you can contemplate such things.

Unfortunately, such sites have suffered from vandalism over the years, with individuals writing their names or doing their own versions of "Indian" pictographs over the originals. If you happen to come across such a place, please avoid touching the painted areas with your hands or fingers, as skin oils may have a destructive effect on the pigments.

Neknekata

Just north of Upusani is Highway 88. Leaving Highway 49 for a while and traveling east on 88, the traveler comes to the town of Pine Grove and the road leading to Indian Grinding Rock State Park. If the window is down, the pungent

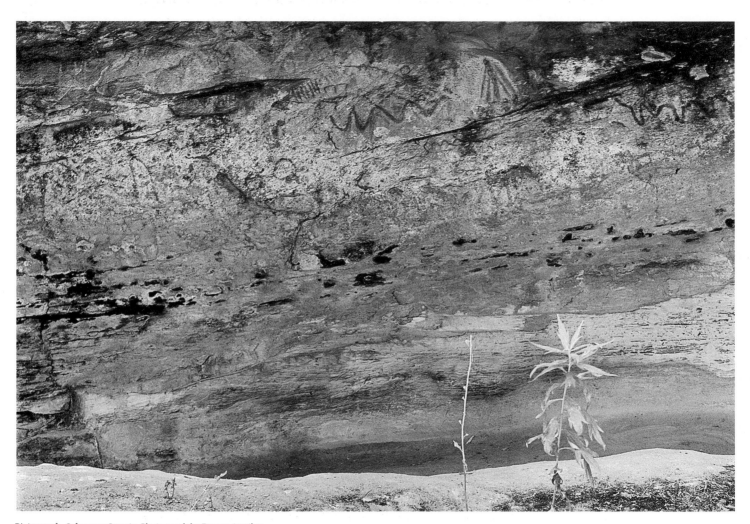

Pictograph, Calaveras County. *Photograph by Dugan Aguilar*

aroma of *kitkittiisə* (*Chamaebatia foliolosa*) will permeate the air, especially on a warm day. This ground cover is prevalent in the surrounding underbrush and along the roadside. Early California pioneers called it "mountain misery" because its dense tangle of fern-like fronds was so difficult to walk through. However, the sticky, resinous properties that caused such consternation may have resulted from the very compounds that made the plant so useful to native people. Among the Sierra Miwuk, the plant was steeped in hot water to make a tea for treating a variety of ailments in which skin eruptions were a symptom, including chicken pox, smallpox, and measles. It was also used to treat rheumatism.

Interestingly enough, this is one of the few plants native to California whose indigenous name has carried over into an English common name. A number of publications on western flora use the Miwuk term (often spelled "kit-kit-dizze") as the common name, along with mountain misery.

An impressive reminder of native tenure in the region can be seen at Indian Grinding Rock State Park, also known as Chaw'se (from the Northern Sierra Miwuk *choose'*). More than a thousand depressions of various sizes cover the expansive surface of bedrock for which the park is named. Here, as in countless other locations throughout the Sierra, native women pounded acorns, manzanita berries, and other foods, using heavy stone pestles.

Just as living aspects of the natural world found expression as mythic characters within Miwuk cosmology, so too did stone. A pestle may appear to be an unremarkable implement, but in this story from the village of Walle, near the canyon of the Mokelumne River, it is acknowledged for its essential contribution.

In the mountains among the rocks by the river lives Neknekata, the little rock girl. She is herself a rock. In some way she produces or gives off people. These people are hard like rocks and you cannot cut them or shoot them with an arrow.

A long time ago *əsəəmaṭi*, Grizzly Bear, and *hoyyako*, the First People, made the choose', or mortar holes, in the big, flat-topped surfaces of bedrock. Neknekata then came and helped make the *kawaachi*, or stone pestles, for the people

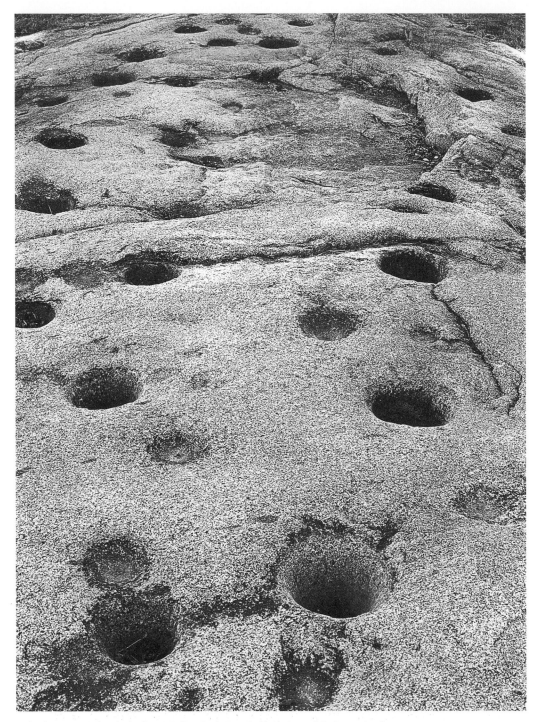

Bedrock mortar at Chaw'se (Indian Grinding Rock State Park). *Photograph by Dugan Aguilar*

to pound acorns with. That's how they got there. That's how they came to be.[15]

The *kawaachi* was an important personal possession, a woman's work partner. The weight, shape, and overall feel of the stone became familiar and predictable. Miwuk/Paiute elder Della Hern, who grew up in an era when pounding acorns in stone mortars was still fairly routine, recently recalled the value her family placed on pestles: "You took that home. That was one of your precious tools that you had. You always took care of that."

Traveling east on Highway 88 from Pine Grove and turning south on Highway 26, one crosses the north fork of the Mokelumne River before arriving at the small town of West Point. The historic Miwuk village of Kənəsəə was located just a mile to the east. Today the area hosts a strong and vital population of Miwuk people and has been one of the last strongholds of the ancient language. Ironically, the people here are not officially recognized as a tribe by the United States government.

Here, as the elevation rises, the blue oak gives way to black oak, and the bull pine to ponderosa and sugar pines. Merriam visited a village here in August 1903 and found residents busy harvesting sugar pine nuts, *sangakə*. Typically harvested in the late summer, the cones were roasted in a fire until the nuts came loose. The nuts were then shelled and the meats pounded into flour using a stone mortar and pestle. The flour was mixed with water and boiled in a basket to make a rich soup. Merriam made the following observations:

The main camp at West Point is on a brushy slope a mile east of town and at an altitude of three thousand feet. It is in smoke brush and chaparral, along the lower edge of the ponderosa pine forest. The place commands an extensive view to the west. It now consists of the usual polygonal ceremonial house (with low conical roof of split shakes), a house or two of similar type but smaller and more nearly rectangular, and a couple of ordinary rough brush shelters. Besides these are a couple of rough brush shelters in which some of the old people are now [in summer] living.

The people I saw here are an old man, two old women (one of whom is nearly blind), a middle-aged woman, a boy of perhaps sixteen, and a girl child about four. The others are away at work. There were some last-year's acorns left here and a few baskets of acorn mush. There were also quantities of recently gathered manzanita berries — for food and making cider. The old blind woman was pound-

ing up manzanita berries in a small, round portable mortar.

The Indians say their people did not make them [the mortars] but found them in the ground. I watched an old woman here pound sugar pine nuts in one of them."[16]

Merriam's observations reveal a significant, continuing effort by at least some of the village residents to use traditional food more than fifty years after the gold rush. At a time when many Miwuk men and women found work on local ranches and lumber operations, thus earning money to buy food, their preference for, and perhaps reliance on, native food resources to supplement their diet is noteworthy.

Pedro O'Connor

Just seven miles south of West Point, beyond the middle and south forks of the Mokelumne River, is the settlement of Railroad Flat. The historic Miwuk village of Hechenə was located very near here. One of its residents was Pedro O'Connor, a Northern Miwuk man renowned as a ceremonial dancer and instructor, and as a doctor. Pedro lived at Hechenə with his wife, Mattie Jim, from approximately 1900 through 1924.[17]

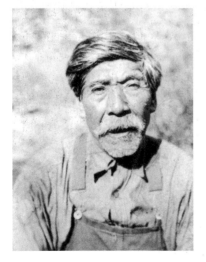

Pedro O'Connor, c.1920.
Photo courtesy of Jennifer Bates

U.S. census records listing Pedro's place of birth conflict: El Dorado is mentioned in the 1910 census, while the 1920 census indicates Fiddletown as his place of birth. His father, known as Hotchəng[18] or Ho-tchai-yah-guh, apparently hailed from Calaveras County.[19]

Sometime before 1930, Pedro married his second wife, Lily Wilson (Hukaya), born in Volcano in 1876. The couple moved to a small flat of land at Big Bar, located a short distance upstream from the Highway 49 crossing of the Mokelumne River, between Jackson and Mokelumne Hill. There, in addition to their small cabin, Pedro constructed his own roundhouse, or *hangi*.[20]

During his life Pedro found employment as a laborer at a sawmill, and as a wood chopper. Lily worked as a domestic and may have made traditional Miwuk baskets for sale to supplement their

income. However, Pedro's real career took place within the context of Miwuk social and ceremonial life. Traditional Sierra Miwuk society recognized a number of formal ceremonial positions, including the *sobobbe* (head dancer or dance leader), *mulikbe* (head singer), and *tumukbe* (foot drummer). Pedro held the position of *sobobbe* at Hechenə and at West Point. The *sobobbe* taught young men how to dance and informed them about food restrictions, such as not eating certain foods until a ceremonial dinner had been held, that they must observe as part of a dancer's life.

To be a *sobobbe* required extensive knowledge of the dance tradition, its history, song repertoire, ceremonial procedures, and purpose. Some of the old dances Pedro was known to have led are the *tula*, *hiweyi*, *luhuyi*, and *sulesko*.

The *sobobbe* wore black streaks of charcoal on each cheek, and stripes encircled his legs below each knee. A photograph of Pedro and Lily shows both wearing ceremonial headbands, *temmakəla* made from the feather quills of the red shafted flicker, *tiwwayə*. The quills were stripped of all their feathering except at the tips and then sewn together.

The *mulikbe* often had several assistant singers, although he generally sang solo during the dance. He used a rattle, *ṭakaṭṭa*, made from the slender limb of elderberry, *angtayə*, to keep time for himself and the dancers. Miwuk singers still use this traditional instrument. The limb is split lengthwise nearly to the end, until it is weak enough to rattle against itself when shaken lightly, although it is generally slapped against the singer's palm. The spongy pith is removed from the core, providing a hollow chamber that enhances the tone of the rattle. Flutes were also made from elderberry limbs. The drummer, *tumukbe*, kept time to the song by dancing or stomping on a wooden plank made from a hollowed tree trunk. It lay over a pit in the rear of the *hangi* and produced a low, muffled boom when struck.

Pedro O'Connor's career as a ceremonialist took him to a great many places throughout Sierra Miwuk country, including dances at Ione, Murphys, Tuol-

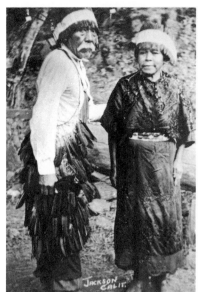

Pedro and Lily O'Connor, c.1935. In this photograph Pedro wears several items of Miwuk ceremonial dance regalia, including a forehead band of flicker quills called *temakkla*; a pair of forked hair pins, *chalila*; and a waist cape of feathers called *metikkila*. *Photo courtesy of Jennifer Bates*

Temmakəla, flicker quill headbands, collected at West Point, 1906. *Courtesy of the Phoebe A. Hearst Museum of Anthropology and the Regents of the University of California—photographed by C. Hart Merriam*

umne, and quite possibly other Miwuk communities with roundhouses, such as Six Mile (Kosoinumonu), Bald Rock (Hung'ah), Buena Vista (Upusani), and Jamestown (Chakachino).

In 1924 Pedro danced at the "Burning of the Digger" in Jackson Valley. This public event was attended by a large number of Indian and non-Indian people and received considerable coverage in local newspapers. The purpose of the event was to formally put an end to the use of the derogatory term "digger" as a reference to local native people. "Miwuk" was suggested to the public as a more appropriate term.

Miwuk elders interviewed in the 1980s recalled that Pedro was a very good handgame player, difficult to guess when he held the bones. His reputation as a doctor is well established. He often helped people with their illnesses by using roots, leaves, and flowers that had medicinal properties. Elders recall that Pedro carried a small cloth bag that contained dried herbs from which he made teas to relieve headache, sore throat, stomachache, or coughs. In addition, he apparently practiced as a "sucking doctor," a line of doctoring acknowledged within Miwuk tradition as very strong, requiring spirit helpers.

Frank Villa remembered an incident that took place during his youth, on a bus trip from Ione to the annual jumping frog competition in Angels Camp. Apparently Frank had eaten a number of cherry plums and developed severe stomach cramps—"doubled over," as he recalled—and was unable to sit up. Pedro, also a passenger on the bus, ordered everyone off except young Frank.

One of the botanicals Pedro O'Connor likely used is *kichinga*, wormwood *(Artemisia douglasiana)*. Found along most foothill streams, wormwood was sometimes dried and steeped for use as a tea in treating rheumatism. Small folded bundles of wormwood were tied onto a string and worn as a necklace to prevent dreaming of the recently deceased. Such a necklace, *poko*, was worn following the death of a close relative, as a sign of mourning, for several months or until it broke in two.

The hairpins Pedro O'Connor wore as part of his ceremonial dance regalia were often made from the forked branches of *limme'*, chamise *(Adenostoma fasciculatum)*. Evenly sized forks are readily found on this bush. *Limme'* was also an important source of arrow foreshafts for the Miwuk. A six- to eight-inch piece of the straight hardwood was inserted into the hollow shaft of the main arrow. This foreshaft could be either fitted with a stone point or merely shaped to a sharp point.

Wormwood

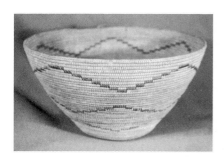

Cooking basket by Rose George, collected in 1902. Made from split maple shoots and bracken fern roots over a three-rod foundation of whole shoots. *Courtesy of the Phoebe A. Hearst Museum of Anthropology and the Regents of the University of California, no. 1-10058*

Working on his patient in the back of the bus, he placed his mouth over Frank's stomach and sucked the pain from him. Pedro then coughed up the sickness he had taken in. Frank recalled feeling better almost immediately.[21]

Pedro always kept himself in fine physical condition, which enabled him to endure long periods of rigorous dancing, often over a period of four days and nights. One story relates how Pedro killed a deer by sneaking up and leaping on its back, killing it with his knife. He is said to have ridden in a horse race at the Ione picnic when he was close to seventy years old—and won. At about this same time in his life he was also credited with capturing an escapee from the Preston School of Industry, a correctional institution in Ione.[22]

Pedro and Lily lived out their lives in their small cabin at Big Bar. Lily died on March 2, 1941, of double pneumonia at the age of sixty-five. She was buried in Jackson. Less than a year later, on January 5, Pedro was found dead in his cabin, apparently from influenza. He was seventy-eight.

Nearly forty years earlier, in October 1906, Pedro's father (also known as Pedro) had been called upon to lead the second phase of a mourning ceremony, or "cry," at Hecheneꝑ. The ceremony was witnessed by C. Hart Merriam, who noted, "Since the old chief was too ill to take part, his place was taken by a local chief, Pedro, who at half-past five (a.m.) addressed the mourners in the roundhouse. He finished sometime before daylight, after which there was an interval of silence."[23] Delivering speeches was one of the responsibilities involved in leading a mourning ceremony. The words of the speaker encouraged mourners to let their emotions be free: "We shall never see them again, do not be ashamed to cry. No one will laugh at you. No one will talk about you."[24]

Pedro—like so many of the old people—appears to have been a person of great vigor. Memories of Pedro dancing in the roundhouse at Jackson Valley in the late 1920s were still vivid to elders more than fifty years later. "He was a tough dancer," recalled Frank Villa,

The ceremonial roundhouse, *hangi*, at the village of Hecheneꝑ near Railroad Flat, Calaveras County, October 1906. According to federal records (Bureau of Indian Affairs Application for Enrollment, 1929), there were still ten people living at Hecheneꝑ in 1929. However, the village was likely abandoned by 1940. *Photo courtesy of Phoebe A. Hearst Museum of Anthropology and the Regents of the University of California, no. 15-2750*

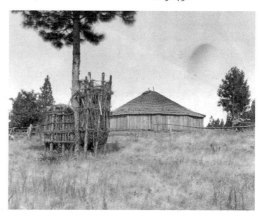

Jennifer Bates, stone-boiling acorn soup *[nəppa]* in a basket. Jennifer's grandmother and great-great-grandmother were among the last residents of Hechenə, residing at the village as late as 1924. In 1902, at Hechenə, anthropologist Samuel A. Barrett collected baskets made by Jennifer's great-great-grandmother Mattie Jim and great-grandmother Rose George which are now in the collections of the University of California's Phoebe Hearst Museum of Anthropology.
Photograph by Dugan Aguilar

"light on his feet." Looking out Frank's window toward the deep, open pit—the remains of the roundhouse—I could picture him as a young boy sitting on pine-needle bedding somewhere in the recesses of the small, stone-walled *hangi*. The genuine look of excitement in Frank's eyes and the tone of his voice said to me, "Oh, if you could only have seen it."

Frank continued to try to paint a picture for me of how Pedro, crouching low to dance the *tula* with its quick, shuffling, hopping movements, appeared to hover over the earthen floor . . . as he glided around its surface, the fitful waver of the fire created deep shadows in the generous lines of his face, illuminating the sweat erupting over his dark, sinewy body like shiny beads of silver flashing in the light. I thought how this image of Pedro must have played through Frank's memory over and over again, dreamlike, through the years. Frank leaned back into his sofa, grinning widely and faintly shaking his head. Today, we are left to wonder about Pedro's magic on the dance floor. There is no film, no videotape of his mastery; only the briefest glimpse, through the memories of people like Frank Villa, has been left to stimulate our imagination.

Manuel Jeff

For some native Californians, surviving oral narratives reach back even farther than Frank Villa's memories of Pedro O'Connor; they reach back to the experiences of ancestors before the arrival of Europeans. Manuel Jeff, born in 1906, was one of those rare individuals who carried a story from that era into the present age. The event he recounts here, in which his great-great-grandfather participated, may well have occurred at a time before California became a state or Calaveras a county. It was a different world.

At the close of the twentieth century, Manuel Jeff was one of the rarest people on earth: he was a fluent speaker of the Northern Sierra Miwuk language. The twentieth century witnessed the extinction of more than half of California's one hundred or so native languages. With few exceptions, only a handful of elders can speak any of the remaining languages. Their passing involves more than the disappearance of words. Lost are the unique perspectives of a human society, windows to a world most of us will never know, remarkable

Manuel Jeff. *Photograph by Dugan Aguilar*

insight that is borne of intimate relationships with the land—this land—and reflects a daily life we can now barely imagine. But whenever Manuel Jeff spoke his language, the old Miwuk world flickered with life. The sound—the characteristic intonations, unique rhythms, unfamiliar vowels—floated out across the room for anyone to hear. It was like some ancient wind gently brushing over you as it passed.

Manuel Jeff was born near Murphys, in Calaveras County. His father, John Jeff, was from the West Point area. Renowned as a ceremonial singer and dance leader, John Jeff had been trained by Pedro O'Connor. Manuel Jeff's mother, Tillie, was from the Quartz Hill vicinity near Murphys.[25] Manuel Jeff spent much of his childhood at the village of Kosoimuno'nə, also known as Six Mile Rancheria; the Jeff family lived at this now abandoned site near Vallecito until 1927.

In the days of Manuel Jeff's great-great-grandfather, there were always consequences associated with traveling. Aside from the obvious physical dangers —falling from a high place, drowning while crossing a river, being bitten by a rattlesnake or attacked by a grizzly bear—there were dangers associated with certain areas known to be frequented by supernatural beings who could either kill people outright or cause them to be sick. Besides that, when traveling outside the defined parameters of his world, a person might also encounter strangers. While there were often alliances and peaceful relations between neighboring communities, there was a certain tension associated with traveling into another's country. Sometimes there was conflict.

I was thinkin' about old timers . . . Indians. Wars, Indian wars. When they [would] fight each other, kill each other. California [Miwuk] Indians and Washoes and Paiutes. Paiutes up there, they used to have California Indians for enemy.

Some Paiutes was camping down the river. They were havin' a lot of fun talkin' about California [Miwuk] Indians. Then Father Lord put into my great-great-grandpa's mind they were coming over to kill 'em. That's what come into my great-great-grandpa's mind. Father Lord put it in his mind, told him about it.

So he told his old wife he'd have to go down and kill a few of those Paiutes. "They're coming to kill us," he told his old wife. Then his old wife started crying; she didn't want him to go down there all alone. He was mad, he went down anyway.

Got a little stick and put a hot coal in there, put it under his arm. Them days, years ago, they didn't have no coat, no nothing. They used to be bare naked in the wintertime. It was cold, but they used to stand it. Just the women use little diaper out of tanned hide, deer hide. They made little diapers out of that. Then some of the young fellas too, that's all the clothes they used to have.

So my great-great-grandfather went down there, sneak up to them guys. He seen that they had a bonfire. Them guys were right around there talkin' about us. Laughing. My great-great-grandfather sneak up to them. Then he got close enough to recognize the one's his enemies. Then he had that bow and arrow.

Then he shot 'em with a bow and arrow, one of 'em. Killed him dead. Then the other one gettin' ready with his bow and arrow. All of 'em were. Then he recognized another one and he got him too. Then after that, them guys, they recognize which way that arrow come from. They was going up there. Then he run back up the hill, come back up here. Used to been a roundhouse right over here where Virginia's house is.

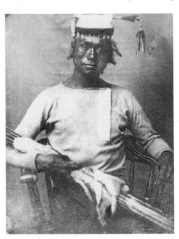

Unidentified man with arrows, c.1851. This ambrotype, rescued from a dump in Southern California in the 1960s, may be the oldest known photographic image of a native Californian. It provides an extremely rare view of a culture experiencing the initial effects of what would be a tidal wave of change, yet still in possession of some purely traditional accouterments, symbols, and values. Most researchers believe his tribal affiliation to be Nisenan or Plains Miwuk.

On his lap rests an open-ended, fox-skin quiver turned inside out, so the fur is on the inside. It is amply supplied with arrows, their foreshafts and points extending across his elbow. They would be nearly identical to the quiver and arrows Manuel's great-great-grandfather used. *Photo courtesy of Southwest Museum*

Shoots from the spice bush, *soksokotu (Calycanthus occidentalis),* were a favored material for arrow shafts. *Soksokotu* is most commonly found growing in shady areas near streams throughout the foothills and mountains. The pith was reamed near the point end, to which a short foreshaft of hardwood, such as chamise, was fitted. Regular pruning stimulated the growth of straight shoots.

Arrow shafts and bows were finish-sanded using a handful of the rough-edged horsetail rush *(Equisetum arvense)*. It has also been suggested that this rush may have been used to produce the peculiar ribbing found in the upper area of a few surviving arrows, where the fletching is found. Horsetail rush prefers sandy soil and is often found growing alongside streams.

Horsetail rush

Then he told the rest of 'em, he said, "I killed two of them enemies. They was talkin' about comin' over here and kill us. But they're going away. They're gathering up their things."

They never come over here. They must have went home. Up to their home, up the mountain. That's it."[26]

A Room with a View

From his office window on the fourteenth floor of the Water Resources building in downtown Sacramento, Dwight Dutschke has a panoramic, bird's eye view of the Sacramento Valley. Looking to the east, he can see the Sierra foothills—the small, rising convolutions in the landscape that mark the beginning of his homeland from this vantage point. He cannot see the long-abandoned villages from his window, but he knows they are out there. Adjusting his focus to the foreground, he sees a jumble of angular shapes within grids of black pavement—downtown buildings and streets. But he can reflect on his people's history here, too, by looking down, literally, onto Sutter's Fort.

My great-grandmother Sarah [Miller] and her family were from the Pigeon Creek area, around Fiddletown. Her grandfather Peter was taken to Sutter's Fort. He was fed in the troughs and was required to work, but more importantly, he was away from his family. He had a family that was living up here in the foothills, and he was taken away to work at the fort. As soon as he was able to leave, he did, he escaped. I was told that he associated white people with shoes, and so when he finally escaped, he basically never wore shoes again. He associated wearing shoes with being at the fort.

Dwight Dutschke is the Native American coordinator of the California Register of Historical Places, part of the California Department of Parks and Recreation's Office of Historic Preservation. He lives on his family's property near Ione, commuting to his job in Sacramento. Living within a landscape of such considerable cultural and historic depth has played a big part in forming his identity.

Dwight Dutschke. *Photograph by Dugan Aguilar*

I work in historic preservation, and most people think of historic preservation as a hundred years, or even two hundred years. To us, that's just really talking about the infancy of things. There are all these places where people used to live, at Popcorn Hill, at Middle Bar, or like down here at Smokey Corners where *sulesko*, a ghost, dwelled . . . and all these places are not only locations of current activities, but they represent most of your cultural history. I think it's the reason it continues to be important, for me, to live here. Part of maintaining an identity, as far as a group is concerned, is being able to have that interaction.

Glenn [Villa] and I were talking recently about being kids, visiting over there at Tuolumne, or being kids over at Oliver's, and just the kinds of things that we did. And those shared experiences make up as much of an identity to us as almost anything else that we could do. I think that's what was so disruptive about the gold rush, because it made that real difficult to occur. And even subsequent to that. I have a hard time imagining, looking around at the Indian population now, what it would be like if half of them would be dead within a few years. What would that be like, as far as trying to maintain who we are? And then, within twenty years from now, three-quarters of them being dead: how would that change us?

Notes

1. C. Hart Merriam, "Distribution and Classification of the Mewan Stock of California" (*American Anthropologist* vol. 9, no. 2, 1907), 338-357

2. *2004 Field Directory of the California Indian Community*, Department of Housing and Community Development, State of California

3. Catherine Callaghan, *Plains Miwuk Dictionary* (Berkeley: University of California Publications in Linguistics, vol. 105, 1984)

4. Catherine Callaghan, *Northern Sierra Miwok Dictionary* (Berkeley: University of California Publications in Linguistics, vol. 110, 1987)

5. C. Hart Merriam, Journals [California] of C. Hart Merriam, 1898–1938, vol. 4 (Manuscript Division, Library of Congress, Washington, D.C.), 324

6. Edward W. Gifford, Northern and Central [Sierra] Field Notes (Manuscript No. 203, University Archives, Bancroft Library, University of California, Berkeley, 1917)

7. C. Hart Merriam, *Dawn of the World: Myths and Weird Tales Told by the Mewan Indians of California* (Cleveland: Arthur H. Clarke, 1910)

8. Frank Villa Sr., personal communication, 1972–1986

9. Nicholas Villa Sr., personal communication, 1972–1994

10. Merriam, *Dawn of the World*

11. Pauline Ringer, undated handwritten letter, Amador County Historical Society, Jackson, Calif.

12. C. Hart Merriam, Journals, 321

13. Ibid., 325

14. Nicholas Villa Sr., personal communication

15. Merriam, *Dawn of the World*

16. Merriam, Journals, 292–294

17. Craig Bates, personal communication

18. James Gary Maniery and Dwight Dutschke, "The Northern Miwok at Big Bar: A Glimpse into the Lives of Pedro and Lily O'Connor," *The Californians*, July/August, 1992

19. California Indian Enrollment Applications, 1928 (National Archives, United States Dept. of the Interior)

20. Maniery and Dutschke, "The Northern Miwuk at Big Bar"

21. Frank Villa, personal communication

22. Nicholas Villa Sr., personal communication

23. C. Hart Merriam, *Studies of California Indians* (Berkeley: University of California Press, 1962), 55

24. Edward W. Gifford, *Central Miwok Ceremonies*, Anthropological Records, vol. 14, no. 4 (Berkeley: University of California Press, 1955), 314

25. James Gary Maniery, "Six Mile and Murphys Rancherias: A Study of Two Central Sierra Miwok Village Sites," San Diego Museum Papers, no. 22 (San Diego: San Diego Museum of Man, 1987)

26. Manuel Jeff told this story in an interview with Suzanne Wash, June 26, 1994, West Point, California.

Five
Angels Camp to Coulterville

The canyon of the Stanislaus River marks another change in indigenous language. Linguists classified the language of this region as Central Sierra Miwuk, and though it is closely related to the speech and dialects of the Amador-Calaveras area, there are some fairly significant differences. The black-tailed deer was still known here as *'əwəəya*, and valley quail remained *hekkeke*, but pine needles changed from *cheeke'* to *hoose'*, and *'upuksu* (ground squirrel) became *ṭichaasə*.

The language has changed, but the ecology of this region is much like that of the Northern Sierra Miwuk. Oak woodlands and two major rivers—the Stanislaus and the Tuolumne—course through the foothills toward the great valley in this water-rich part of California shape the landscape. Traveling down Highway 49 and taking a few side trips onto other roads, we will pass within a stone's throw of one former community in which the full complexity of Miwuk social structure was once revealed in a grand display of ceremonial and artistic genius. The late afternoon sun may be obscured from view by a long volcanic mesa that holds the form of an ominous figure from mythic times. And, through the words of an old man, we will glimpse the extraordinary mind of a ceremonialist of the old world.

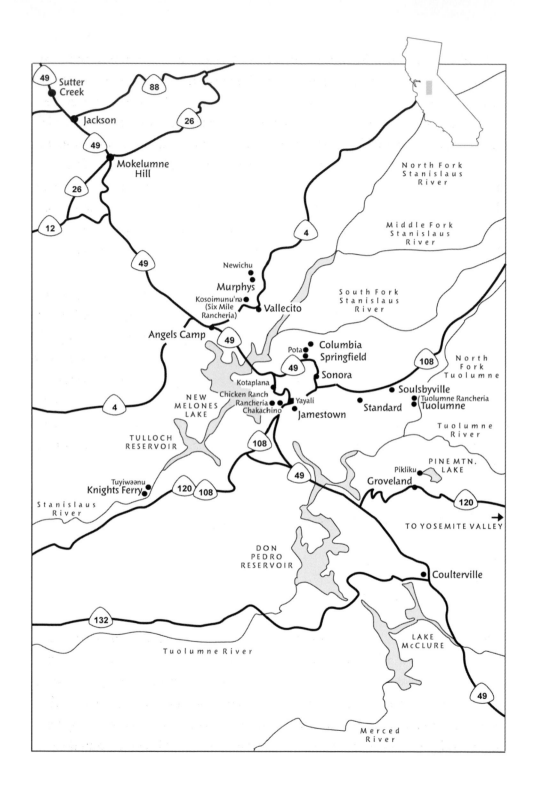

49 Sutter Creek

88

Jackson

26

49

Mokelumne Hill

26

12

49

4

North Fork Stanislaus River

Middle Fork Stanislaus River

Newichu

Murphys

South Fork Stanislaus River

Kosoimunu'nə (Six Mile Rancheria)

Vallecito

Angels Camp

49

Pota

Columbia

Springfield

108

North Fork Tuolumne

49

Sonora

Soulsbyville

Kotaplana

Tuolumne Rancheria

Chicken Ranch Rancheria

Yayali

Standard

Tuolumne

Chakachino

Jamestown

Tuolumne River

NEW MELONES LAKE

4

TULLOCH RESERVOIR

108

PINE MTN. LAKE

Pikliku

49

Groveland

Tuyiwəənu

Knights Ferry

120

108

120

Stanislaus River

TO YOSEMITE VALLEY

DON PEDRO RESERVOIR

Coulterville

132

LAKE McCLURE

Tuolumne River

49

Merced River

Traditional Miwuk life was organized into a particularly profound and complex social system, a way of living that for the most part no longer exists. Based on a concept known in anthropological terms as the "moiety," this system reflects the order of things in the world and provides a window through which we can view the interrelationships of human beings with their environment. Fortunately, anthropologist Edward W. Gifford recorded many of the details of this system among the Miwuk. Naming traditions that refer to moieties give us a hint of life within a society based on centuries of observation and interaction with the natural world. The essay below by folklorist and ethnomusicologist David Roche defines moieties and explores Miwuk naming traditions within that system.

Sadly, when Gifford was conducting his fieldwork in 1913 through 1915, the impact of the gold rush and its aftermath was obvious: as villages were broken up or displaced, native values and traditions discouraged, and individuals gradually assimilated into the American cultural mainstream, the social system of the moiety had begun to decline. The radical drop in population also made it increasingly difficult for marriageable Miwuk men and women to find an appropriate partner from the opposite moiety. Today the system is largely defunct, although some families have retained knowledge of their moiety affiliation.

What's in a name? *by David Roche*

I think the loss of the moiety system is about the worse thing that ever happened to us.
Glenn Villa (Northern Miwuk), 1999

Perhaps nothing better illuminates the intimate, personal relationship that native people had with the land than the naming traditions of the Sierra Miwuk. Miwuk personal names are associated with a social-familial organizational system known, in anthropological terms, as the moiety. The moiety is similar to a clan, in that it links individuals to a line of descent, in this case through the father's side. However, unlike most clan systems, the Miwuk system divides

Land and Water Affiliations

Following is a list of land and water affiliations recorded by E. W. Gifford during fieldwork among the Central Sierra Miwuk. We might consider this a partial list, based on the memory of individuals interviewed in the early twentieth century. It's quite possible that many more plants and animals were included in the system during earlier times. *Kikkəy'a,* the Miwuk term for the water moiety, is based on the word for water, *kikkə.* The etymology of the word for the land moiety, *tunuka,* is unknown; it does not coincide with other Miwuk terms for earth, dirt, or ground, which usually have the word *walli* as their root.

Tunuka (Land Moiety)

acorns
farewell-to-spring
Indian potato
manzanita berries
bull pine nuts
sugar pine nuts
sugar pine sugar
salmon berry
salt
tobacco
tule
vine
arrows
bow
quiver
hairpins

pota ceremony pole
clear weather
red cloud
dawn
sun
sky
stars
fire
badger
bald eagle
bear
blue jay
condor
creeper (bird)
dog
falcon

fox
goldfinch
hawk
horned owl
jackrabbit
lizard
magpie
raccoon
raven
red-shafted flicker
tree squirrel
wildcat
woodpecker
yellow jacket

Kikkəy'a (Water Moiety)

buckeye nuts
cedar
elderberry
jimson weed
oak leaf gall
white oak
wild cabbage
wild pea (vetch)
rocks
ice
fog
clouds
rainy weather
lightning
north
lake
abalone shell
olivella shell beads

feather cape
football
mountain lion
minnow
quail
salmon
swan
water snake
ant
bluebird
bumblebee
burrowing owl
butterfly
buzzard
caterpillar
cocoons
coyote
crane

deer
dove
eel
frog
goose
jacksnipe
hummingbird
katydid
kingbird
kingfisher
killdeer
meadowlark
otter
salamander
snail (fresh water)
turtle
white fish (sucker)

the natural world and its elements into two parts. In the Miwuk view, the natural world is brought together by the action of two phenomena: land and water. These two elements are symbolic of the two moieties, and they give them their names: *tunuka* (the land moiety) and *kikkəy'a* (the water moiety).

Miwuk personal names, being based on the moiety system, reflect a world where life is prismatic and every facet illuminates the idea that the human individual is part of a larger world. In traditional Miwuk times, children's names were connected to plants, animals, or other natural phenomena that belonged to their father's moiety. This precise system of classification reflects not only complex social understanding but complex poetics as well. Although they express human activity and movement, Miwuk personal names do not make their central reference to humans, but rather to animals, birds, plants, water, or weather. Names nearly always represent action, being based on verbs rather than nouns, and the true meaning of a name is implied rather than literal.

A good example is the name *Kuyunu,* associated with "dog" of the land moiety. This name had the connotation of "dog wagging its tail." It is derived from the verb *kuyaage',* "to whistle." The implied meaning appears to be that the whistling of a man caused the dog to wag its tail; instead of naming the child after the action of the dog, the name comes from the cause of the dog's action.[1] The Miwuk word for bear, *'əsəəmati,* does not appear in any of the sixty-four names for which the association is "bear," and no two associations are alike.

Miwuk personal names were astoundingly specific and evocative, bringing to mind sounds, sights, and tactile images. They were based on acute and thorough observation of the natural world: the subtle perception of the way a bear bends its foot while walking; the knowledge that doves act as decoys by feigning injury; the image of a bear scattering unwanted intestines from its prey as it eats. Following is a short list of names that reflect images well known to people of a hunting and gathering society. Many are hard to fully grasp, since we lack knowledge of their associations and roles within Miwuk mythic tradition (*m* and *f* specify male or female name).

Land Moiety[2]

PERSONAL NAME	IMPLIED MEANING
la'uyu (m)	Mashed farewell-to-spring seeds adhering to lips when eating
situtuyu (m)	Running hand down a branch over a basket and collecting berries that way
tukeye (f)	Pine cones dropping and making dust
he'uluye (f)	Bow, arrows, and quiver being placed against a tree while hunter rests
hatawa (m)	Bear breaking the bones of a person or animal using its foot to press down.
siwili (m)	Long tail of fox dragging on the ground
tiponya (m)	Great horned owl sticking head under its body and poking egg when hatching
pilitcyano m)	Jackrabbit putting ears back when lying down
kono (m)	Tree squirrel biting through the middle of a pine nut
momosu (m)	Yellow jackets piled up in nest in winter
pele'me (m)	Coyote with head down passing a person

Water Moiety

iskemu (m)	Water running gently when creek dries
yanapaiyak (m)	Little clouds passing by the sun and making small shadows
taipa (m)	Valley quail spreading its wings as it alights
moitoiye (f)	Valley quail's topknot bobbing as bird walks
tunaa (m)	Salmon's intestines pulling out like a string
liptcu (m)	Dropping of eggs of female salmon when it is lifted up
pusui (m)	Buzzard putting rattlesnake to sleep by circling over it
tənə (m)	Deer thinking about going to eat wild onions
tcatipə (f)	Deer's antlers hitting brush when deer is running
hokoiyu (m)	Falcon hiding extra food

For a boy or girl, receiving a personal name was the moment of individuation; within some Native American cultures, a person was not considered fully

human until he or she had received a name. The moiety also comes into play within certain performance contexts, several of which are connected to major stages of life: birth, puberty, marriage, and death. Traditionally, the moiety opposite the family of the deceased performs many of the funeral rituals, including the important ceremonial washing of the dead person's family members and other mourning relatives who are associated with the same moiety. In the *ahana* dance, two dancers from opposite moieties perform, while members of opposite moieties give each other gifts.[3] It is the unity of opposites in nature that is important. Through performance, the system reinforces an individual's identity and sends important signals that publicly announce one's membership in a moiety.

The reason for placing particular plants, animals, or other naturally occurring phenomena in one moiety or the other is often far from obvious, likely hidden deep within oral tradition. The anthropologist Edward W. Gifford, when questioning one of his Miwuk informants as to why Quail was placed within the water moiety, was told it was so because a turtle ancestor had once turned into a quail, a reference to a myth about a kind of evolutionary transformation or metamorphosis.[4] Similar tales of animal transformation can be found throughout the world. Stories of wolves turning into whales can be found farther up the Pacific coast, at Neah Bay, Washington, told by Makah elders. The discovery of whales with vestigial leg bones confirms that some sea mammals indeed walked on the land in the past. Some ancient knowledge whose connections have been lost can be assumed to exist at the core of a moiety system whose natural logic now eludes us.

Miwuk moieties reflect a culture based on bloodlines flowing from the natural world. An individual's lineage, his or her fundamental identity, is rooted in the flora, fauna, and phenomena of the earth. This is the exact opposite of alienation; as a system of classification, the moiety provides a remarkably natural psychological grounding for the individual and for the community. It is all about finding security in the world of the animate. It's not an abstract mental construction, but rather a system connected to the tangible world, totally understandable to the individual. It's a world of personal experience, of phenomena lived every day. You can touch and be touched by it all, and know where you fit into it. What kind of comfort must this be?

Names Associated with Bear

Some Miwuk personal names from the land moiety,
associated with bear (*m* represents male, *f* female)

akaino Bear holding its head up (m)

anawuye Stretching bear's hide to dry (m)

elki Bear hanging intestines of people on top of rocks or bushes (m)

engeto Bear bending its foot in a particular manner while walking (m)

esege Bear showing its teeth when cross (f)

etuməye Bear climbing a hill (f)

etumu Bear warming itself in the sun (m)

haiyepuku Bear becoming angry suddenly (m)

hateya Bear making tracks in the dust (f)

hausə Bear yawning as it awakes (m)

hehemuye Bear out of breath from running (f)

heltu Bear barely hitting people as it reaches for them (m)

hoiyitcalu Bear becoming angry (m)

hulwema Dead grizzly bear killed by a hunter (f)

katcuktcume Bear lying down with paws folded, doing nothing (m)

kulmuye Bear eating young leaves just sprouting (f)

kutattca Bear scattering (unwanted) intestines of a person as it eats him (m)

kutcuyak Bear with nice hair (m)

laapisak Bear walking on one place making ground hard (f)

liktuye Bear licking something it has killed (f)

lilepu Bear going over a man hiding between rocks (m)

luituye Bear crippled from being shot (f)

lusela Bear swinging its foot while licking it (f)

luyunu Bear taking off leg or arm of person when eating him (from *luyani,* to shake head sideways) (m)

mo'emu Bears sitting down looking at each other (m)

molimo Bear going into shade of trees (m)

notaku Growling of bear as someone passes (m)

peeluyak Bear flapping its ears while sitting down (m)

putsume Bear sitting on top of a big rock with soles of feet turned forward, legs spread (m)

sapata Bear dancing with forefeet around trunk of a tree (f)

semeke Bear lying down looking at ground (f)

semuki Bear looking cross when in its den (m)

sewati The curving of a bear's claw (f)

solasu Bear taking bark off tree (m)

songeyu Bear walking with its short tail hanging down (m)

sutuluye Bear making noise climbing up a tree (f)

talatu Bear walking around a tree, its steps close together (m)

tcukululuye Bear making so much noise when walking that it frightens other creatures (f)

tcumela Bears dancing in the hills (f)

tcumutuya Bear catching salmon with paws in riffle (f)

titci Bear making motion at every jump when running (f)

tolkatcu Small ears of the bear (f)

tuketə Bear making dust while running (m)

tulanu Two or three bears taking food from one another (m)

tulmisuye Bear walking slowly and gently (f)

ukulnuye Bear taking its young into the den (f)

usepyu Bear eating something it finds dead (m)

utatci Bear scratching itself (f)

utnepa Bear rolling rock with foot when pursuing something (m)

wassusme Bear standing on hind feet scratching tree (f)

wopemə Bear bearing down a small tree when climbing it (m)

yelutci Bear traveling among rocks and brush without making noise (f)

yewetca Bear wasting away at death (f)

Lena Thompson Cox, 1913. Her name, *Kulmuye,* meant "bear eating young leaves just sprouting" and was associated with the land moiety. She was the daughter of Sophia Thompson. *Courtesy of the Phoebe A. Hearst Museum of Anthropology and the Regents of the University of California—photographed by E. W. Gifford, no. 15-5527*

The symbols of the two moieties, land and water, are both earthly materials. As a stream washes against its banks, you can clearly see a fluid boundary between the two elements, as the Miwuk consciousness understood it first-hand. Although the two represent a division, they do not represent a divided world based on opposition, but rather a complete universe. One laps against the other. There is a natural magnetism, a natural containment. One element complements the other, one is essential to the other, and, because individuals must marry into the "other side," the two moieties come together to create new life. The two are made one. And it is not only a matter of interdependence, but also one of balance. It's all an incredibly apt metaphor for human existence, and the moiety system is the core.

Moiety society survived over untold generations, a testament to its vitality. In contrast to a European society hinged on the Cartesian axis, separating the needs of the body from the life of the mind, moiety society left the individual completely integrated into the fullness of natural life. In every facet of human activity, life's catalogue of possible experiences was reflected, like sunlight striking a prism, constantly illuminating the individual's immanent connection to natural law.

Kosoimuno'nə

Traveling down Highway 49 today, one can see signs of many generations of Miwuk inhabitants, including those of the present and the recent past. Traveling east on Highway 4 from Angels Camp toward Murphys, one passes the former village of Kosoimuno'nə. This small Miwuk community was also known as the Six Mile Rancheria, although it was never held in trust by the U.S. government. The village appears to have been occupied on an intermittent basis from as early as 1830[5] until the last residents abandoned the place about 1945.[6]

In 1898, W. H. Holmes, head curator at the National Museum of Natural History's Department of Anthropology (Smithsonian Institution), visited Kosoimuno'nə and took several photographs. The images include a series of a woman processing acorn in one of the bedrock mortars. Straddling a large pile

of acorn flour that resembles a small volcano, she raises her pestle, *kawaachi*, to head level, ready to drive the oblong stone into the little crater of meal. Three small children sit nearby, observing. At left, her sifting tray, *hettalu*, rests atop a cooking basket, *pulakka*. In another image she is sifting her acorn flour, separating the fine flour (which likely has been dumped into the large basket at left) from the coarse pieces, which are to be repounded with the pile in front of her. A third image shows her resting for a moment, pestle anchored upright in the mound of acorn flour. Two other small bedrock mortars can be seen on the right.

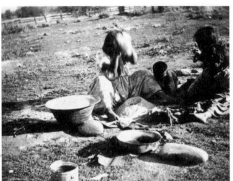

Woman pounding and sifting acorn flour at Kosoimuno'nə, 1898. *Photo by W. H. Holmes, courtesy of Smithsonian Institution, no. 81,8377*

This was a scene still common at the approach of the twentieth century. Children grew up accustomed to the sound of acorns being pulverized by stone implements. They helped crack the shells with small hammerstones and rubbed the paper-thin husks from the nutmeats, occasionally gouging out a spot of spoiled acorn with their thumbnails.

Standing on the roadside adjacent to the village site, I saw very little to indicate that Kosoimuno'nə ever existed. A summer afternoon's breeze pushed the dried stalks of johnsongrass back and forth in slow, fluid motion across the broad expanse that rises, gently, to a tall ridge in the distance. I could smell the tarweed in the wind. Such a quiet place.

As I leaned against the post of a barbed-wire fence, surveying the landscape, my eyes eventually focused on the foreground. There lies what appears to be the very mortar the woman in Holmes's photograph was using. It is low to the surface of the ground, nearly level with it, scarcely detectable. A woman used to prepare food for her family here. The subtleness of the mortar's appearance seems symbolic of the near invisibility of California Indian history today. However, this small, flat boulder with a single hole penetrating its crust also serves as a solid reminder of the tenacity of a people who clung to a way of life at a time when nearly everything moved against it.

By the 1930s, only two families resided at Kosoimuno'nə.[7] Within a decade, the village was completely abandoned. Like the epilogue in a novel, the last known gatherings at the place were for funerals.

Manuel Jeff [see Chapter 4] grew up here, later working in local mining operations near Vallecito. And one of the most decorated soldiers of World War II was laid to rest here: Manuel's brother, Ray Jeff. His headstone rests at the foot of a great buckeye overlooking the former village, its twisting, gnarled limbs reaching out in all directions, then drooping back toward the earth, caressing the space around the trunk, holding Ray in an eternal embrace.

Ray Jeff was killed in action on April 22, 1945, in the Marshall Islands while covering his platoon's retreat. His third citation for the Silver Star, given in response to action that occurred just eleven days before his death, reads as follows:[8]

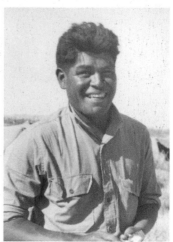

> While an infantry company was in defensive position on a ridge near Tsuva, one of the platoons was subjected to heavy enemy artillery concentration. When a falling round rendered two soldiers unconscious, Staff Sergeant Jeff, with complete disregard for his own safety, ran four hundred yards through murderous enemy fire and dragged the men to safety. In accomplishing this feat Staff Sergeant Jeff was twice thrown violently to the ground by explosions of large shells which landed near him. But despite the fact that he was dazed by the concussions, he steadfastly continued on his mission until it was accomplished. Staff Sergeant Jeff's gallant action, which undoubtedly saved the lives of two fellow soldiers, was in keeping with the highest traditions of the military service.[9]

Ray Jeff in the Marshall Islands, c.1945. *Photo courtesy of Ray Taylor*

In addition to the Silver Star, Ray Jeff was awarded the Bronze Service Medal for valor and received two Purple Hearts. The disparity between the sacrifices of Ray Jeff and the historical treatment of his people in the Sierra is cause for a great deal of contemplation. Perhaps writer Ray Taylor, a friend of Ray Jeff's, best articulated the tragic irony: "He gave his life for his country—for the country, rather, of the Caucasians who had taken it from his forebears and left him a pauper."[10] Knowing he is buried on this lonely, abandoned site is more than enough to make it holy ground.

Arvada Fisher with her great-uncle Ray Jeff's Silver Star. *Photograph by Dugan Aguilar*

Murphys Rancheria

The gold rush town of Murphys is located off of Highway 4, a few miles east of Kosoimuno'nə. Just outside of town was Murphys Rancheria, now abandoned. This native settlement epitomized the tremendous upheaval that native people experienced as a result of the discovery of gold in California

In 1844 Martin Murphy built his home in the Sacramento Valley, near a Miwuk village on the lower Cosumnes River just south of the future settlement of Elk Grove. The people of this village have been identified as the Newachumne, or "people of the village of Newachu." Horatio Hale, as a member of the U.S. expedition led by Captain Charles Wilkes in 1841, mentioned the tribe as one of fifteen native communities near Sutter's Fort,[11] and in November 1846, a Mr. Gatten was employed by John Sutter to take a census of local villages and recorded a population of sixty-one Newachumne.[12] Shortly after the discovery of gold at Coloma in January 1848, Murphy went to Webber Creek (near Placerville) with an Indian labor force, presumably Newachumne, and began mining. Later that same year, in the fall, Murphy appears to have transported the entire village of Newachumne south and east into the upper Stanislaus River country, where he established a trading post at "Murphy's Camp" and continued to use his Newachumne labor force in the mining of gold.[13]

The relocation of the Newachumne from their valley homes some sixty miles into the Sierra to labor in a mining operation was not an isolated scenario. In the spring of 1848, Isaac Humphrey took a number of John Sutter's Indian laborers up the American River to Coloma. As historian J. S. Holliday writes, "With some of the Indians digging, others carrying dirt and water to the rockers, Humphrey and his partner greatly increased the quantity of dirt they could wash each day. Their success caused others to imitate their methods."[14] Indeed, one of Sutter's ranching neighbors brought another fifty Indians to Coloma in April 1848. After observing Humphrey and his method, the rancher moved downstream. There, using baskets to carry dirt to the rocker, Indian laborers retrieved sixteen thousand dollars in gold in just five weeks. Meanwhile, farther north, seven men who had come from Monterey with a work

crew of fifty Indians worked the Feather River. In June 1848, Governor Mason visited the Sierra goldfields and estimated that of the four thousand miners in the gold district, two thousand were Indians.[15]

Several Miwuk settlements came to be located near mining operations, particularly in the years after the original rush of 1849. And while some of the relocation was involuntary, it appears that at least some of this movement was a response by Miwuk communities to the deterioration of natural conditions and increasing inaccessibility of traditional food resources. Living near mining operations created opportunities for employment and at least partial participation in the cash economy.

Murphys Rancheria, 1900. Lizzy Domingo (center) and children, with Captain Yellow-jacket (right). *Photo by C. Hart Merriam, courtesy of Bancroft Library, University of California, Berkeley, no. 1978.008 v/21c/P1 no. 1*

It is not certain what eventually happened to the Newachumne and their descendants, but it appears that many of them remained in the area. The community known as the Murphys Rancheria, located adjacent to the Ora Plata mine, was occupied by Miwuk people from approximately 1870 until about 1912.[16] Most dwellings there, as they appear in turn-of-the-century photographs, exhibited a mixture of traditional Miwuk and Euro-American features in their construction and materials.

Murphys Rancheria. *By S.A. Barrett, October 1906, courtesy of Phoebe A. Hearst Museum of Anthopology, University of California, Berkeley, no. 15-2747*

Largely round in form, the homes had exteriors of board lumber with shake roofs. However, the interiors often contained unmilled poles set in dirt floors, with a fire pit near the center. There were also a few rectangular, pitched-roof cabins and small outbuildings in the village. A remnant population continued to live in small cabins on the outskirts of town through the 1930s.[17] C. Hart Merriam recorded the village name as Kut-too-gah,[18] which Kroeber modified to Katuka.[19] The most consistent name for the rancheria appears to have been Molpeeso. A. M. Tozzer offered a possible translation for the village's name, which he recorded as Mol-pe-zio: he had been told it referred to ear plugs. This is interesting in light of the rancheria's close proximity to the Ora Plata mine, which operated a stamp mill, an earthshakingly noisy setup for crushing ore.[20]

Pota

Driving south toward Springfield on Highway 49, a few miles beyond the Rawhide turnoff (near the town of Columbia), you will pass near the site of Pota. The name of this village refers to an important and spectacular ceremony that was once an important part of Miwuk life, a multidimensional ritual that wrestled with the complex and ever present human problem of how to deal with death as a result of violence.

A central purpose of the ceremony was to deal with issues of revenge and justice and afford some degree of satisfaction to the surviving relatives of people who had been killed as a result of violence or who had been poisoned by a *tuyuk* (Indian doctor). This was played out through the ritual shooting of an effigy that represented the killer or killers. Relatives of the killers were also present at the ceremony.

The *pota* ceremony took place outside in a large open area beyond the residential part of the village. Central to the ceremony was the pole, called *helme*. It was made from a pine sapling that was cut by a group of men who were designated for the task by the village chief. The pole gatherers, known by the ceremonial title of *welubek*, painted themselves according to which moiety they belonged to: alternating black and white horizontal stripes for the land moiety, and black and white hand marks for the water moiety.

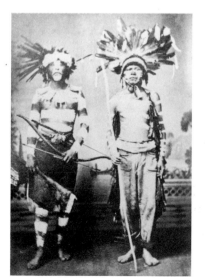

Two Miwuk dancers painted in the fashion of the land moiety, c. 1870. The man on the left holds a sinew-backed bow and single arrow in his left hand, and a quiver in his right hand. The upper portion of the bowstring is wrapped with fur, which may have acted as a silencer, muffling the buzz of the bowstring against the wood near the nock. The man on the right wears a flicker-quill headband that appears to be made entirely of tail feathers. *Photo by Daniel Sewell Studio, courtesy of Mrs. Mary Etta Segerstrom, the Yosemite Museum, no. RL-14,031*

The *Pota* ceremony and the *helme* pole appear to be connected to the land moiety, or *tunuka*. In 1916, E. W. Gifford recorded four personal names, all from individuals of the land moiety, that are associated with the *Pota*:

Heteltci, "leaning against the *helme* pole"
Tuwume, "arrow sticking in *helme* pole"
Lanu, "people passing one another when running around the *helme* pole"
Putsume, "brushing ground around the pole before Pota ceremony"

Once the pole was brought to the village, the bark was stripped away and the pole was painted, sometimes with red horizontal rings from top to bottom, or it might be covered with white clay paint and then with a black spiral design traversing the length of the pole.

The sharp-edged, grassy stalks of sedge, *kissi,* were gathered and wound around the pole near its top, in two distinct bundles. The upper bundle represented the chest of the effigy, and the lower bundle the abdomen. A ball, sometimes made of deer hide and stuffed with grass, sat at the top of the pole to represent the head. This effigy was made by relatives of the people who had been killed. Arrows were inserted through punctures on each side of the effigy head and small baskets were attached to the end of each arrow, so that the arrows and baskets represented ear pendants.

People from other villages were invited to the event, and there was a great deal of feasting, gambling, dancing, and visiting before the ceremony began. The visitors camped on four sides (north, south, east, and west) of the perimeter of the open space where the *helme* pole was erected. Early in the morning of the day on which the ceremony was to begin, groups of twenty to twenty-four men assembled in each of the four camps. They wore flicker-quill headbands and carried sinew-backed bows and fox-skin quivers full of arrows. Similarly to the pole gatherers, land moiety dancers had their legs, arms, faces, and torsos painted in alternating black and white horizontal stripes, and water moiety dancers with black and white spots.

The four groups approached the pole in the center of the clearing, stopping

Wekwek, **Prairie Falcon.**
The presence of a live falcon was an important feature of the Pota ceremony. In 1883, Tom Williams captured a falcon from its nest, and it was used for Pota ceremonies at three different villages. When a person who has captured a falcon enters a village where the Pota is to be given, people go out to meet him and scatter various types of seeds over him and the bird. Interestingly, the falcon is considered to belong to both water and land moieties. A woman dances with the falcon on her head at a climactic moment in the Pota ceremony.

about a hundred feet from it. There they danced. Next, four dancers broke away from one of the groups, and with bows drawn and arrows in place, they approached the chief of the host village and performed a mock attack on the village, sometimes letting arrows fly at baskets. The host villagers had no right to object, since it was all considered part of the ceremony.

Approaching the chief of the host village, who stood leaning against the *helme* pole, a leader of the marauding group would recite a ceremonial speech: "Help me out with a little food, for I am going to throw away my arrows. My men are going to throw away their arrows. Therefore, help me out with a little food. My men are going to dance around your pole."

The host chief replied, "Help me out with your arrows. Help me out and I will give you some food for your men."[21]

This formal speech served as a prelude to the ritual shooting of arrows into the effigy by the four successive groups of visitors, the climax of the ceremony. While the effigies themselves were abstract in appearance, the identities of those they represented were certainly known to the victim's relatives, and to the relatives of the killer. And while the ceremony involved details too numerous and complex to explain here, the basic elements illustrate a remarkable method for diffusing tensions caused by death from violence, within the context of Miwuk social relationships, ceremonial protocol, and religion.

This opportunity for the victim's relatives to vent their anger and frustration, the shame directed at the perpetrator's relatives and the accountability

Describing Marikita's memory of a mock attack, Gifford wrote, "One day when Marikita was attending the pota at Hunga, she was cooking acorn mush near some brush huts. It was a hot September, so they were using brush (shades). A man came rushing in among them, his bow drawn. Someone had tied up a dog in one of the huts to conceal him, but he dashed out to bite the man. The man turned suddenly, with drawn bow, but he did not shoot because the chief had ordered them not to kill any dogs."

Marikita. *Photograph by E. W. Gifford, c.1920, courtesy of Yosemite Research Library, no. YRL-14,316*

demanded of them, were meant to keep deadly vengeance in check, and to stave off any escalation in violence. As the moieties and family lineages came into play, the ceremony reinforced social structure in the face of events that might otherwise have threatened or violated order.

Driving along the road toward Springfield, surveying the landscape and wondering where that open clearing might have been, one can only imagine the spectacular sight of that ceremony: of some one hundred men approaching the village center, running, prancing, feigning, their flicker-quill headbands fluttering and flashing their orange brilliance in the open countryside; of all the villagers in attendance; of the steam rising from dozens of large baskets filled with acorn soup.

Columbia and Wolangasu

Not far from Pota, just northeast of Columbia, was the village of Wolangasu. The name for the village refers to white clay—there is a large, natural deposit of the material nearby. An early twentieth-century interview with an elderly Miwuk man briefly describes an episode of contact with Mexican forces in the foothill country:

> They brought strange Indians with them to fight for them. My people lost the fight . . . over there on the flat near where Columbia is now. And the white men took away six Wolangasu village girls tied together . . . Down by the San Joaquin River, where they spent the night, my mother worked herself loose from the ties and came back home."[22]

The man indicated that the event took place about the time, or "just a little after the great fire in the sky," referring to the Leonides meteor shower of 1833.

Sonora and the Village of Mass

While the popular image of a bustling gold rush town like Sonora doesn't generally include native people, in truth many of these frontier boomtowns were also the locations of Indian settlements. Some villages, like Yuloni at Sutter

Indian Camp, Sonora. Believed to be site of the village of Mass, c. 1900. *Photo courtesy of Yosemite Research Library, no. RL-15,309*

Creek, were literally built over by the immigrants. Others, like Murphys Rancheria, were established in or near new towns after the discovery of gold, for much the same reason that other people were there: a chance to make a living in the new cash economy.

A community that combined both scenarios was Mass, a Miwuk village whose residents had the misfortune of finding themselves living in the midst of what was quickly becoming the town of Sonora. In the early 1850s, the villagers were run out of their homes, shot at by miners and other locals. Some of them then took up residence, and refuge, at a place known as Potato Ranch, located outside of Sonora toward Apple Valley. As years passed, a few Miwuk families returned to Sonora and moved into several small wooden cabins that miners had built in the 1850s and later abandoned, in the area now known as Rotary Park. This reoccupation likely took place in the 1880s or 1890s. Among those who returned to Sonora were the Mass family, hence the village's name.[23] The earlier name, or names, of the village from the time before it was disbanded in the 1850s are not known.

Not far down the street from Mass, a bedrock mortar can be found at the end of a row of buildings in a strip mall, a mute reminder of another Miwuk village bulldozed into oblivion. Other native village and contemporary American town sites in the area that coincide include Hung'a at old Bald Rock, Hangitwuu'e at Soulsbyville, and Sukanola near Standard.

Visualizing traditional Miwuk dance performances on Sonora's Washington Street may be just as challenging as imagining a native village in Rotary Park. On occasion, as early as the 1860s, groups of dancers performed in the streets of Sonora, Jamestown, and Columbia to raise money.[24] One observer reported that the women circulated among the spectators asking for contributions. Around 1880, several Miwuk people were photographed during just such an occasion. The idea of dancing for money was not necessarily a new concept; within the context of Miwuk ceremonialism, spectators were often expected to compensate dancers and singers who performed. An example would be the *helikna*, a dance performed by a woman. As she danced in short, shuffling steps, circling the dance house, it was customary for the spectators to

give her gifts and presents. Following is a translation from a portion of what is either the *helikna* song or, more likely, an accompanying oration given during the dance.

Now you can tell your people to get ready to give her whatever they have. Just throw it close by her. Every little [thing] helps, will help her. Tell those people of yours, chief, to get ready to give little things. It does not make any difference what you give her. Give her anything — arrow, basket, hide — anything you have to give away.[25]

It's important to recognize that these performances were not necessarily, as local non-Indians likely would have perceived them, acts of begging, but rather

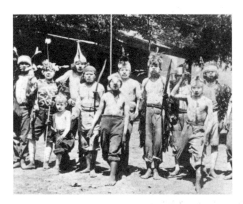

Miwuk dancers in the streets of Sonora, c. 1870. *Photo by Daniel Sewell Studio, courtesy of Mrs. Mary Etta Segerstrom, the Yosemite Museum, no. RL-14,033*

During the 1860s, Miwuk men were known to dance in the streets of Sonora while a woman went among the onlookers with a hat, collecting donations. It was noted that the *kale'a* was one of the dances performed in this context. The *kale'a* had much the same performance context within Miwuk society, and when it was performed in the ceremonial roundhouse, donations were similarly sought. It was what some of the old people called a "pay" dance. Not an adaptation to the post-gold rush cash economy, it was well within the tradition of Miwuk ceremonial dance.

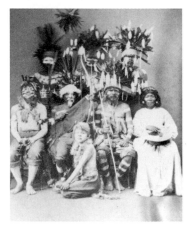

Miwuk ceremonial dancers, Sonora, c. 1870. *Photo by Daniel Sewell Studio, courtesy of Mrs. Mary Etta Segerstrom, the Yosemite Museum, no. RL-14,035*

While it is unknown which dance or dances are represented by the dress of the individuals in this historic photograph, the young boy kneeling in front and the man seated at the far left appear to be dressed as ceremonial clowns *(woochi)*. The *woochi's* body is covered with white clay paint, and he wears a necklace of bird heads and skins, sometimes from the scrub jay or Steller's jay. Dancers fasted during ceremonial dances, and according to Gifford's *Central Miwuk Ceremonies,* if a *woochi* detected a dancer hiding a bite to eat during a ceremonial dance, he would sneak up on the violator, pull a bird head from his necklace, and place it alongside the dancer. This served as a fine of sorts, as the dancer would later have to return the bird head to the *woochi,* apparently within full view of everyone in the roundhouse.

perhaps a traditional means for alleviating episodes of poverty among individuals in the community.

The flicker-quill headbands worn by three of the dancers in the photograph shown here are easily recognizable items of Miwuk dance regalia. One of the bands is worn vertically over the head, rather than horizontally, which is apparently the way a band was worn for the *tula, kilaki,* and *hiwe* dances. Two of the dancers appear to be holding sinew-backed bows. Several appear to be covered almost completely with white paint, with one individual's upper body showing a complex of vertical and horizontal lines likely achieved by scraping away the paint after it was applied to the body, similar to an etching process.

Another early portrait of Miwuk dancers from Wells Studio in Sonora provides us with a window into a world that is now, for the most part, lost. Like the moiety system, the intricacies of Miwuk ceremony would suffer a steady decline during the decades following the gold rush. The number, complexity, and meaning of ceremonial dances among the Sierra Miwuk is likely only hinted at in Edward W. Gifford's *Central Miwok Ceremonies.* The most complete reference work on Miwuk ceremony, it describes thirty-nine distinct ceremonial dances briefly, largely based on interviews with the remarkable storyteller and ceremonialist Tom Williams. Manifestations of dreams, performances illusory of events from mythic times, frightening appearances by spiritual beings that left their audiences awestruck, the dances expressed the joy and vitality of the living individual, all integrated into the fabric of Miwuk life, history, and worldview. Maintaining order in both the celestial and profane worlds, they were full of significance and symbolism to members of the society. The photographic images tantalize the imagination with hints about what must have been.

Rawhide and Kotoplana

A mile or so past the tiny settlement of Tuttletown, the Rawhide road forks to the right, offering a shortcut to Jamestown. Here, near the community known today as Rawhide, was the Miwuk village of Kotoplana.[26] Only fragments of the village's history remain, and its exact location is uncertain.

The earliest reference to the village and its people appears in the baptismal records at Mission Santa Clara, where on April 25, 1837, a Cotoplanimne woman was baptized.[27] In June 1840, several Cotoplanimne children and young adults were baptized at Mission San Jose. We might note that these baptisms took place after the missions had been secularized and were no longer actively seeking converts.

On May 28, 1851, the Cotoplanimne were among the six Miwuk (and/or Yokuts) tribes to sign Treaty E at Dent & Vantines Crossing, near Knights Ferry.[28] The Cotoplanimne might very well have made their homes along the lower Stanislaus River a short distance upstream of Knights Ferry; from 1851 until at least 1854, there was a fairly large native settlement in the Knights Ferry vicinity, loosely referred to as a rancheria, although there doesn't seem to have been any federal designation for it. (The Miwuk village of Tuyiwunu is also associated with Knights Ferry.[29])

A semi-subterranean ceremonial roundhouse *(hangi)* in disrepair at Knights Ferry, c. 1864. *Stereoview by Thomas Houseworth, titled "Indian Fandango Hall" by Thomas Houseworth, courtesy of Yosemite Research Library, no. YRL-16,576*

We do not know when or why the Cotoplanimne left the Knights Ferry area and relocated some twenty-five miles farther east into the foothills near Rawhide. Tom Williams recalled sending three messengers to several nearby villages to invite them to a *yame,* or mourning ceremony, held a year after his brother-in-law's death. One went to Knights Ferry, the second to Bald Rock, where the invitation was relayed to the village at Big Creek, near Groveland, and the third went to Kotoplana. This event places Kotoplana near the town of Rawhide sometime between 1860 and 1890.

The history and fate of Kotoplana probably followed a pattern that is familiar throughout the Sierra foothills. With each decade following the discovery of gold, there were fewer and fewer places for a native community to exist, and whether from introduced disease, violence, or dispersal and separation into smaller numbers as a strategy for survival, village populations continued to decline unremittingly. Small groups of families or individuals often sought refuge and employment on local ranches in order to survive. It was not until early in the twentieth century that federal legislation, aptly designated "for homeless Indians," finally created most of the present rancherias.[30]

Tom Williams

Tom Williams, or Molestu, the ceremonialist and storyteller who provided Edward W. Gifford with so much of the material for *Central Miwuk Ceremonies*, was born about 1830 at a village near present-day Tuttletown.[31] He later lived at the village of Chakachino, which was just west of Jamestown, near the turnoff to Chicken Ranch Road. Around 1870 Chakachino was moved to the present site of the Chicken Ranch Rancheria, near the southern intersection of the Rawhide road and Highway 49.[32]

Before he became a village headman, or *hayaapo*, Tom Williams held the position of *liwape*, the official messenger or courier for the village, for some twenty years, delivering invitations for ceremonial gatherings. The *liwape* carried with him a *sutilla*, or knotted invitation string. Each knot represented a day before the scheduled event.

Whenever Tom Williams spoke at a ceremonial gathering, he knelt on the floor near the middle of the ceremonial roundhouse, or *hangi*. As he spoke he bowed his head so low that his beard often touched the ground, and all the while he would rock back and forth rhythmically, swinging his fist horizontally in front of him to emphasize his speech. On such a ceremonial occasion, the orator spoke about the various lineages of the visitors. It is reported that Tom Williams could name all the family lineages, *nena*, and their places of origin encompassing a region up to one hundred miles square.[33] Tom Williams died in 1933.

Following is an excerpt from a speech made by Tom Williams and recorded on wax cylinders in 1913. In traditional times, when a chief died, the *hangi* was destroyed and another was built for the new *hayaapo*, normally the eldest son. This speech commemorates the building of a new ceremonial roundhouse on such an occasion.

Tom Williams at Chicken Ranch, near Jamestown, 1913. *Courtesy of the Phoebe A. Hearst Museum of Anthropology and the Regents of the University of California—photographed by E. W. Gifford, 15-5565*

That boy is getting to be chief.
Now all of you get ready for him.
Get everything ready.
Be prepared to set up the poles and to fix the ceremonial house.
The young chief is going to do the same as his father used to do.
Now all of you men get ready.
Have the ceremonial house ready just the same as for his father.
He is going the same way as his father did.
It is just the same, just the same.
That is what his words tell us.
All of you people get ready,
for he is going to make a big celebration when the ceremonial house is
 completed.

Listen, all you women.
All of you women get the pine needles, get the pine needles.
He is going to do the same as his father did.
He is going the same way as his father.
He has thought of himself, he has thought of himself.
He has prepared himself since his father died.
He has prepared himself since his father died.
He is going to do the same as his father.
He is going to do the same as his father.
He is going to do things as his father did.
Get the things ready, get the things ready.
Fix the ground.
There are lots of poles around us, lots of poles around us.
Get those poles which are nearest.

He is all right, he is all right.
He is becoming a chief just like his father.
That is what you will do.

That is what you will do when the big celebration comes.

He is just the same.

He is going to be just the same kind of man that his father was.

There is nobody around us close by, so he is going to make the celebration
himself.

He is going to get ready.

He is going to get ready for a big celebration after that ceremonial house is
finished.

Do not say, "I am not in it." Do not say that.

All of you people act the same as you used to.

He is going to do just the same as his father and take care of us well.

If you say that you are not like the old people, it will go differently for you, it
will go different.

Things will turn out differently.

We are going to do the same things that the old people in the early days used
to do,

the people who told us what a real celebration was and what a real chief
should be.

We follow the customs of those ancient people,

and we do what they used to do in the early days.

We will try to do what they used to do,

when the time comes, when the night comes.

He is doing the same way.

He is doing well.

He is going to be a good chief.

He is doing well.[34]

Looming near Tom Williams's home on the Chicken Ranch Rancheria is Table
Mountain, a remarkable formation that figures in Miwuk oral literature. Fol-
lowing is the story of its origin as told by Tom Williams.

Yayali

Two women are spreading out buckeye nuts. They have come up from Wakimə to Ləmələm'əla. Yayali, the giant, appears to the east of them. While they are in the midst of spreading their buckeye nuts he reaches the other side of the valley, shouting as he comes. "A monster is coming!" exclaim the two women. The elder of the two women has a child with her. "Give me the boy, let me take him on my lap," says Yayali. "He always cries, you mustn't try to take him on your lap," says the woman.

"So, I've found some wives for myself!" says Yayali. He roasts meat for them, human meat, meat of the pregnant women he has brought in from hunting. When this is finished Yayali says, "I'm going out after bull pine nuts." It's almost dark when he appears again, coming from far away. In the meantime the women make a long torch. When it is almost dark they light it near where the buckeye is spread out and run away to the west, to where their earth-covered home is. Away down in the west, when they're almost home, they hear him.

"Run! He's coming!" says the older one to her little sister. He's close behind and he almost catches up with them. As they come near home they toss the baby to an old woman and go inside the earth-covered house. Tarantula has closed the entrance with a rock and sealed it with his nasal secretion. "Give me the boy!" shouts Yayali to the old woman. He tossed the baby into his burden basket and brought him to Sewiya. He threw the baby against a tree and the baby was transformed into a tree.

Some people went out hunting deer after he had left. Over on the other side the hunters found Yayali up in a tree, crushing pine cones with a rock to get the pine nuts out. "Why, here's our grandfather, getting pine nuts!" they said. Two of them climbed up after him and began throwing pine cones in his burden basket. While he is still up in the tree, people are gathering up brush below. He looks about wildly up there, as he feels the load of pine cones growing heavy. The fire has blazed up at the bottom of the tree and the people have climbed down.

Then Yayali cries out. "In what direction am I to die?" he says. "To the west!" they say. They point it out to him. "To the west you are to die!" they say. He

The body of Yayali (Table Mountain) near Jamestown. *Photograph by Dugan Aguilar*

doesn't want to. "Die to the south!" they say. He doesn't want to. "Die to the north!" they say. But that way he doesn't want to. "Die to the east!" And as they say it he falls that way, east. His head rolls away east, and there it turns into obsidian. His dead body turns into rock. They named it Kulto, the place that used to be his body. That is the place where he died.[35]

Pikliku

Near the clear waters of Big Creek about two miles northeast of Groveland was the Miwuk village known as Pikliku (the Miwuk pronunciation of "Big Creek"). It was also known as the Big Creek Rancheria. An earlier Miwuk name for the village may have been Tappinahgo.[36]

The history of Pikliku follows the familiar and ironic pattern repeated throughout the Mother Lode: native communities displaced by mining camps and towns would return ten or fifteen years later to participate in the same industry and economy that had driven them from their homes. Like so many

Roundhouse at the village of *Pikliku,* July 1903. *Photo courtesy of The Field Museum, no. CSA10252*

other native communities of the late nineteenth century, Pikliku appears to have been a settlement of Miwuk people from several different villages who were displaced shortly after the arrival of the Americans. Some of Pikliku's residents may have come from the village of Aplatci, reportedly located five miles northeast of today's Coulterville.[37]

It was not simply the presence of mining camps or towns that led to the displacement of local Indians; it was the lawless and violent behavior of individuals therein. As early as 1848, California pioneer James Savage and his crew of Indian workers were panning the gravel deposits near what later would be known as Big Oak Flat. The native people don't appear to have had any philosophical objection to gold panning, but the miners that now poured into the area objected to the presence of Indian work parties. Savage found it necessary to leave Big Oak Flat with his native entourage soon after a Texan stabbed and killed a local Indian known as Luturio and was himself soon killed by Indians.[38]

A newly arrived prospector recalled an incident that occurred in 1850.

We had been there only a few days, when one night a band of Mt. [mountain] Indians made a raid on some on the miners on the flat and robbed them of a horse and other valuables, killing one miner and wounding another with their arrows. The miners followed the Indians for twenty-five miles up into the mountains, then they found their settlement and killed old men, squaws and children, the bucks having fled. I am thankful that I did not join them, as their acts were more foul than the Indians.[39]

Like most major villages, Pikliku had a roundhouse, or *hangi*. The last ceremonial gathering at Pikliku was held about 1898, when Sophia Thompson, who had assumed the role of hereditary village leader after the death of her father, Nomasu, invited people from Tuolumne and Mariposa to play handgame.[40]

Nomasu trained Sophia Thompson for a position of leadership largely because her brothers had all died. Generally, the oldest male son of a chief was trained to inherit the position, with each following son next in the line of succession. But in the absence of a son, or if a son was deemed incapable of assuming the chieftainship, a daughter was trained. A woman chief was known as *maiyəngə*. Much of the extant information regarding Miwuk moieties came from Mrs. Thompson. Her knowledge of family genealogies and moiety affiliations and her recollection of personal names were remarkable. She was of the water moiety, and in *Miwok Moieties*, Gifford records that her Miwuk name, Pilekuye, means "shell nose-stick staying in the ocean."

Sophia Thompson. Photograph by E. W. Gifford, 1923. *Photo courtesy of Phoebe Hearst Museum of Anthropology, University of California, Berkeley, no. 15-7113*

In the three decades that followed Nomasu's death, the population of Pikliku began to decline. During the Kelsey Census of 1905–06, a community of thirty-five people lived there.[41] The 1910 U.S. census indicated only twenty residents. Edward W. Gifford noted that the roundhouse was still standing when he visited in 1917.[42] By 1920, most people had left the village, some moving to the Tuolumne Rancheria.[43] At least one resident, Jimmy Bill, remained there as late as 1922.[44] The roundhouse was gone by then. The entire site was destroyed, inundated when Pine Mountain Lake was created in 1972.[45]

Mildred (Hendricks) Hawkins, great-granddaughter of Sophia Thompson, at the Tuolumne Rancheria, Tuolumne County.
Photograph by Dugan Aguilar

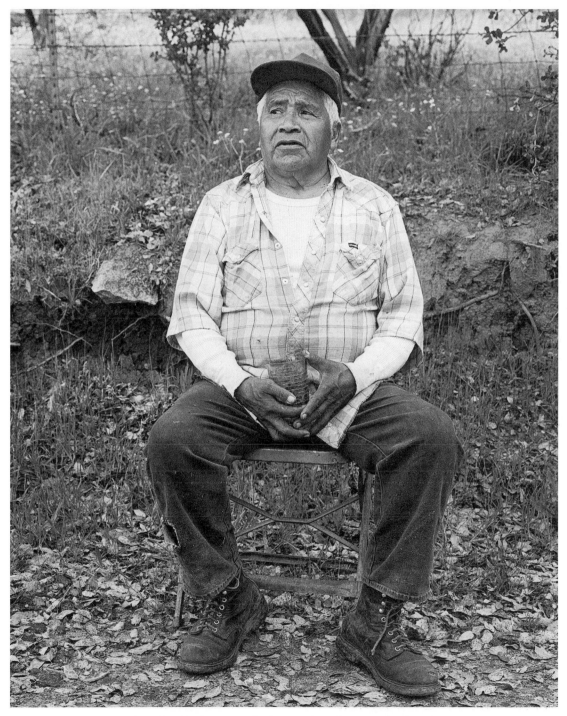

Russell Hendricks, great-grandson of Sophia Thompson, at his home on the Tuolumne Rancheria, Tuolumne County.
Photograph by Dugan Aguilar

"This has always been Miwuk country. The only trace of our being here is cast in stone." Sonny Hendricks, great-grandson of Sophia Thompson, at the Tuolumne Rancheria, Tuolumne County. *Photograph by Dugan Aguilar*

'Amta

In the wide, flat meadows near the village of Pikliku, Miwuk women played *'amta*, a game much like field hockey: the object was to send the ball through your opponent's goal. Each player held two small woven rackets (*'ammutna*) resembling the baskets used to knock edible seeds free from grass stalks, only a little smaller. It was with these rackets that a buckskin-covered ball (*posko*) about two and a half inches in diameter, stuffed tight with deer hair, grass, or moss, was carried, passed to team-mates, and hurled toward the goal; participants were not allowed to touch the ball with their hands or feet. The field of play was about two hundred yards long, with goals at either end. The goals were reportedly made of a bent willow in the form of an arch, or of two upright poles. Perhaps a dozen or more women might participate. Opposing teams were sometimes formed according to moiety affiliations.[46]

'amta rackets, made of buckbrush *(paywa)* shoots. Collected at Avery, Calaveras County by S. A. Barrett, 1906. *Courtesy of the Phoebe A. Hearst Museum of Anthropology and the Regents of the University of California, no. 1-10363*

A man, called the *pochukbe*, began the game by going to the center of the playing field and throwing the ball down on the ground hard enough so that it would bounce. At that point, much like a face-off in hockey, the competing women in the best position attempted to catch the ball in the air as it bounced, cradle it in their *'ammutna*, and begin the task of advancing against their opponents, who were free to disrupt the progress of the ball by bumping, jostling, or otherwise tackling the ball carrier. Advancing the ball and getting it through the goal must have been quite a difficult and exhausting task, as one score was sufficient to win the game. The contest was of great interest to the rest of the village and their guests, with significant amounts of property and valuables wagered on the outcome.

Dr. John Hudson, who visited the community at Big Creek in 1902, mentioned a variation of the game, called *sakumship*, in which two women competed at throwing the ball to each other at some distance.

Two women, standing fifty feet apart, throw a four-inch ball of buckskin filled with [deer] hair, each using two baskets to throw the ball, which they may not touch with their hands. The casting baskets, called *shak-num-sia*, are made somewhat stronger than the *a-ma-ta*. This is a great gambling game between women, and is played for high stakes. It is counted with sticks, and a player forfeits one if she fails to catch or throw the ball so that it goes beyond the other's reach.[47]

The people who lived at Pikliku had already experienced a great deal of loss by the time Hudson visited the community in 1902. Their population was a fraction of what it had been fifty years earlier. The tenuous, spasmodic changeover from a communal hunting and gathering society to a labor-for-cash economy was undoubtedly stressful, and there had clearly been a decline in the community's cultural and ceremonial life, which had provided stability in the Miwuk world for centuries. By 1900 this was a damaged culture, and these were damaged people. Yet there was still play.

There may be no clearer symbol of surviving the gold rush and all that followed in its wake than a spirited game of *'amta* progressing in the meadow: the chaos of bright cotton print dresses wrestling and racing about, struggling with great energy and desire to advance the ball; the exhilaration of being alive; the chance to win something.

Notes

1. Edward W. Gifford, *Miwok Moieties*, University of California Publications in American Archaeology and Ethnology, vol. 12, no. 4 (Berkeley: University of California Press, 1916), 139-194

2. Ibid.

3. Ibid.

4. Ibid.

5. James Gary Maniery, *Six Mile and Murphys Rancherias: A Study of Two Central Sierra Miwok Village Sites*, San Diego Museum Papers, no. 22 (San Diego: San Diego Museum of Man, 1987)

6. Ray Taylor, personal communication, 2001

7. Maniery, *Six Mile and Murphys Rancherias*

8. Because Ray Jeff was cited for three such acts of heroism, the actual medal consists of the Bronze Service Medal containing a single silver star at its center. Oak leaf clusters are added

for additional acts of heroism and gallantry in action. A silver star with two oak leaf clusters is essentially the same as three silver stars.

9. Ray Taylor, *Native Son of the Mother Lode* (Sonora, Calif.: The Mother Lode Press, 1973)

10. Ibid.

11. Horatio Hale, *Ethnology and Philology* (United States Exploration Expedition, 1838–1842, vol. 6 (Philadelphia: C. Sherman, 1846)

12. "Names and Locations of Some Ethnographic Patwin and Maidu Indian Villages" in Robert F. Heizer and Thomas R. Hester, eds., *Contributions of the University of California Archaeological Research Facility*, vol. 9, *Papers on California Ethnography* (Berkeley: University of California Archaeological Research Facility, Department of Anthropology, 1970), 79–118

13. James A. Bennyhoff, *Ethnogeography of the Plains Miwok*, Publication/Center for Archaeological Research at Davis, vol. 5 (Davis, Calif.: Center for Archaeological Research, 1977)

14. J. S. Holliday, *The World Rushed In: The California Gold Rush Experience* (New York: Simon & Schuster, 1981)

15. Ibid.

16. Maniery, *Six Mile and Murphys Rancherias*

17. Jack Burrows, *Black Sun of the Miwok* (Albuquerque: University of New Mexico Press, 2000)

18. C. Hart Merriam, "Distribution and Classification of the Mewan Stock," *American Anthropologist*, vol. 9, no. 2, 1907, 338–357

19. A. L. Kroeber, *Handbook of the Indians of California*, Bureau of American Ethnology, no. 78 (Washington, D.C.: Government Printing Office, 1925)

20. Maniery, *Six Mile and Murphys Rancherias*

21. Both speeches as remembered by Tom Williams in E. W. Gifford's *Central Miwok Ceremonies*, University of California Anthropological Records vol. 14, no. 4 (Berkeley: University of California Press, 1955), 261–318

22. Harriet Helman Gray, "A Story of Jackass Hill" (ms., Bancroft Library, University of California, Berkeley, 1939)

23. Brown Tadd to Craig Bates, personal communication, September 16, 1992

24. Lewis C. Gunn, "Records of a California Family: Journals and Letters of Lewis C. Gunn and Elizabeth LeBreton Gunn" (ms., Bancroft Library, University of California, Berkeley, 1928)

25. Gifford, *Central Miwok Ceremonies*, 261–318

26. Kroeber, *Handbook of the Indians of California;* "Ethnographic and Ethnosynonymic Data from Central California Tribes," in Robert F. Heizer, ed., *Contributions to Native California Ethnology from the C. Hart Merriam Collection*, No. 2 (Berkeley: Archaeological Research Facility, University of California, 1976); Gifford, *Central Miwok Ceremonies*

27. Early Spanish spelling for "people of Kotoplana" is Cotoplanimne. The -imne suffix translates roughly to "people of."

28. Robert F. Heizer, *The Eighteen Unratified Treaties of 1851–1852 between the California Indians and the United States Government* (Berkeley: Archaeological Research Facility, University of California, 1972)

29. Gifford, *Central Miwok Ceremonies*

30. *Field Directory of the California Indian Community* (Indian Assistance Program, California Dept. of Housing and Community Development, 1990)

31. According to Gifford's *Miwok Moieties*, "Molestu" refers to a stone shaped liked a deer's foot which brings good luck to its owner when he is deer hunting.

32. In 2004, this three-acre rancheria has a tribal membership of twenty-one people (*Field Directory of the California Indian Community*, 2004).

33. Edward W. Gifford, "Miwok Lineages and the Political Unit in Aboriginal California," *American Anthropologist* 28, 1926, 389–401

34. Gifford, *Central Miwok Ceremonies*

35. As told by Tom Williams, in L. S. Freeland and Sylvia M. Broadbent, *Central Sierra Miwok Dictionary with Texts*, University of California Publications in Linguistics, vol. 23 (Berkeley: University of California Press, 1960)

36. Heizer/Merriam, "Ethnogeographic and Ethnosynonymic Data"

37. John Hudson, unpublished field notes (Ukiah: The Sun House, 1901)

38. Anon., *History of Tuolumne County* (San Francisco: B.F. Alley, 1882); Irene D. Paden and Margaret E. Schlichtmann, *The Big Oak Flat Road, an Account of Freighting from Stockton to Yosemite Valley* (Oakland: The Holmes Book Co., 1959); Carl Parcher Russell, *One Hundred Years in Yosemite: The Story of a Great Park and Its Friends* (Yosemite National Park: Yosemite Natural History Association, 1968)

39. Charles Pancoast, *A Quaker Forty-Niner* (Philadelphia: University of Pennsylvania Press, 1930)

40. Gifford, *Central Miwok Ceremonies*

41. C.E. Kelsey, *Census of Non-Reservation California Indians, 1905–1906* (Berkeley: Archaeological Research Facility, 1971)

42. Gifford, *Central Miwok Ceremonies*

43. Still the home of many Miwuk families, the 1,035-acre Tuolumne Rancheria has a tribal membership of 614 in 2004.

44. Brown Tadd to Craig Bates, personal communication, 1992

45. Carlo DeFerrari, "Captain Louie" (*Chispa*, vol. 33, no. 2, 1993), 1134–1135

46. S. A. Barrett & E. W. Gifford, *Miwok Material Culture: Indian Life in the Yosemite Region* (Bulletin of the Milwaukee Public Museum, vol. 2, no. 4, March 1933)

47. Stewart Culin, *Games of the North American Indians* (New York: Dover, 1975; orig. printed as *Games of the North American Indians*, Twenty-Fourth Annual Report of the Bureau of American Ethnology to the Smithsonian Institution, 1902–1903, Washington, D.C.: Government Printing Office, 1907)

Six
Coulterville to Oakhurst

Leaving Tuolumne County and heading south on Highway 49 at Moccasin, our journey takes us through steep, hilly, brushy topography. Two major rivers, the Merced and the Chowchilla, flow through the region. The Merced originates high in the Sierra Nevada and cuts through the awesome granite gap of Yosemite Valley before churning down the Merced River Canyon on its way to the San Joaquin Valley. The Chowchilla River also weaves its way to the great San Joaquin Valley, flowing under Highway 49 south of Mariposa, between Usona and Nipinnawasee.

In the vicinity of the present-day town of Coulterville, the native language experienced yet another transformation. Black-tailed deer changed from ʼəwəəya to hikah, and hekkeke (valley quail) became məʼanəna. A fundamental change in phonetics also occurred, with "h" being substituted for "s" in many words, such as the term for bear: ʼəsəəmaṭi in Central Sierra Miwuk, and ʼəhəəmaṭi in Southern Sierra Miwuk.

Highway 49 passes through Coulterville, Bear Valley, Mariposa, and Ahwahnee before coming to an end at Oakhurst. This final chapter includes the story of one more native family that survived the gold rush and the subsequent challenges to their culture. And once again, the earth reveals its hold on the people:

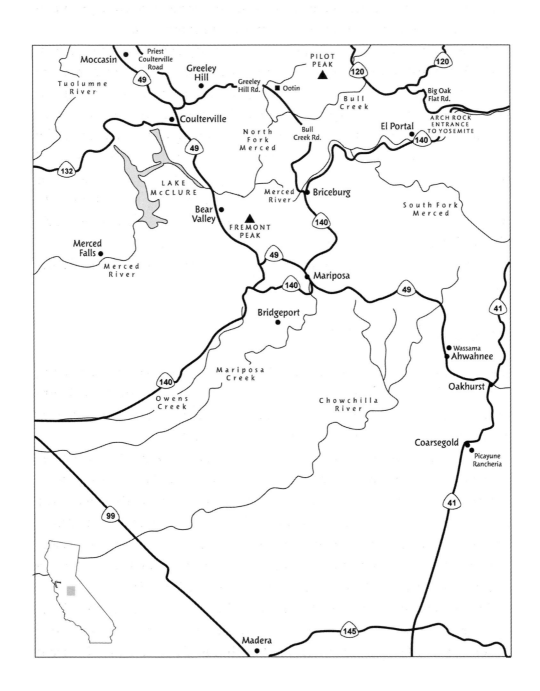

out of the silent darkness of a cave, the beginning of things; against a granite wall, long ghastly stains are cold reminders of lurking dangers; and pock-marked boulders commemorate the Miwuk experience. Ancient yet contemporary personal spaces link people to the very core of the earth.

Perhaps here, in the final chapter of our journey across this multidimensional landscape, a clearer picture of the California Indian experience will come into focus, exemplified by the people who live here: the great-great-grandchild of a man who signed a treaty in 1851; the smartly dressed woman who pounded acorns in a bedrock mortar fifty years ago; and the woman who still thinks in a language that has been native to the region for over a thousand years. For the public at large, Indians in the gold country have been mostly invisible, yet they have always been here. The transparency with which tradition is carried has fooled most of us. It exists largely within the memory of individuals, including some we may pass unknowingly on the street. Even after a century and a half of occupation, few Americans know this place at its deeper levels.

Ootin (Bower Cave)

East of Coulterville, near the hamlet of Greeley Hill, there is a large cave. Long before this dark house of stone was named Bower Cave, it was known to Southern Sierra Miwuk speakers as Ootin.[1] It was here that one of the early races of people lived during mythic times, when animals could talk.

Miwuk oral tradition refers to six different races that existed before the creation of the Miwuk people. The first race was similar to today's Miwuk people, but they were killed off by the cannibal giant Uwulin. The second race were bird people who were stolen by a spirit named Yelelkin. Those that survived Yelelkin left the earth when it was overrun by giant black ants. The third race of people who came to live on the earth took the form and characteristics of both human and animal. It was the chiefs of these people that lived in Ootin.

Tuu-le, the Evening Star, and Heeleecha, the Mountain Lion, lived there. They were chiefs and close friends and had a room on the north side of the cave. Others that lived there were Tolomah, the Wildcat; Yuwel, the Gray Fox; and

Kahkul, the Raven. Following is a myth about how Kahkul became a great hunter. It was collected by C. Hart Merriam in the first decade of the twentieth century.[2]

They used to send out hunters for meat. One of these, Kahkul, complained to Tuu-le and Heeleecha that he could not come near enough the game to shoot; the animals saw him too easily . . . he was too light-colored. So he decided to make himself black. He took some charcoal and mashed it in a basket and rubbed it all over his body wherever he could reach, and he had the others help put it on his back where he could not reach. When he was black all over, he went hunting and killed two or three animals the first day, for now they could not see him.

One day Kahkul went to Big Meadows and climbed on top of Pilot Peak, and when the moon rose, he saw away in the east two big things like ears standing up. He had never seen anything like them before and ran back to Ootin and told the chiefs. He said the animal must be very big and very wild, for it turned its big ears every way. He wanted to see it.

Every evening he went back to Pilot Peak and saw the ears in the east, and each time they were a little nearer. But he did not yet know what the animal was. Then he went again, and this time the ears were only two or three miles away, and he ran back quickly and told the chiefs that the new animals were coming. They were deer coming over the mountains from the east. They had never been here before.

The next morning Kahkul went out and, for the first time in his life he saw a bunch of deer; but he did not know what they were. He saw that they stepped quickly, and that some of them had horns. So he ran back and told Tuu-le and Heeleecha what he had seen, and he said that the new animals looked good to eat and he wanted to kill one. "All right," answered the chiefs. "If you see one on our side go ahead and kill him."

So the next morning Kahkul again went out and saw that the animals had come much nearer and were pretty close. He hid behind a tree and they came still nearer. He picked out a big one and shot his arrow into it and killed it; for he wanted to try the meat. He watched it kick and roll over and die, and then he

went back and told the chiefs that he had killed one and wanted two men to go with him and fetch it. The chiefs sent two men with him, but when they got there they had nothing to cut it with and had to carry it home whole. One took it by the front feet, the other by the hind feet. They carried it to the cave and showed it to the chiefs. Heeleecha said it was a deer and was good to eat and told the people to skin it. They did so and ate it all in one meal.

Next morning Kahkul returned alone to the same place and followed the tracks and soon found the deer. He hid behind a tree and shot one. The others ran, but he shot his arrows so quickly that they made only a few jumps before he had killed five — enough for all the people. He did not want to kill all; he wanted to leave some bucks and does so there would be more.

This time the chiefs sent five men with Kahkul. They took flint (obsidian) knives and skinned the deer and carried home all the meat and intestines for supper and breakfast. Chief Tuu-le told Kahkul that he wanted to see how the deer walked and would hunt with him. Kahkul replied that he was too light, too shiny, and would scare the deer. Tuu-le said he would hide behind a tree and not show himself. So he went, and Kahkul kept him behind. But he was so bright that the deer saw him and ran away. Tuu-le said, "What am I going to do?" Kahkul made no answer; he was angry because he had gone home without any meat.

Next morning Tuu-le went again. He said he was smart and knew what he would do. The deer had now made a trail. Tuu-le dug a hole by the trail and covered himself up with leaves and thought that when the deer came he would catch one by the foot. But when the deer came they saw his eye shine and ran away.

The next morning he tried again. He said that this time he would bury himself, eye and all, and catch a deer by the foot. Kahkul answered, "You can't catch one that way, you will have to shoot him." But Tuu-le dug a hole in another place in the trail and covered himself all up, eye and all, except the tips of his fingers. The deer came and saw the tips of his fingers shine and ran away. So again the hunters had to go back without any meat.

Then Tuu-le said, "I'm going to blacken myself with charcoal, the same as Kahkul did." He tried but the charcoal would not stick — he was too bright. He said, "I don't know what to do; I want to kill one or two deer." Then he tried

again and mashed more charcoal and put it on thick. The others helped him and finally made him black all over. Tuu-le did not know that the deer could smell him, and he again hid on the trail. The deer came again. This time the doe was ahead, the buck behind. The doe smelled him and jumped over him; the buck smelled him and ran back. So this time also, Tuu-le and Kahkul had to go home without meat.

The next morning Tuu-le tried once more. He had two men blacken him all over. Then he went to the trail and stood still between two trees. But the deer smelled him and swung around and ran away and went down west to the low country. This discouraged him so that he did not know what to do, and he gave up hunting and stayed home.

Then Kahkul began to hunt again; he went every morning alone and killed five or ten deer. The people ate the meat and intestines and all, but did not have enough. Then Kahkul worked harder; he started very early in the morning, before daylight, and killed twelve to fifteen deer every day. This was too much for him and before long he took sick and could not hunt at all.

Then the chiefs and all the others had nothing to eat and did not know what to do. Tuu-le asked Heeleecha, and Heeleecha asked Tuu-le, what they should do. Heeleecha said he would stay and kill his own deer and eat the liver only—not the meat—and would eat it raw. Tuu-le said he would go up into the sky and stay there and become the Evening Star. Each did as he had said. So the rancheria at Ootin was broken up.

Another version of this story explains that these people turned into the birds and animals of today, and tells how the great amounts of food Raven stored in the cave hardened and became the stalactites and stalagmites seen there to this day.[3]

Huhepi

Throughout the Sierra, with its many streams and rivers, Miwuk oral tradition includes a beautiful mermaid-like being who inhabits certain deep pools. Among the Southern Sierra Miwuk, she is called Huhepi. She has long dark

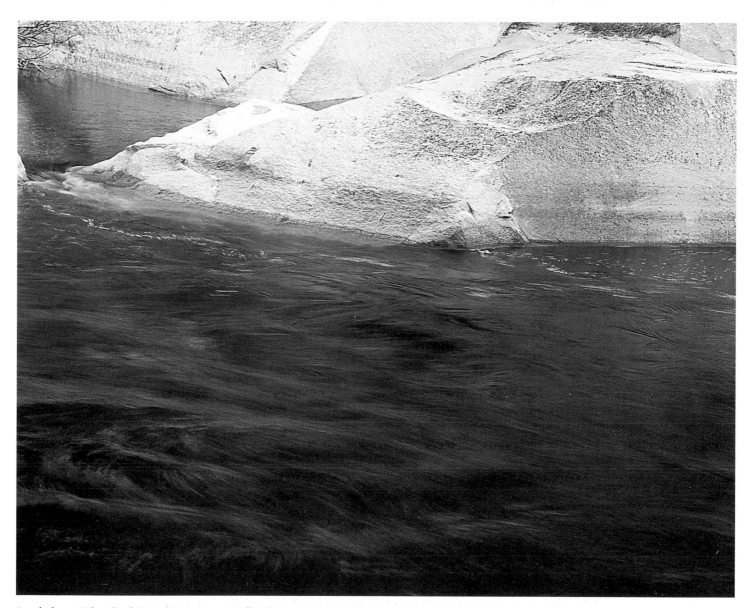

A pool where a Huhepi lived, Merced River, Yosemite Valley. *Photograph by Dugan Aguilar*

hair that she often uses to entangle her victims beneath the surface of the water, drowning them. There are several places along the Merced River that a Huhepi has been known to frequent. One lived in a deep pool located between the Arch Rock entrance station and the Cascades in Yosemite Valley. Another was often seen in the river at the upper end of Pleasant Valley, in a large pool at a place called Owwal. In the early days two men used to fish for salmon at Owwal, one on each side of the pool. They reported seeing a Huhepi several times.[4]

Another Huhepi lived in the deep water at Welleto (on the Barrett Ranch, below Pleasant Valley). Many years ago, some Indians from Bear Valley and Coulterville went there to catch salmon. They put their net in a deep place in the river, and when it was full of fish they tried to pull it out but could not because it was stuck on something at the bottom of the pool. One of the men went down to find where the net had caught. Huhepi had fastened it to a rock. While the man attempted to free the net, Huhepi put a turn of the net-rope around the man's big toe, and he drowned. Several men had to go down to get him. After they brought up his body they looked back into the pool, and there in the depths, they caught a glimpse of Huhepi, her long hair floating out in the current.[5]

Both Owwal and Welleto now lie beneath the waters of Lake McClure. At Bagby, Highway 49 passes over the upper reaches of this man-made lake where the Merced once flowed freely.

Bear Valley

Anyone who makes the steep, twisting, exhausting climb out of the Merced River bottom at Bagby finds a reward upon entering lovely Bear Valley. The transformation from steep hillsides packed with brush to spacious oak wood-lands and grassy savanna occurs so quickly that it's always a bit of a surprise. In the waning days of spring, the grasses here are dry, and the undertone of the entire landscape is a warm yellow brown . . . *taṭaṭṭi*.

Standing in stark contrast, the deep, rich violet flowers of harvest brodiaea (*waala*) contradict the whole scene. Alone or in scattered groups, the small trumpet-shaped flowers look like serrated fragments of some dazzling, violet

blue sky that have dropped to earth unexpectedly. The bulbs that lie below the slender stalks of *waala* were an important food for Miwuk people in the old days. And I have tried to visualize the loveliness of women inserting these flowers in their earlobes for the fun of it, and the fleeting beauty the flowers provided at that time of year.

Along the road through Bear Valley, several patches of a delicate pink flower I only know as *palahli* can also be found. They seem to be more plentiful here than anywhere else. When I see them, I often think of Isabelle Howard Jimenez (1926–1996), one of the last fluent speakers of Southern Sierra Miwuk; she drew my attention to them one time when we were traveling this road together. Her maternal grandfather, Henry Johnson, was raised in Bear Valley, and she knew the country well.

As you pass the hamlet of Bear Valley heading toward Mariposa, Fremont Peak is visible on your left. Near the base of this peak, John Frémont and his wife, Jessie, maintained a home, and several Miwuk families lived on what was loosely termed the Fremont rancheria. As you gaze toward the east you realize that somewhere within your field of vision are the long-abandoned sites of people's homes.

Indian settlement in Bear Valley, located on Fremont's Rancho, 1860. *Photo by Carleton Watkins, courtesy of The Bancroft Library*

A photograph taken at the Fremont rancheria in 1864 by renowned pioneer photographer Carleton Watkins provides a rare image of the early relocation and resettlement of the native peoples in this region. Several domed structures are visible, covered with pieces of fabric—probably discarded canvas from miners' tents—and assorted boughs from bull pines and nearby brush.

As ever greater numbers of non-Indians poured into California during the gold rush, the indigenous people of the Sierra Nevada became exiles in their own homeland. In the case of the Southern Sierra Miwuk, within a ten-year period numerous village populations had been removed to three different locations: the Fresno River Reservation near Madera in 1851; a rancheria near Belt's Ferry on the lower Merced River near Merced Falls in 1851 to 1852; and the Fremont rancheria in Bear Valley by 1860. Not knowing where and when they

were going to be moved next, the native people no doubt found it unfeasible, or perhaps impossible, to build the more permanent, substantial, earth-covered structures that were traditional to the area. Federal Indian Agent William Crenshaw noted in 1854:

> Indians now arrange their camps for the winter more carelessly than formerly. They build few large huts covered with dirt as it was their custom to do formerly. They build huts now by setting up a few old sticks at the bases and fastened at the top by knives, [and] on this conical shafted frame they throw a few brush and cover that with old pieces of canvas obtained from dissected tents.[6]

Bautista

As patriarch and perhaps the last recognized captain of the Miwuk people of the Mariposa—Bear Valley region, Bautista left a legacy that is still known to his descendants, and it is remarkably well-preserved in the written historical record as well. His experiences recall nearly every critical juncture between natives and Europeans of the nineteenth century.

Within traditional Miwuk society, positions of leadership were hereditary, not unlike the monarchies of Europe and Asia. One native term often used to identify a hereditary leader, *hayaapo*, means "one who watches out for," or simply "watcher," alluding to a leader's responsibility for community welfare. Another term, which may have been more common in the Mariposa locality, was *ti'yah*.[7] The second syllable of this term carries a good deal of significance. Among Southern Sierra Miwuk speakers, the formal way to address a chief was to add the affix *-yaa* to the end of a sentence. The following excerpt is from a rare recording made by linguist Sylvia Broadbent in 1956 of a conversation between Chris Brown and John Lawrence. Brown speaks to Lawrence as one would to a chief.

CB: *hopiitəninti' keehuyyaa. 'əwwə'a'nəə wachaa.* (I can eat angleworms with biscuits, sir. Tell me if you ever ate any.)

JL: *ken.* (No.)

CB: *mitan'ee luulumet lakhəyi'yaa.* (When is it that edible cocoons will come out, sir?)[8]

Isabelle Howard Jimenez, Bautista's great-granddaughter, recalled that people used the *-yaa* suffix when speaking to her father, Joe Howard. In fact, many simply called him "Yaa." Among the Miwuk people living in the Bear Valley — Mariposa area, Joe Howard was recognized as a captain until his death in 1964. His hereditary position of leadership came to him by way of his father, Bill Howard, who had received it from his father, Bautista.

Known also by his native name, Kechee, Bautista may have been born about 1800. The baptismal records of Mission San Carlos Borromeo at Carmel show that in 1812 an eleven-year-old boy, wounded and captured in a skirmish with forces under Sergeant Vallejo, was brought into the mission with perhaps five or six others. In 1814 he appears in the mission's baptismal record as number 2920, given the name Juan Bautista Maria.[9] The baptismal entry includes the following extraordinary information regarding this boy:

Members of the Howard family near Mariposa. *Photo courtesy of Mariposa Historical Society*

> They took him during an expedition made by the troops of this Royal Presidio under the command of Sergeant Vallejo during the year 1812 to a refuge that they [the Indians] had in the *tulares* near San Juan Bautista, bringing him wounded, and as he seemed in danger, they sprinkled him with water to, in effect, baptize him; surviving, he was brought in and adopted by Cadet Don Taimundo Estrada. His parents' names are not known, although they still lived when he was brought in. They were not from the rancheria where the refuge existed, but from farther away . . . he is the brother of a neophyte at Santa Cruz, much older than he, called Oyzus.[10]

Prisoners of war such as those in Bautista's group were generally separated from their relatives and fellow villagers when brought into the missions. Plains and Sierra Miwuk people were usually taken to Mission San Jose. And Juan Bautista was a fairly common baptismal name, appearing some forty times in the registers of Mission San Carlos Borromeo (Carmel), Mission San Juan Bautista, Mission Santa Clara, and Mission Santa Cruz (the majority of these also appear in the pre-1850 death records of the missions).[11] For all these reasons, it is difficult to pinpoint Bautista's origins. Nonetheless, he was apparently transferred to Mission Santa Cruz, where records indicate he may have

married a woman identified as Blanda. The mission record for this union identifies Bautista's tribal affiliation as Luttasme. The Mission San Juan Bautista records show that in 1834 a man named Bautista married Eufrosina, who is identified as being a member of the Potoyunthere [i.e. Potoyenchee, Potoyencee] tribe.[12] The Potoyencee homeland likely occupied the area now largely covered by the reservoir, Lake McClure, located to the south and west of Coulterville.

Bautista returned to Mariposa County sometime in the 1840s. He is mentioned frequently in the gold rush memoir by Sam Ward, *Incidents on the River of Grace*. Ward wrote, "The chief of the former or greater Potoyencee was Bautista, who had received a semi-Christian education in his youth at one of the Jesuit Missions,[13] where he had learnt to speak Mexican." [14] Ward also stated that Bautista was quite adept with a horse and at roping skills, having worked at the various missions as a vaquero. He added, "His manners were polished, and he wore a civilized air over the quiet dignity of the savage; his face was handsome, the expression of the mouth good-natured, but he had the fugacious eye of a London cracksman surveying a crowd." [15] Ward also recalled an incident revealing Bautista's sense of humor:

> He (Bautista) had been successful in hunting; had killed an elk, and having brought me what the trappers call the *depouilla*, and the Romans termed the *spolia optima*, had invited himself to supper. The meat was fat and tender, but sweet. Nevertheless it was more palatable than fried bacon, which would otherwise have been my supper, and imparted a relish to the musty ship-biscuit to which our rations were reduced. When I had finished supping, the chief burst into an uncontrollable and undignified fit of laughter. While drying his tears, he replied to my puzzled look by exclaiming that I had been eating horse. It appeared that on some occasion I had expressed repugnance for that Scythian diet, and great was his glee at my unconsciousness of the trick.[16]

Bautista was clearly an influential individual. After assisting José Rey and the Chowchilla in a raid on James Savage's trading post on the Fresno River in 1850, he became an advocate for peace with the emigrants and the United States military. In March 1851, the United States treaty commissioners anxiously

waited several days for Bautista to lead his people into Camp Fremont on the Little Mariposa River (Mariposa Creek) to sign a formal treaty.

On March 19, 1851, Bautista, along with nine others representing the Potoyunte [Potoyencee], was a signatory of the Treaty at Camp Fremont (Treaty M).[17] Of the nine signatures representing the Potoyunte, Bautista's appears at the top. His younger brother, Feliz, was also a signatory. Two days after the signing, Bautista visited Stockton as a guest of O. M. Wozencraft, the United States Indian agent in charge of treaty negotiations in California. The *Stockton Times* of March 21, 1851, reported:

> The Indian Chief Bautiste (Ke-chee) . . . one of the first who made an open declaration of war to (Major) Savage, arrived in this city on Friday, in company with Dr. Wozencraft. . . . He is about five feet six inches in height, is of stout proportions, and is reputed to be a chief of great courage and influence.[18]

In the article, Wozencraft stated that Bautista's father had been "tied up and executed" by a United States Army patrol in 1848, and as he was dying he had "told his son to revenge his death." Wozencraft was of the opinion that this event was a leading cause of the Mariposa War of 1850 to 1851. In April 1851 it was Bautista who was able to persuade some one hundred runaway Nutchu captives from the Mariposa War to return and make peace.[19] Ward mentioned that Bautista was "eminently popular with his lieges."[20]

Ward, himself lured to the area in search of gold, makes it clear that many Sierra Miwuk communities found themselves in vulnerable situations following the gold rush. Here, he provides an early reference to the potential for genocide that plagued the region:

> For the ensuing three days, two or more of Bautista's kinsmen, or lieutenants, were continually hanging around the door of my sanctum; and when I sallied forth for my "constitutional," I had a bodyguard of volunteers, besides sundry urchins who seemed beating up the plain or the woods before me, as if engaged in a battue or a German *treibjagd*. One night, when I had been reading *Bleak House* until a late hour, I opened my door and found one of the chief's half-brothers stretched before it, and as I was closing my window, an Indian awoke beneath it and bade me good-night.

The dignity of my position forbade me any inquiry into the motives of these unusual attentions. Were they cautions against my escape? Or were they anticipatory of some peril to me? I withheld these speculations from the whites attached to the rancho for, upon the slightest intimation or rumor of danger to me being put into circulation at Quartzburg or among the miners up the river, lots of Texas rangers "spoiling for a fight" would be down with offers of the friendly service of extermination.[21]

Sam Ward was not in any danger, and the "Texas rangers" did not appear in Bautista's camp.

Mary Ann Johnson

On January 26, 1879, a scene that had played itself out so many times two and three decades earlier was manifest once again. Mary Ann Lewis witnessed the bloodshed on that early Sunday morning. The settlement where she lived, situated near a place called Mariposita, was located just a couple of miles south of Mariposa adjacent to a small creek. Three young Indian men, Charlie, Amos, and Sam, were shot and killed, and an elderly man was hung. An elderly woman was shot in the face but survived. Eight white men were arrested and charged with the murders.[22]

Born in the spring of 1863, Mary Ann Lewis was a girl of fifteen at the time of the murders.[23] She was apparently a member of the Miwuk-speaking Nutchu tribe, whose ancestral home was in the vicinity of Yosemite. This is the same group from which over a hundred runaway captives of the Mariposa War had been persuaded by Bautista in 1851 to make peace with the Americans. (James Savage's estimation of the entire Nutchu population in 1851 was about two hundred individuals).[24]

Today, an apple orchard rests on the killing site, just off of Old Highway Road. Mary Ann Lewis survived the incident and later married Henry Johnson. She gave birth to four sons and lived to the age of eighty-five. Mrs. Johnson's account of the murders has now traveled through five generations of descendants, some of whom still make their home near Mariposa.

Frances Gann's house sits less than a mile from the place her great-grand-

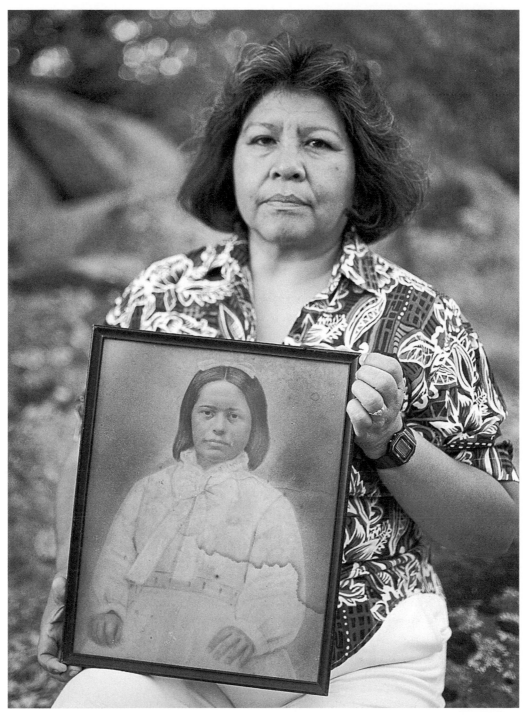

Frances McCabe Gann with a portrait of her great-grandmother, Mary Ann Lewis Johnson, Mariposa County.
Photograph by Dugan Aguilar

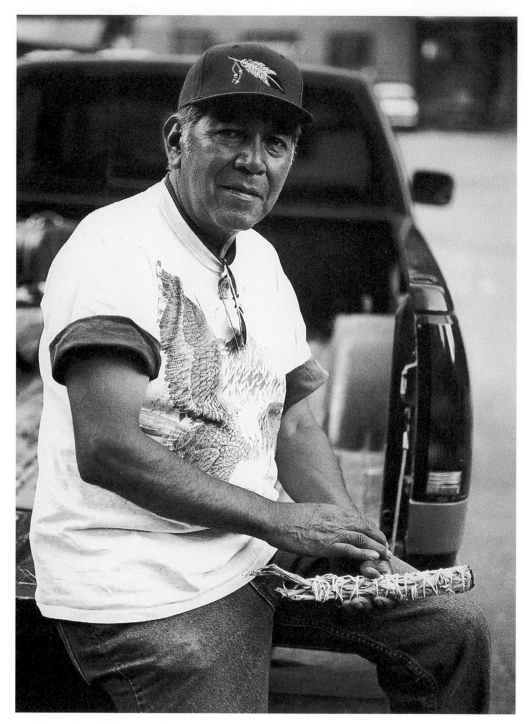

Jay Johnson. *Photograph by Dugan Aguilar*

mother was forced to flee. Repeating the story she learned from her mother, Frances says, "They were chased from their camp at Mariposita to an area near Bridgeport [Mariposa County]. They hid in the rocks and brush."

One of Mary Ann Johnson's grandsons, Jay Johnson, retired from the National Park Service in the spring of 1997 after forty-five years of service in Yosemite. As a member of the U.S. Marine Corps, Jay served his country during the Korean conflict. Since 1982 he has led efforts to bring federal acknowledgment to his community; like many others throughout California, the tribe has never been officially recognized as such by the U.S. government. After more than twenty years of work, they remain unrecognized. Thus while the landscape exudes the history of their presence, they continue to exist without a tribal land base.

Uwulin

In that distant time when animal people inhabited the earth, there was an ogre known as Uwulin.[25] This being liked to eat the bird and animal people. He would catch fully grown people and carry them away to a hiding place near the foot of Yayan (Cascade Falls), in Yosemite Valley. There he cut his victims into small, thin pieces and made jerky of their meat.

When Uwulin found a child that pleased him, he would hide it among the rocks and raise it as his own. There were two boys he had obtained in this way. Uwulin's home was far to the north. When he came to Awaani (Yosemite Valley) he used to step across Wakaalməto (Merced River) at a narrow place below Briceburg. There the marks of his huge feet can still be seen on both sides of the river. At night he used to hide in a cave near Coulterville.

The bird and animal people of Awaani tried in every way to kill Uwulin, but nothing they could do would hurt him. Their arrows glanced off his body and their spears shattered against his huge frame. Finally, the people of Awaani called upon Uchum, the fly, to help them. They told Uchum to bite Uwulin all over his body and find where they could hurt him.

Uchum followed Uwulin all the way to Awaani. He bit the giant from the top of his head to his feet but found no place where he could be hurt. Later, Uwulin

lay down to rest, and Uchum thought, "Ah! Here is one place I have not tried." So he bit Uwulin on the bottom of his feet. Each time Uchum bit him under the heel, Uwulin kicked. "Now," said Uchum, "I know where I can hurt him."

Uchum flew to the people of Awaani and told them what he had learned. They held a council and tried to think of some way by which they could hurt Uwulin under his heels. Finally they decided to set a trap for him. Long, slender bone awls were set upright in the trail near Yayan where Uwulin passed. When he came along he stepped on the awls and they punctured his heels, killing him.

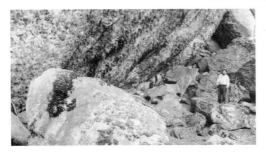

The large granite boulder where Uwulin hung strips of meat to dry at Yayan. Blood from the flesh of the bird and animal people stained the boulder, leaving long dark streaks. Chris Brown (Miwuk) is standing to the right. *Photo by Frank Latta, 1936*

As soon as he died, the bird and animal people held another meeting to decide what to do with the body. At last they decided to burn it.

All the people carried wood and piled it on Uwulin. They set it afire. When the fire began to burn, the people were afraid that some part of the body might fly off and not burn. Then the part would grow, and Uwulin would come back to life. Everyone watched closely to see if any part of the body would fly off. The rest of the people did not think that Goldfinch and Catbird could see very well, so they made these two go to one side.

While the fire was burning, one of Uwulin's eyes popped out and fell in the grass and leaves near Goldfinch and Catbird. They saw where it fell but said nothing. The other bird and animal people ran around in all directions but could not find where the eye had fallen. Chapukala, the Blackbird, came to Goldfinch and Catbird. He asked them if by any chance they had seen where the eye had gone. They pointed it out and became heroes of the day.

When Uwulin was killed, he had lots of jerky hanging on the big rock where he lived near Yayan. The old-time bird and animal people would never go near the place, and the jerky is still hanging on the rock to this day.[26]

I once visited Uwulin's killing den near Yayan. The boulder is enormous, befitting a giant, truly of mythic proportion. It is blanketed in deep shade, and I wondered if the sunlight ever fingered its way into this closet of granite. There is an eerie quiet, and the cold, dank air is noticeably heavy. And there, high above my head, were the long, dark, ghastly strips of jerky, draped against the granite forevermore.

Loppapəə (pound it they did)

For some people in this region, a granite boulder with mortar holes is a place with direct family ties. It's not unusual to hear people say, "My grandmother pounded acorns there," or "I pounded sourberries here." These are ancestral stones, anchors in the personal history of families on the land. Within a group of bedrock mortar holes, a cupule that was used a thousand years ago might be right next to one that was used into the 1950s.

Acorn has persisted in the cuisine and culture of native people of the Sierra despite great changes in social economics. Even after more than half a century of working in a cash economy, the Miwuk/Paiute people who were relocated to the "new village" on the north side of Yosemite Valley in 1932 continued to process acorns in a traditional manner. From that time until the National Park Service liquidated the village in 1969, there were several women who used stone pestles to pound black oak acorns in the bedrock mortars there. In fact, this had gone on at this very place much longer; the 1932 relocation was actually a reoccupation of the village of Wahaka, a site recorded by Stephen Powers in 1872.

Sitting atop an outcrop, one might easily become lost in time; yesterday and today mingle on common ground. The sense of place, of carrying out a task within inches of the spot where an ancestor performed exactly the same motions perhaps a hundred generations ago, illuminates the extraordinary experience and legacy of native people in the Sierra Nevada. In a sense, these are the monuments of a culture that did not leave statues or ruins upon the land.

The subtlety of these stone features, lone boulders and outcrops of bedrock —exposed surfaces of the earth's core—reflects a direct, tactile relationship with the land, a society with little need or desire to dominate the landscape. These stones are the most noticeable indication of native life in the region. To say that is not to note a deficiency but to pay a compliment. And while the mortars conjure a vision of ancient cultures in most minds, some are surprisingly recent.

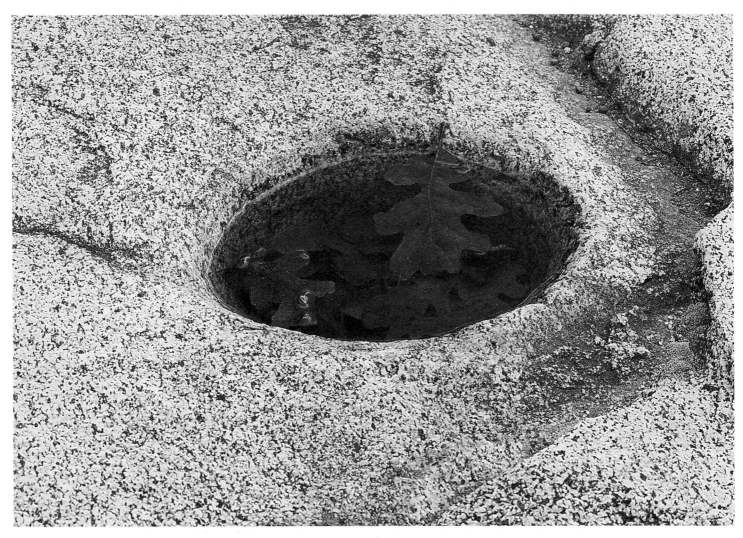

Sosse'aa. Bedrock mortar hole with black oak leaf and water. *Photograph by Dugan Aguilar*

Living among us are a few women, born between 1915 and 1930, who grew up when stone mortars were still being used to pound acorns or sourberries into flour. They are familiar with the sound of a stone pestle ramming into a mortar full of acorn meal, and soft conversations in the native language emanating from atop the bedrock. They recollect the motion of a sifting basket quivering as acorn flour moves over its corrugated surface. Their memories and experiences are tied to a place and connected to individuals: a mother, an aunt, a grandmother.

Although the nuances and knowledge required to process acorn correctly may surprise someone new to the art, there's more to it than merely learning the technique. These women were also bathed in their families' histories, personal anecdotes, and inside humor. For them, the perforated bedrock provides, quite literally, a touchstone to a thousand years of tribal experience, as well as memories of a more immediate, personal involvement.

Hettal, a Miwuk tray for sifting acorn flour: the foundation is made of deer grass stalks, the sewing strands of split bull pine branchlets, split winter redbud shoots, and bracken fern root. *Photo courtesy of Yosemite Museum, Yosemite National Park, YM-13512*

Della Hern

As remote as life before Euro-American settlement in the Sierra may seem to most of us, a link to that era was for some no farther away than a relative sitting across the room. This was true for Della Hern. She spent much of her childhood in Yosemite Valley, visiting with relatives during the summer in the modest group of thirteen cabins that comprised the valley's "Indian village." There, in the company of her elder relatives, she heard stories of events and people from long ago. Recently Della related her grandmother's account of the time when the Miwuk and Paiute residents of Yosemite Valley were routed from their homes by the Mariposa Battalion in 1851.[27] Della's great-grandfather, known as Captain Sam, was forced to leave his two daughters behind as the able-bodied made a hasty retreat up the steep, treacherous trail leading out of the valley near Indian Creek.

Della Hern, seated next to bedrock mortar where she used to pound acorns. *Photograph by Dugan Aguilar*

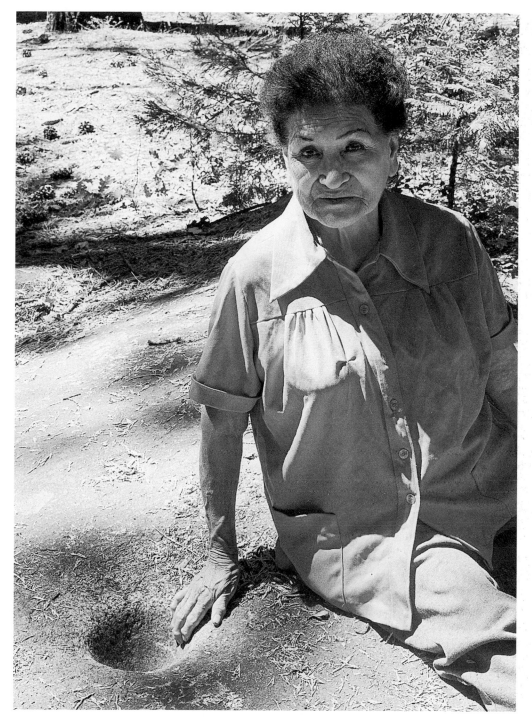

Lorraine Cramer at the Yosemite Valley bedrock mortar where she and her aunt pounded acorns.
Photograph by Dugan Aguilar

He had two daughters, that's Louisa Tom and Leanna Tom. And I would say they must have been between eight and ten years old or somewhere around there. And their dad, Captain Sam, had to leave the girls. I have tried to picture that. Anyway, in a rock crevice they were placed and told to stay. "Don't you move until I come back for you." Because they were excess baggage for him to get away. But she said that the dust . . . they would have to hold their clothing up so the dust [from the passing soldiers' horses] wouldn't go up their nose [and make them sneeze or cough]. But they stayed there. See, nowadays you can't ask that child to stay in one place. It's different. In those days you had to because your life was at stake.[28]

The two sisters survived and went on to live long lives, each raising a family. One of the sisters, Louisa, was Della's grandmother. While visiting the now abandoned site where she learned to pound acorns, Della recalled the sights and sounds of women going about their task, and her own connection to the ancient stones.

I learned how to do my acorn in the village from my grandmother, Louisa Tom. See, my grandmother didn't die until 1956. It was a thing that the Paiute and Miwuk ladies did. They made their acorn. And they climbed that rock. How did my grandmother get up there? How did my aunt get up there? There would be a group of ladies, maybe four or five, and they'd pound their acorn. Ohhh, you could hear the thud of the rock as it hits the acorn. My grandma used to get it and bring it down, just "Uhh!" when she'd hit her acorn . . . "Uhh!" You could hear that and you know grandma's pounding the acorn.[29]

Louisa Tom, c. 1930.
Photo courtesy of Yosemite Research Library, YRL-17825

Lorraine Cramer

Like many children and adolescents at the Indian village in Yosemite Valley, Lorraine Cramer helped her elder relatives when they prepared acorns. As Miwuk and Paiute children had always done, they learned by doing. They were expected to assist the family in the quest for food. And despite the change from a full-time hunting and gathering lifestyle to one that relied on cash, it was not

uncommon to see women preparing acorn during the 1930s and 1940s. There were still people in the village who had been raised on native foods and never abandoned them.

> I used to see my grandma [Louisa Tom] and Lucy Telles sittin' up there pounding acorn...and Alice [Wilson]. All of them used to sit there and pound acorn. They'd all get together in the evening. But those rocks were so heavy. Then you pound, like that. Then you learn how to sift. But I didn't know how to sift it good. I helped my aunt to sift it. And then she'd put the coarse acorn back in the hole I had there, and then I'd pound that for her.[30]

Julia Parker

Julia Florence (Domingues) Parker first went to live in the Yosemite Valley in 1949. Of Kashaya Pomo and Coast Miwok heritage, she met her future husband, Ralph Parker, while attending Stewart Indian School near Carson City, Nevada. Almost immediately after meeting Ralph's Yosemite Miwok/Paiute family, Julia was introduced to traditional food processing and preparation by Ralph's grandmother, Lucy Telles. Julia's recollections illuminate the subtle intricacies of pounding acorns, a skill learned through the direct transfer of knowledge and technique that have resonated in the Sierra for some two thousand years.

> She taught me how to pound. When she'd go to the rock she'd clean off the rock. I remember that. We always had to clean them rocks off with her soaproot brushes. She'd use water and we had to sweep those (holes) out good. Then she'd pound the

The hairy fibers from the bulb of *palaawi*, the soaproot plant *(Chlorogalum pomeridianum),* are used to make brushes, and the rest of the bulb is boiled and mashed to make a paste that is mixed with acorn flour and used to coat the brush's handle. Besides being used to clean mortar holes and sweep up acorn flour around the pounding or sifting area, soaproot brushes are used to scrub baskets.

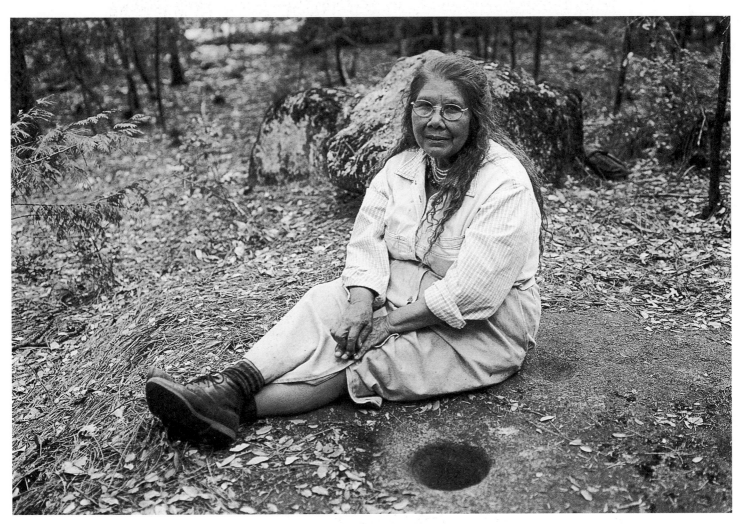

Julia Parker at the Yosemite Valley bedrock mortar where she first learned to pound acorn. *Photograph by Dugan Aguilar*

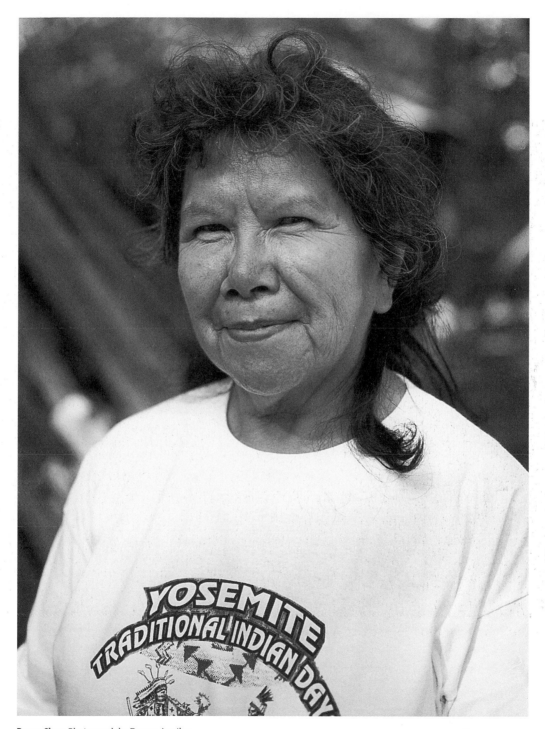

Peggy Shea. *Photograph by Dugan Aguilar*

acorns in there, and she'd just start to pound away and pound away. She'd straddle the rock [pestle] and lift it, and just really go at it. Strong!

When I got there Lucy was always using her pounding rock. She had the one below Norman James's house with a lot of pounding holes in it. And then she had her own pounding rock, up on the hill. That was hers, and she was always pounding acorn up on the hill. Whenever the acorns came she always had acorn.

What she would do is take the rock and balance it in the hole. It would just stand up. Then she'd take the acorn and we'd scatter the acorn all around the rock [pestle]. Then she'd lift it up and all the acorns went into the hole. That's how I test my pounding rock. If I can set it in there like hers and let it balance, then that's a good rock because it's what you need.

She always kept her acorn neat. When she pounded it was never scattered all over. It's because of the way she hit it. It would come down and go in there and then she'd hit it again, and then after a while you could see the action of the flour at the bottom of the hole. All the heavy pieces would fall around on the outside, and then she'd take her hand and pick up all those pieces and lay it up against that rock again. Then she'd keep pounding it, pounding it, always keeping it clean. That's what I remember about her.[31]

Peggy Shea

Granite boulders of all shapes and sizes dominate the landscape bordering Crane Creek as it makes its way through the hamlet of El Portal. Some are surely as big as a house. Many are scarcely noticeable from the roads and driveways of the small town, as they appear to be lost in the overgrowth of buckbrush, live oak, manzanita, and buckeye. But they are there, the large flattish boulders with round holes of various widths and depths penetrating their surfaces. How did they get there? Who made them?

Most of their names have been lost to time. However, remarkably, there are some people who do know the names. And they know the places—the exact places. Peggy (Beale) Shea knows. Born in Yosemite Valley and raised along Crane Creek in El Portal, she lived with her family on the grounds of a former Miwuk village known as Sas'ulah. Peggy's grandmother Emma (Oliver) Beale used the bedrock mortars there until the onset of World War II, when the family

moved to Richmond (California) to work in the defense industry. Over the years, Peggy has taken her children, nieces, and nephews to the spot where her family lived, recalling her grandmother at the demanding physical work of pounding acorn.

> I used to worry about her because it was hard for her to get up, and sometimes I'd help her up. You know, you sit there a long time, you get stiff. I know I wouldn't want to sit there all day like that. But she sat there for a long time. El Portal gets pretty hot, so she'd pound over there most of the time when it's shady. I used to help.[32]

Helen Coats

Helen (Hogan) Coats spent much of her childhood with her grandmother, famed Miwuk/Paiute basket maker Lucy Telles. The two places where her grandmother pounded acorn have great significance for Helen. One in particular, heavily shaded by black oak and cedar and largely obscured by manzanita and other brush, stirs strong emotions. The intimacy and privacy of the secluded spot is clearly felt. A deep connection with her grandmother is embedded in this piece of granite, a cultural legacy of the most personal type.

> She [Lucy Telles] had two places she liked to pound. One was that big rock. To this day I'm wondering how she even climbed it. The other one was farther over. Most of the time she liked to pound there because I think it had two [holes] where two of them could pound. That's where she really liked to do her pounding.
>
> We'd take them up lunch and water and stuff like that, but they stayed right there until they got their pounding done. Then they would clean up their area, get the rock all clean.

The tart, sticky berries of *tama'* (sourberry, *Rhus trilobata*) are gathered in summer. With a little water added, the pounded berries can be rolled into small balls to be eaten as a snack. The straight, slender shoots of the shrub are used as foundation rods in baskets.

Helen Coats at the Yosemite Valley bedrock mortar where she pounded sourberries and her grandmother pounded acorns. *Photograph by Dugan Aguilar*

When we pounded sourberries we used to like to put water [in the hole] afterwards and drink the juice. Lay on your stomach and drink the juice from that.[33]

As Helen spoke, her jaw muscles tightened, imagining the tartness of *ṭama* (sourberry). A smile washed across her face and I imagined a young girl sipping from this boulder fifty years ago.

Umuucha

Driving about Sacramento during a recent heavy downpour, going from one business establishment to another, I could not help but realize how truly insulated and protected we are from adverse weather. Commuters were undaunted. No one, with the exception of a landscape maintenance worker who had donned a slicker in order to mow the lawn on schedule, was affected by the weather. Inside the large office buildings that proliferate throughout the urban and suburban landscape, one could be entirely unaware of the inclement weather outside; the environment inside is constant, the insulation complete.

I recalled a summer afternoon in 1985 when I worked in Yosemite National Park as a cultural demonstrator in the Indian Village.[34] Large, bright cumulus clouds began to stack up as they reached the crest of the Sierra. Looking toward Half Dome from my vantage point I could see the towering, massive wall of white slowly move towards us. A distant but powerful rumbling bounced off the deep, nearly perpendicular walls of this great canyon, as if giant mythical children were hop-scotching through Yosemite Valley. What had been a very warm day began to cool quickly as the sun disappeared, and the wind began scattering pockets of dust and twigs in short, spasmodic blasts . . . like something panting. The tops of the taller trees rocked as with the tide.

Those of us working in the village began to collect our things: willow sticks and bracken fern roots, dogbane and netting shuttle, blankets and firewood. We went inside—Dorothy, Ivadelle, Julia, and I. One by one, bending slightly, ducking our heads, we entered the *umuucha*. I built a small fire, and each of us found a spot around the perimeter of the circular cone. We spread blankets over the pine needle bedding. As I looked up toward the apex, our humble fire gave

a soft, wavering light accentuating the uneven grooves in the cedar slabs. Distorted shadows of our forms hovered over us on the sloping walls.

It was now raining in earnest and I waited, poised to plug or divert any major leaks in this less-than-high-tech structure. The smoke was somehow disappearing through the roof, even though there was no apparent smoke hole.

Lena Brown and Mary in front of *umuucha,* Yosemite Valley, c. 1886. *Photo by I. W. Taber courtesy of Yosemite Research Library*

Everyone seemed to be dry. The air was cool and fresh, filled with the wonderful smell of newly dampened earth and the aromatic scent of cedar. The fire was beginning to warm the four of us nicely. I looked around the little circle and saw the glow of light on their faces, each looking downward, intent on the task of basketmaking. The initial laughter and banter had dropped off, and with the exception of irregular snaps from our fire and the scraping of willow shoots, it was quiet.

The muffled boom of thunder still rolled through the canyon, and the sound of rain on our shelter reminded us of our safety. We valued the protection it provided. I thought about the old-timers who once lived in *umuuchas*—they would never have taken them for granted. I believe we all liked where we were right then. Someone suggested we just stay there.

Chukchansi Memories

Minnie Wilson Karamanos was born in the "old Indian village" in Yosemite National Park in 1916.[35] Her father was a Miwuk man, Billy Wilson, who worked for the Curry Company stables in the park. Her mother, Elizabeth George, was a Chukchansi from the Coarsegold area. Minnie remembers her maternal grandfather, Captain Sore-Neck George, and grandmother Mollie, whose face still held the blue-green geometric patterns of traditional Chukchansi tattooing.

My grandma had tattoos here [on the forehead to the bridge of the nose], because her husband was a captain, you know, so they wore tattoos to signify how much power [they had] I guess. She had three, I think, zig-zaggy ones. And then down

Minnie Wilson Karamanos. *Photograph by Brian Bibby*

here [chin] she had three. They looked kind of green as far as I can remember, because they looked kind of faded. I saw other women too. Other women had markings. Some had straight lines, up on the forehead and down here [chin]. They were old.[36]

As a child, Mrs. Karamanos observed and assisted in the gathering of traditional foods using age old methods. At the appropriate time of year several of her elder relatives combed the hillsides of chaparral near Coarsegold. Buckbrush *(Ceanothus cuneatus)*, in addition to its use as a basketry material, is host to a species of caterpillar that provided an important part of the traditional Chukchansi and Miwuk diet. They were harvested between the larval and adult stage, when encased in a chrysalis.

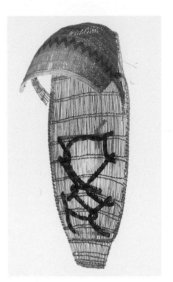

Chukchansi cradle basket, made by Ellen Amos c. 1920. Buckbrush shoots are peeled and scraped clean, matched for evenness, and then twined together to make the back of this type of cradle. *Photo courtesy of Yosemite Museum, Yosemite National Park, 46193*

We used to go with them [elders], because you had to make some kind of noise, like "hui." You have to say it loud, and then these things would rattle on the bush. They were hanging out on the limbs. I can't hardly remember that. But I know I went with my grandmother . . . my mother's mother went. They used to pick them. It was a delicacy for them.

Anyhow, you had to make this noise and then those things would rattle on the bush and then you'd pick it off, knock 'em off with a stick. We'd hit 'em with a stick into a basket or a bucket or something. They called them *huihui'na*. And then when you called 'em you'd say, *hui!* real loud. Those Chukchansi Indians ate that. They made sort of a stew.[37]

During her early childhood in Yosemite, Minnie had occasion to visit with Lucy Brown. Born sometime in the early 1830s, Lucy was a young woman when the Mariposa Battalion became the first non-Indians to enter Yosemite Valley, in 1851.

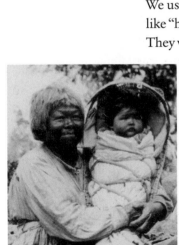

Lucy Brown holding Minnie Karamanos's sister, Alice Roosevelt Wilson, Yosemite Valley, c. 1903. *Photo by J. T. Boysen, courtesy of Yosemite Research Library, no. YRL8703*

I remember Lucy when I was about five because she used to chew gum, she used to make pitch gum. She'd get the light pitch off of the pine tree and she'd chew it and it would turn like gum, like chewing gum, and then she'd give it to us. My mother would say, "I don't want you chewing the gum out of that old lady's mouth." So we thought . . . that's good.[38]

Wassama

About twenty-five miles south of Mariposa, Highway 49 passes through the lovely hamlet of Ahwahnee, a term associated with a former Miwuk village in Yosemite Valley.[39] Just east of the highway is Wassama Roundhouse State Historic Park, which features a restored ceremonial roundhouse, two large bedrock mortars, and a cemetery. The 9.6-acre parcel is jointly managed by the California State Parks system and the local native community.

The roundhouse rests on almost the exact spot as three previous buildings. The first, constructed sometime in the 1860s, was apparently burned down in the 1870s upon the death of the headman. Ritual destruction of the ceremonial house was a well-established tradition throughout the Sierra. A second roundhouse (*hangi*) was erected in the 1870s and also destroyed after the death of a headman, about 1893.[40] Sometime between 1901 and 1904, the third roundhouse was built.[41] It remained upright until 1978, when it collapsed only days after the state had purchased the entire site for preservation. At the time, the roundhouse was being used as a chicken shed and for storing farm equipment. Whether it was a cow or horse that leaned against the building or vandalism that caused it to collapse has never been determined. In 1984, the present structure was completed, and it has once again become a gathering place for local native people.

During the 1870s, the *hangi* at Wassama was the site of great activity, as new religious movements, ideas, and dances came to the area. And even after many of the dance ceremonials ceased, the *hangi* at Wassama continued to find purpose as the focal point for meetings, gambling games, weddings, and funerals.[42] The cemetery was still active in the 1990s.

C. Hart Merriam visited Wassama in October 1905 and wrote in his field notes:

> In the course of my walks in this interesting region I visited two Indian rancherias—one inhabited by a single family (father, sons, and son's wife), and the other deserted except for the graves of the dead. The latter is Wah-sam-ah

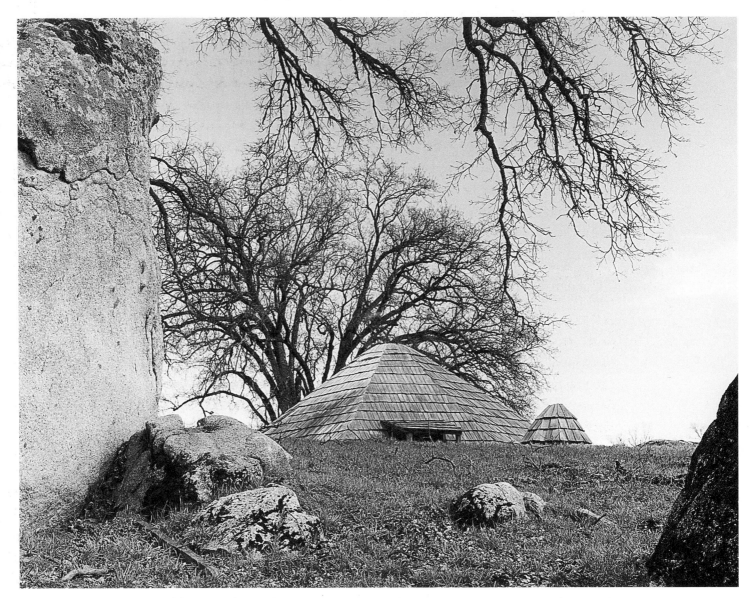

Roundhouse and grounds at Wassama, 1997. *Photograph by Dugan Aguilar*

proper and was once a large and prosperous village of the Chowchilla Mew-uh tribe. It is on a knoll on the east side of Wassamma Creek,[43] about half a mile below the Ahwahnee Hotel. A large ceremonial house remains, and close by is a big granite rock full of mortar holes.

The old graveyard is still used. Mr. Gillespie told me that when the former chief died two or three years ago, the Indians came and burnt the old ceremonial house and built the present one in the same place. When they had a "big time" here, they killed a beef and cut it in two and hung it on a scaffold in front of the roundhouse. I saw the scaffold, which is still standing. On certain occasions the Chowchilla Indians still come here to perform certain ceremonials.[44]

One of the leading figures in the Miwuk community at Wassama was Peter Westphall. Recognized as a chief, he was therefore considered owner of the *hangi*. He died in January 1924, and for several days his body lay in state inside this ceremonial house. Sometime earlier, he had requested that the building not be destroyed when he died, and that white people be allowed to attend his funeral.[45] This departure from established traditions and attitudes reflects change, but that should be no surprise — the elder Westphall, and those before and after him, have had to negotiate change throughout their lives. The environment has changed, as have traditional native economics and lifestyle, and population size. New and different beliefs have been introduced through interaction with other people. These are all issues that people like Peter Westphall had to think about.

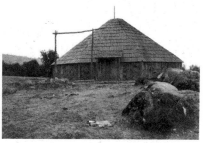

Roundhouse at Wassama, October 11 or 12, 1905. *Photo by C. Hart Merriam, courtesy of Bancroft Library, University of California, Berkeley, no. 1978.008 v/21d/P18 no.5*

There is sometimes confusion regarding tradition and change, and the question of whether the two are mutually exclusive. Peter Westphall was a man steeped in the cultural traditions of his people, and he surely possessed a deep knowledge of his people's mythology, history, and values. Yet he was capable of accepting new ideas, and he was not necessarily opposed to change.

His native name is not known. He worked for a county supervisor named Westphall and in the early days he was known as "Westphall's Indian".[46] This was a common scenario for the acquisition of European surnames among native people in California.

In 1915, anthropologist Edward Winslow Gifford interviewed Peter West-

phall concerning the cultural history and traditions of his people. Gifford stayed at the home of William Sell, who owned Ahwahnee Station and was a good friend of the local Miwuk and Chukchansi. It was in the Sells' living room that Gifford made the historic wax-cylinder recordings of Westphall that are now housed at the University of California, Berkeley.[47]

One of the speeches Gifford recorded was of the type that would be made at a mourning ceremony, or "cry." Usually delivered before the nightly wailing began, it proceeds in short, rhythmic stanzas characteristic of Miwuk ritual oratory. As one might expect, his age is apparent in his voice, which sounds like that of an old man, somewhat raspy and a little weak, far from the strong, booming quality he likely possessed decades earlier. But the emotion in his speech is undeniably audible in the gentle falling, fading of the voice as each phrase ends.

Peter Westphall on the Ahwahnee Station porch at Ahwahnee, c. 1915. *Photo courtesy of Yosemite Research Library, no. RL-14,142*

In this photograph, his hands are comfortably folded in his lap, his legs are crossed, and a dark suit-coat and hat add a certain formality to this otherwise casual pose. He is shoeless, and both he and the dog lying nearby appear to be enjoying the warmth of the sun as it bathes the porch in light. It's a remarkable experience to look at his image and listen to his voice some eighty-six years after it was recorded. They say the imprint of his father's thumb is on one of the federal treaties made in 1851.[48]

When C. Hart Merriam visited Ahwahnee and Wassama in 1905, a young Miwuk man, Johnny Gibbs (1884–1962) assisted the anthropologist in his work. Merriam apparently took several photographs of young Gibbs and his Chukchansi wife, Theresa. In one image, the young couple pose before a massive valley oak trunk not unlike the several giants that still tower over Wassama. In the fall, their deeply lobed leaves create a mosaic on the ground in tones of rust. Early autumn rains fill the bedrock mortars with water, tranquil pools that host the newly fallen leaves, which float like little rafts before they succumb, and sink to the bottom.

Johnny Gibbs and wife, Theresa, at Wassama, October 1905. *Photo by C. Hart Merriam, courtesy of Bancroft Library, University of California, Berkeley, no. 1978.008 v/21d/P3 no. 6*

Johnny Gibbs raised his grandson Les James about a mile above Wassama on property adjacent to Peter Westphall's place. At seventeen, Les joined the

Les James. *Photograph by Dugan Aguilar*

Marine Corps, and he later enjoyed a thirty-year career in Yosemite for the National Park Service, working in the sign shop as an engraver. When the *hangi* at Wassama was rebuilt in about 1903, Johnny Gibbs was part of the construction crew.[49] During the 1984 restoration, Les James helped set the four main posts in the structure.

After thirty years of living at Yosemite's doorstep and a short period in Merced, Les has returned to an area near his boyhood home. His new address? Highway 49.

Notes

1. Ootin is likely derived from the Southern Sierra Miwuk *utenə*, to tell stories; *utenhiime*, long ago, the legendary past

2. C. Hart Merriam, *The Dawn of the World: Myths and Weird Tales Told by the Mewan Indians of California* (Cleveland: Arthur H. Clarke Co., 1910)

3. Edward W. Gifford, *California Indian Nights Entertainment* (Glendale: The Arthur H. Clark Company, 1930), 95–96

4. Merriam, *The Dawn of the World*

5. Ibid.

6. United States Bureau of Indian Affairs, Letters received by the Office of Indian Affairs 1824–1881. Roll 34, December 16, 1854

7. Sylvia Broadbent, *The Southern Sierra Miwok Language*, University of California Publications in Linguistics, vol. 38 (Berkeley: University of California Press, 1964), 274

8. Ibid., 153

9. Letter from Randall Milliken citing information based on references from the mission register database for Mission San Carlos Borromeo (Carmel), Mission San Juan Bautista, Mission Santa Clara, and Mission Santa Cruz, 1998

10. Fr. Sarria (1814), Mission San Carlos Borromeo, First Register of Baptisms, Chancery Archives, Diocese of Monterey, California

11. Milliken letter

12. Ibid.

13. Actually Franciscan

14. Carvel Collins, ed., *Sam Ward in the Gold Rush* (Stanford: Stanford University Press, 1949) 55–56

15. Ibid., 56

16. Ibid., 127

17. This was one of the eighteen unratified treaties between the United States and tribes of California that were ordered filed under an injunction of secrecy until 1905.

18. Collins, *Sam Ward in the Gold Rush,* 57

19. C. Gregory Crampton, ed., *The Mariposa Indian War, 1850–1851: Diaries of Robert Eccleston: The California Gold Rush, Yosemite, and the High Sierra* (Salt Lake City: University of Utah Press, 1957), 61.

20. Collins, *Sam Ward in the Gold Rush,* 86

21. Ibid., 81–82

22. "Horrible Massacre, Three Indians Killed—One Hung—and a Squaw Wounded," *Mariposa Gazette,* February 1, 1879

23. Application for Enrollment No. 2714, United States Department of the Interior, Office of Indian Affairs, 1929

24. Wallace W. Elliott (publisher), *History of Fresno County* (San Francisco: Wallace W. Elliott & Co., 1882), 181

25. *ʔawellin,* from the Sierra Miwuk *ʔwwə,* "to eat"

26. Frank F. Latta, *California Indian Folklore* (Shafter, Calif.: Frank F. Latta, 1936), 121–122

27. The Mariposa Battalion's first foray into Yosemite Valley in search of Tenaya's band occurred on March 7, 1851. The battalion entered the valley a second time, in May 1851, and captured some thirty-five Indians on the shores of what is now known as Lake Tenaya. In 1852, after two miners were killed, armed forces under Lt. Tredwell Moore entered Yosemite Valley and caught and killed six Yosemite Indians. It's unclear which of the three operations relates to the experiences of Louisa and Leanna Tom.

28. Native American Oral History Project, sponsored by The Yosemite Fund (San Francisco). Interview by Brian Bibby, June 9, 1995 (Yosemite Research Library, Yosemite National Park)

29. Ibid.

30. Native American Oral History Project, sponsored by The Yosemite Fund (San Francisco). Interview by Brian Bibby, June 6, 1995 (Yosemite Research Library, Yosemite National Park)

31. Native American Oral History Project, sponsored by The Yosemite Fund (San Francisco). Interview by Brian Bibby, June 7, 1995 (Yosemite Research Library, Yosemite National Park)

32. Native American Oral History Project, sponsored by The Yosemite Fund (San Francisco). Interview by Brian Bibby, May 12, 1997 (Yosemite Research Library, Yosemite National Park)

33. Native American Oral History Project, sponsored by The Yosemite Fund (San Francisco). Interview by Brian Bibby, June 6, 1995 & July 12, 1996 (Yosemite Research Library, Yosemite National Park)

34. Located on the west side of Indian Creek, directly across from the Yosemite medical clinic, this village was identified as *Yowatchke* by C. Hart Merriam. It was occupied by Miwuk and Paiute people until about 1933.

35. Native American Oral History Project, sponsored by The Yosemite Fund (San Francisco). Interview by Brian Bibby, January 14, 1997 (Yosemite Research Library, Yosemite National Park)

36. Ibid.

37. Ibid.

38. Ibid.

39. *Awooni ~ owooni*, from *owwo*, "mouth," alluding to Yosemite Valley as a place with a large, gaping mouth, according to Sylvia Broadbent's *The Southern Sierra Miwok Language*

40. Michael J. Moratto, "The Archaeology of the Buchanan Reservoir Region, Madera County, California," pt. 8, Treganza Anthropology Museum Papers, vol. 7 (San Francisco: San Francisco State University, 1970), 1–85

41. Gene Rose, *Fresno Bee*, April 15, 1984; Anon., *Sierra Star*, September 14, 1983; Lou Evon, *Fresno Bee*, June 11, 1959; Brian Wilkinson, *Sierra Star*, July 6, 1978

42. John L. Smith, Interview of Eleanor Sell Crooks, *Fresno Bee*, February 3, 1977

43. i.e. Patterson Creek

44. Robert F. Heizer, ed., *Ethnographic Notes on California Indian Tribes III: Ethnological Notes on Central California Indian Tribes*, Reports of the University of California Archaeological Survey, vol. 68, no. 3 (Berkeley: University of California Archaeological Research Facility, 1967), 325

45. Lou Evon, Interview of Johnny Gibbs, *Fresno Bee*, June 11, 1959

46. Anon., *Fresno Bee*, January 12, 1924

47. Eleanor Sell Crooks to Craig Bates, April 17, 1980

48. Anon., *Fresno Bee*, January 12, 1924

49. Lou Evon, Interview of Johnny Gibbs

Notes to Photographs

Following is a list of photographs by Dugan Aguilar and their dates

Indigenous Linguistic Geography of the Western Slope of the Sierra Nevada

Language	Dialects	County
Maidu	Big Meadows	Plumas
	Indian Valley	Plumas
	American Valley	Plumas
	Susanville	Lassen
Konkow	Nemsu	Butte
	Otaki	Butte
	Mechoopda	Butte
	Eskeni	Butte
	Cherokee*	Butte
	Feather Falls	Butte
	Challenge	Butte
	Bidwell Bar	Butte
Nisenan	Valley	Sacramento
		Sutter
	Oregon House	Yuba
	Nevada City	Nevada
	Clipper Gap	Placer
	Auburn	Placer
	Colfax	Placer
	Placerville	El Dorado

Language	Dialects	County
Plains Miwuk	Lockeford	San Joaquin
	Jackson Valley	Amador
Northern Sierra Miwuk		
	Fiddletown	Amador
	Ione	Amador
	Camanche**	Amador, Calaveras
	West Point	Calaveras
Central Sierra Miwuk		
	East Central	Tuolumne
	West Central	Stanislaus
		Tuolumne
Southern Sierra Miwuk		
Merced River/Yosemite		
		Mariposa
		Tuolumne
	Mariposa	Mariposa
	Chowchilla	Mariposa, Madera
Yokuts	Chukchansi	Madera

*Cherokee, a small town near Oroville, has no correlation to the Cherokee tribes.

**Camanche, a small town now inundated by Camanche Reservoir, has no correlation to the Comanche tribes.

Note on Pronunciation of Special Characters

ə ("schwa"), as it is used in Northern and Southern Sierra Miwuk language curricula, is pronounced like the *u* in "but."

ṭ ("palatal *t*") is pronounced much like *t* in English. The undotted *t* is post-dental, with a sound close to that of *th* in "the."

198

Index

About the Author and Photographer

Brian Bibby has for over thirty years been a partner, with members of many of California's native communities, in documenting and maintaining various elements of native cultural history and traditions. He has taught at a number of institutions and has served as a consultant and guest curator for cultural and folk arts programs. He is the author of *Precious Cargo: California Indian Cradle Baskets and Childbirth Traditions* and *The Fine Art of California Indian Basketry.*

Dugan Aguilar (Paiute/Pit River/Maidu) works as a graphic artist for the *Sacramento Bee.* His photography is inspired by the work of Ansel Adams and by the people and landscape who "give" him pictures. His work has been exhibited at the National Museum of the American Indian, San Francisco's Ansel Adams Gallery, the Crocker Art Museum in Sacramento, the Barbicon Art Center in London, the Oakland Museum of California, and the Wheelwright Museum in Santa Fe.